SULLIVAN'S CITY

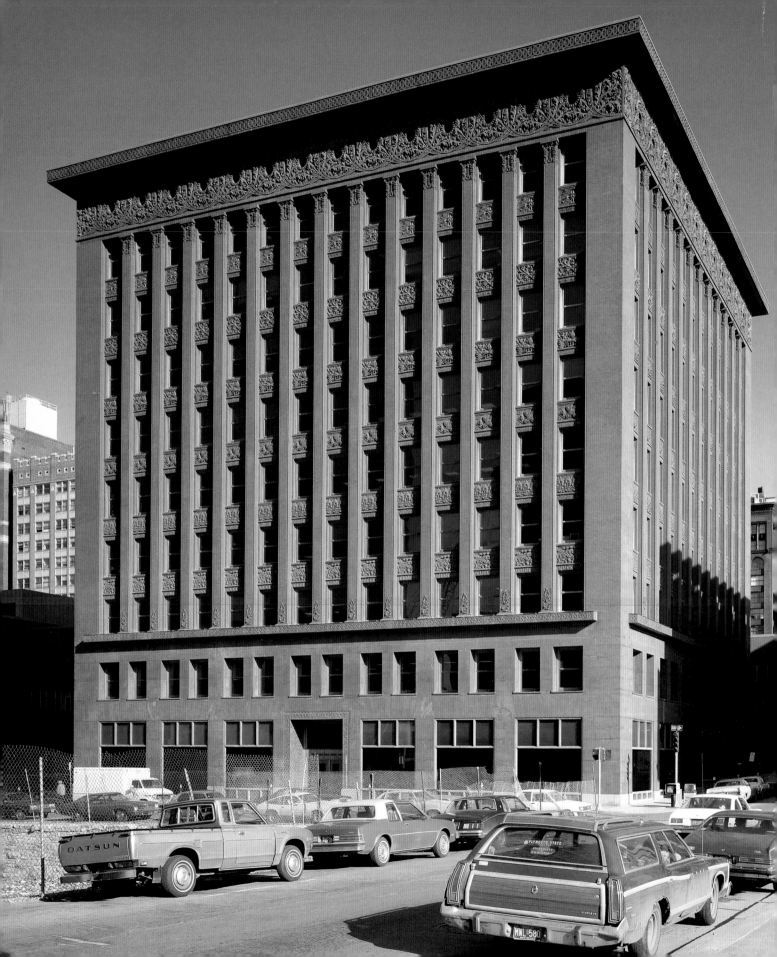

SULLIVAN'S CITY

The Meaning of Ornament for Louis Sullivan

DAVID VAN ZANTEN

PHOTOGRAPHS BY CERVIN ROBINSON

W.W. NORTON & COMPANY · NEW YORK & LONDON

For information about permission to reproduce selections from this book, write to Permissions, W. W. Norton & Company, Inc., 500 Fifth Avenue, New York, NY 10110

The text of this book is composed in Monotype Walbaum with the display set in Serlio

Book design and composition by Kristina Kachele

Manufacturing by Colorprint Offset

Frontispiece: Figure 1. Wainwright Building, Saint Louis, 1890–91 (Charles K. Ramsey, associate architect).

Library of Congress Cataloging-in-Publication Data

Van Zanten, David, 1943 –

Sullivan's city : the meaning of ornament for Louis Sullivan / David Van Zanten ; photographs by Cervin Robinson.

p. cm.

Includes bibliographical references and index.

ISBN 0-393-73038-7

1. Sullivan, Louis H., 1856–1924—Criticism and interpretation. 2. Decoration and ornament, Architectural—Illinois—Chicago. 3. Architecture, Modern—19th century—Illinois—Chicago. 4. Architecture, Modern—20th century—Illinois—Chicago. I. Title.

NA737.S9 V36 2000

729′.092′dc21 99-0865573

W. W. Norton & Company, Inc., 500 Fifth Avenue, New York, N.Y. 10110

www.wwnorton.com

W.W. Norton & Company Ltd., 10 Coptic Street, London WC1A 1PU

0 9 8 7 6 5 4 3 2 1

For my mother,
for Susan and Lucia,
and for uncles David and Ted

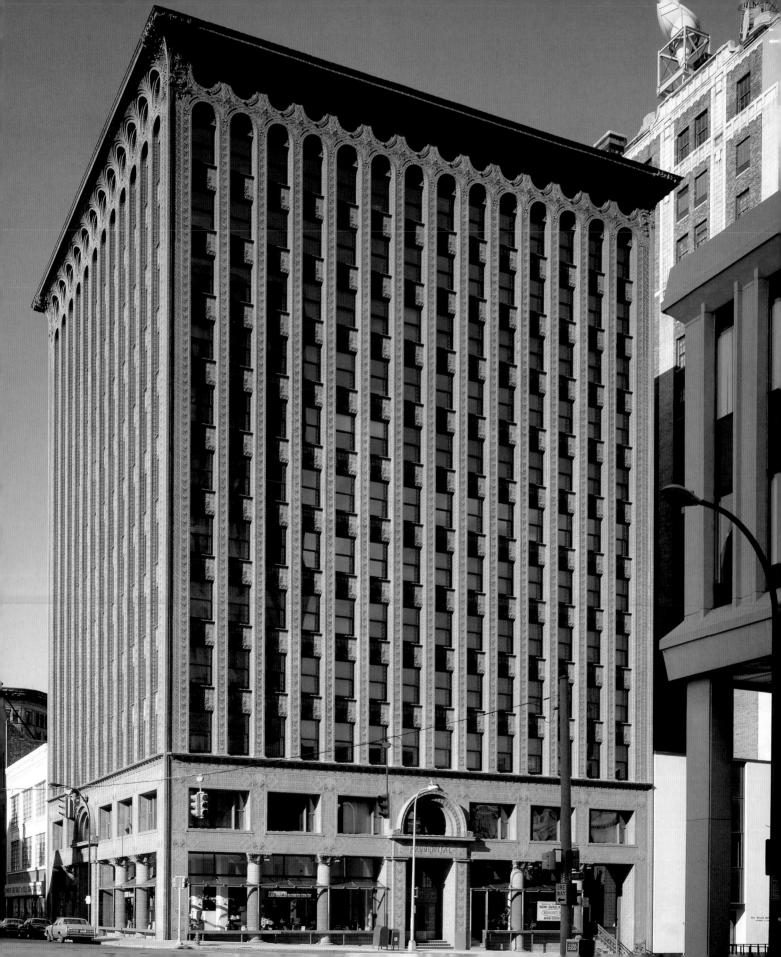

CONTENTS

FIGURE 2. Guaranty Building (later Prudential Building), Buffalo, 1894–96.

Preface and Acknowledgments

This essay is one of interpretation.

It is interesting that in the case of the Chicago architect Louis Henri Sullivan there is thought to be little problem of interpretation because his story seems such a simple one of unappreciated genius—one so well known, so taken for granted, that it is often cited as a cautionary example among historians. But I think this assumption misses the point.

What follows, accompanying Cervin Robinson's exquisite photographs of the volumes, surfaces, and interior spaces of Sullivan's buildings, is an attempt to understand the peculiar force of the ornamental carapace Sullivan increasingly laid over his work as his career unfolded. This book tries to see his architecture through his ornament in several different senses and how he got the last laugh, and in doing so told us something about building at the beginning of the twentieth century that we might not entirely want to know.

This book is necessarily also about Chicago—transformed around 1890 from a fertile chaos into one of the exemplary cities of a suddenly urbanized world—and about a peculiarly self-involved, observant, graphically imaginative architect who sought to find a place in it.

Young, he helped in its creation. Older, he acted out a theatrical scenario of failure within it. Just before his death he polished an extraordinary pair of self-justifying last works, *The Autobiography of an Idea* and *A System of Architectural Ornament*, to fix his place in its history. Thus there are three different cities for Sullivan. First, there was the city of Chicago itself that he helped create in the skyscraper boom of the 1890s. Second was the anonymous, hostile city that grew there and elsewhere within that first, one in which his scattering of interventions come to identify and assert themselves by their signature ornament and—speaking to each other across the commercial cityscape—suggest what might have been a more humanely scaled, sensitively shaped and inflected conurbation. Third was a hermetic city suggested in the strange selfcontainedness of Sullivan's ornament as year by year it burgeoned in richness and effectiveness while his own economic and physical powers waned, an ornament that became an entity in itself and ultimately—spread out in the end only as broad mazes of pencil lines—evoked miniature fantasy-cities. But, most important, by the time we reach Sullivan's hermetic city we must also face the practical consideration from which we

departed a moment ago: the sheer fascination of the architectural drawing that has convinced us—and many before us during the last two centuries—that reform must lie in form, that a problem diagrammed is a world set free. We are unwilling to acknowledge and explore the human attraction of architectural plans, their tremendous power as a simple network of lines. As we follow Sullivan folding in upon himself year by year we see his fertility of design made alive as diagrams. And in studying his dilemma, we can sense our own as we too lose ourselves in the grids, flourishes, and cavities of his creations.

I have thought about Sullivan for many years and must acknowledge many contributions from different friends. First, perhaps, Georges Didi-Huberman whose enthusiasm for Sullivan's ornament as an entity during walks through Chicago's Loop most directly produced this text. Next, Neil Levine with whom I have enjoyed more walks and days of discussion about architectural space, enclosure, thick walls, and settings. In addition, this essay would have been impossible without the generous help of Cervin Robinson and Timothy Samuelson, as well as Martha Averill, Clara Bargellini, Robert Bruegmann, Robert Judson Clark, Joan Draper, Rochelle Elstein, Mary Jo Field, the late William Jordy, Ahuvia Kahane, Paul Kruty, Narciso Menocal, Luigi Mumford, Patrick Quinn, Tom Reese, Bart Ryckbosch, Lisa Schrenk, Howard Schubert, Paul Sprague, Germain Viatte, Lauren Weingarden, Ron White, Deborah Whyte, and Wim de Wit.

Cervin Robinson's photographs benefited from the kindness and hospitality of RoseAnna and Robert Mueller, Susan Lorenz, and Helen Coolidge. I should also mention that the final framing of this essay was done under very specific and helpful circumstances: a collaborative course on Chicago at the turn of the century, taught in 1998–99 at Northwestern University with Carl Smith, Henry Binford, and Diane Dillon to a bright and creative group of students. I owe them all the warmest recognition and thanks.

SULLIVAN'S CITY

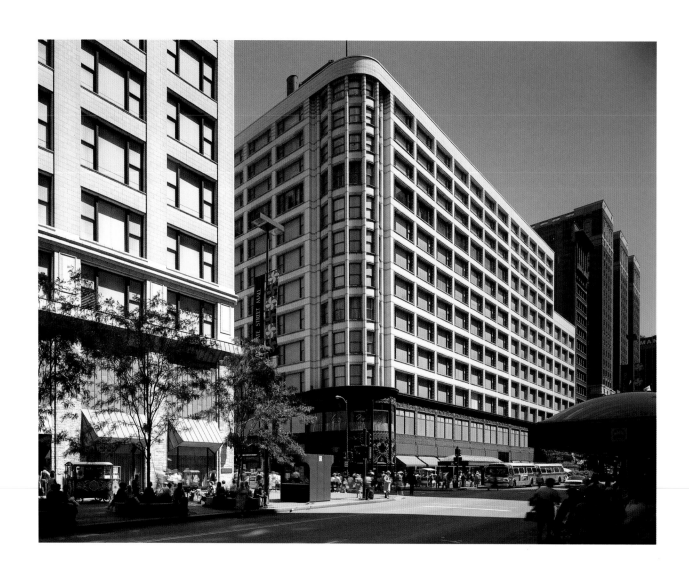

FIGURE 3. Carson Pirie Scott Store (originally Schlesinger & Mayer Store), Chicago, 1898–1904

INTRODUCTION

Ah, that supreme, erotic, high adventure of the mind that was his ornament! Often I would see him, his back bent over his drawing board, intent upon what? I knew his symbolism—I caught his feelings as he worked. A Casanova on his rounds? Beside this sensuous master of adventure with tenuous, vibrant, plastic form, Casanova was a duffer; Gil Blas a torn chapeau; Bocaccio's imagination no higher than a stable-boy's. Compared to this high quest the Don's was as Sancho Panza's ass. The soul of Rabelais alone could have understood and would have called him brother. How often I have held his cloak and sword while he adventured in the realm within, to win his mistress; and while he wooed the mistress, I would woo the maid!

—Frank Lloyd Wright about Louis Sullivan, 1924

LOUIS SULLIVAN has become a myth in American architectural history and, as must happen with a myth, one that has been presented in distinctly different ways —architecturally, biographically, and poetically. Architecturally, Sullivan appears in the myth as the first master of skyscraper design. His contribution is held to have been produced in his Wainwright Building in Saint Louis (figure 1) erected in the winter of 1890–91, and explained as a "solution" to a functional and artistic problem in a celebrated article he published five years later, "The Tall Office Building Artistically Considered," in which he first articulated the famous admonishment: "form ever follows function."[1] This building (erected with the collaboration of his then engineer partner, Dankmar Adler) is a ten-story box, as all rental "skyscrapers" were at that time. His accomplishment, Sullivan explained in the article, was making the exterior transparent of the interior functions. The first floor houses shops, thus requiring wide openings on the street pavement. These distinguish that floor from the second, which is unique in having wide windows required by the presence of public offices—ticket agencies, banks—with direct access to the public first floor by stairs. Above the

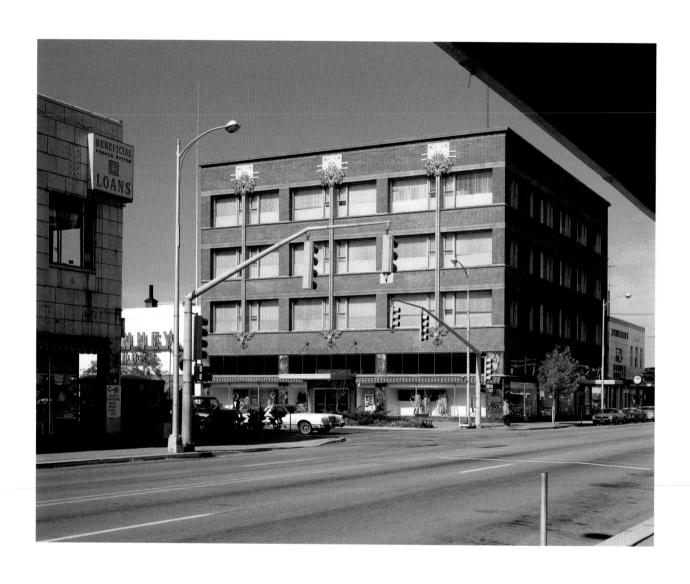

FIGURE 4. John D. Van Allen & Son Store, Clinton, Iowa, 1911–14.

second floor is a stack of floors with identical windows in offices that are each "a cell in a honey comb,…nothing more" (p. 404). At the top is a closed floor screening the water tanks and machinery of the building.

The Wainwright Building is also transparent of its interior in that being supported by a thin steel skeleton—called "Chicago" or "skyscraper" construction—the even grid pattern of this skeleton evident in the equally spaced piers marking the broad window fields of the exterior. These piers, columnlike, are stretched vertically and are closely placed so as to draw the eye upward. This could be seen to communicate what Sullivan considered the final distinguishing characteristic of the building, its verticality. In his Guaranty Building in Buffalo of 1894–96 (figure 2), coincident with the publication of "The Tall Office Building," the verticality is more emphatic, underlining his further declaration: "It must be in every inch a proud and soaring thing" (p. 406).

A third part to his accomplishment is the extraordinary ornament evoked by Frank Lloyd Wright in the epigram heading this introduction, articulating these forms on the exterior, achieving the same transparency, but on a different plane.[2] The ornament underlines the expressive pattern of openings; it makes the Wainwright spandrels "read out" to emphasize the vertical colonnade across the façade; it shapes the supporting piers into columns by providing bases and capitals; it supplies an overscaled, terminating frieze across the top; it identifies the door among the shop fronts on the first floor.[3] This ornament also acknowledges the architectural surfaces by which it seems engendered. The door ornament is barely eked out of the dense sandstone surface. The details of the column piers are abstracted and held close to the surface, as if by stretching that conventional member out its identifying ornament was drawn back into it—his most interesting detail because here he reconstitutes a complex traditional form. The decoration of the spandrels and cornice frieze is flat and subtly modulated

in its extension from the terra-cotta blocks. The terra-cotta cornice is overscaled and sharply incised to read from the street ten stories below and to be visible in the shadow of his abrupt box-lid cornice.

A generation ago Vincent Scully observed how close Sullivan's first solutions around 1890 were to the contemporaneous house and skyscraper designs of the New York classicists McKim, Mead & White.[4] All are in carefully chosen colored brick, shaped into simple cubic volumes marked by unified patterns of openings, and outlined with delicate terra-cotta ornament. But in that last aspect an important difference emerges: McKim's ornament is delicately scaled, sharply patterned, and effectively placed, but it also reproduces Renaissance forms pedantically. Sullivan's ornament is freer: it is based on a few, consistent motifs—still mostly classical and usually from the Greek acanthus plant and its stylization—that are scaled up and down, cast in deeper or shallower relief to respond precisely and powerfully to their situation on the façade as well as to the quality of light falling on them.

The differences between White's and McKim's buildings and Sullivan's are modest around 1890, but the New York paradigm remained fixed and was reproduced over and over again by the firm during the next two decades while Sullivan changed and developed his ornament constantly from this first step. Sullivan's Wainwright "solution" has usually been taken as just that, a fixed model, and has been seen as the first of several boxy, square skyscrapers he produced in the decade after 1890, especially the Guaranty Building and the Carson Pirie Scott Store in Chicago built in stages from 1898 to 1904 (figures 2 and 3). We can indeed read all of these façades in the same manner—the lower two floors open more generously for commercial activities, the top floor deemphasized as a working level, identical cells in between—but unlike McKim's firm's work, something important happened progressively to Sullivan's ornamental surface. The idea of a colonnade between a plinth and cornice

fades after the Wainwright, and the ornament—in the 1890 building used to bring out that architectural motif—emerges and spreads over the entire surface of the Guaranty Building to make it seem to burgeon and shift. Vincent Scully suggests that this is an expression of the carrying work of the inner, elastic, iron frame. Scully's is a striking observation if one is standing before the Guaranty Building, but in Chicago, the surface of the Carson Pirie Scott Store has differentiated into a state in which the body of the façade is clad in inert, almost unarticulated white terra cotta; the ornament is clustered around the two lower levels of show windows in completely unrestrained effulgence; and a corner tower has emerged to mark the door. Even more unusual things are happening on Sullivan's contemporaneous Chicago Stock Exchange Building of 1893–94 and his St. Louis Union Trust Building of 1892–93 (see figures 68–70). Sullivan's problem solving is not the production of models, but a process gone through repeatedly and each time differently in response to slightly changed circumstances to create multiple solutions.

The impression that by 1900 Sullivan's ornament had escaped the traditional structural subordination of the Wainwright solution is made unmistakable in two smaller buildings a decade later: the John D. Van Allen & Son Store in Clinton, Iowa, of 1911–14 and the Merchants National Bank in nearby Grinnell of 1913–14 (figures 4 and 5). In both cases (though in necessarily different ways) the ornament concentrates in single, thick passages that explode across the otherwise lightly articulated surfaces of the structures' volumes. The buildings are basically functional boxes overlaid with knots of thick ornament working on a distinct artistic plane. The emergence of Sullivan's ornament from its traditional role of structural expression (fixed momentarily in the Wainwright Building) calls again into question the finality of any narrowly functional interpretation of his work based solely on the 1896 article.

Sullivan's Life

Our second, biographical Sullivan is easily presented, thanks to Morrison's, Connley's and especially Twombly's careful biographies (working from Sullivan's own *Autobiography of an Idea*). Sullivan was born in Boston on September 3, 1856, the son of an Irish dancing master, Patrick Sullivan, who had immigrated nine years earlier, and Adrienne List, who had arrived with her Mennonite family from Geneva soon after him.[5] Louis was named in part after his grandfather, Henri List. His older brother Albert had been born on September 17, 1854.

The future architect was educated locally, then at Boston English High School in 1870–72, followed (without graduation) by a year as a Special (nondegree) student in architecture at the Massachusetts Institute of Technology. This program was the first in the United States, established by William Rotch Ware, following the French methods of the Ecole des Beaux-Arts in Paris as Ware understood them through his teacher, Richard Morris Hunt.[6]

In 1868 Sullivan's parents moved to Chicago, where Patrick plied his trade with some success among the local elite.[7] Louis stayed behind, living with his mother's parents, Henri and Anna List, and their children, Jennie and Julius, in Wakefield, then an outer Boston suburb. Bits of French were spoken in the house and Louis won the French prize at Boston English. When his grandmother died in April 1871 and Henri List moved to join his son in Philadelphia, Louis moved in with a neighbor, John Tompson, whose son was a student in engineering at MIT.

Quick, seventeen years old, a good draftsman from the start,[8] with three years of high school and college training, and with beds available to him in Philadelphia and Chicago, Louis Sullivan set out in the early summer of 1873 to learn the practical side of architecture.[9] He visited New York to talk with Richard Morris Hunt, the

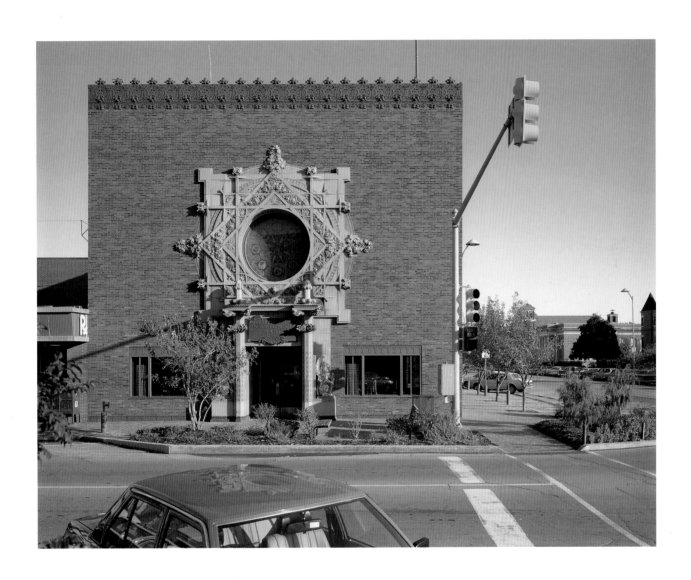

FIGURE 5. Merchants National Bank, Grinnell, Iowa, 1913–14.

most sophisticatedly trained architect in America at that time, Hunt's having spent 1843–55 in school in Geneva and Paris. From there Sullivan headed to Philadelphia and demanded employment of Hunt's extraordinary student, Frank Furness, who fifty years later inspired the most vivid and oft-quoted passages of *The Autobiography of an Idea* (see chapter 1). The financial panic of September 1873 forced Sullivan out of Furness's employ and on to his parents in Chicago, where he sought work with the Paris-trained William Le Baron Jenney, the local equivalent of Hunt (and, to a degree, Furness), a graduate of Harvard University and *diplomé* of the Ecole Centrale des Arts et Manufactures.[10] Sullivan, however, had a broader ambition: to get to Paris, to "headquarters" as he called it in his *Autobiography*. With the money he had earned as a draftsman, he left New York on the *Britannic* on July 11, 1874, studied for a year at the Ecole des Beaux-Arts in the atelier of Emile Vaudremer (teacher of Eugène Letang, the design instructor at MIT, and especially popular among American and foreign students at the Ecole), and on May 24, 1875, returned, again on the *Britannic*.[11]

In the summer of 1875, reestablished in his parents' house on 23rd Street, he set up a short-lived but productive partnership with another imaginative young draftsman, John Edelmann.[12] In 1880, after several years of what Sullivan asserts were well-paid peregrinations around Chicago offices, Edelmann arranged for him to join the thirty-six-year-old engineer Dankmar Adler, to replace Adler's departed partner Edward Burling in the aspect of design.[13] Sullivan was now twenty-four and his arrival in Adler's office eventually led to a partnership—the firm of Adler & Sullivan appeared in 1883—and, with the commission to erect the ten-story Auditorium Building of 1886–90, fame and professional success. Adler & Sullivan shared with the equally young firms of Burnham & Root, Holabird & Roche, Henry Ives Cobb, and Solon S. Beman the remarkable challenge and opportunity of shaping Chicago amid the skyscraper boom of 1890–93 and the contemporaneous creation of the World's Columbian Exposition.[14] In 1893 Sullivan was thirty-seven years old.

To this point Sullivan's was one of the great success stories of the moment: he had work, recognition, and—with the Auditorium interiors and the Wainwright Building put before the public at almost the same moment around 1890—a signature style of his own.[15] The firm established its office on the top floor of the sixteen-story Auditorium tower in a panoramic command post over what many thought would soon be the capital of the world.[16] He built a vacation house on Biloxi Bay next door to his friends James and Helen Charnley and traveled there in the private railroad car of his brother Albert, who had risen to the post of general superintendent in the Illinois Central Railroad. Dankmar Adler proved a polymathic problem solver. The firm's chief draftsman, Frank Lloyd Wright, was the most brilliant designer in the city (and, by the end of his career in 1959, in the world).

By the mid-1890s, however, a tragic flaw of arrogance had appeared in Sullivan's character. Architectural work evaporated with the economic depression of the summer of 1893. Wright left after sharp words with Sullivan, in part because Wright was doing domestic architecture on his own after hours.[17] The partnership with Adler was dissolved in July 1895 and, after efforts at reconciliation failed, Adler died in 1900. The same year Sullivan quarreled with his brother and they became estranged.[18] With the return of prosperity in the late 1890s, a few large commissions came Sullivan's way—the Bayard Building in New York (1897–99), the Gage Building façade on Michigan Avenue (1898–1900), and especially the Carson Pirie Scott Store (1898–1904) at the "world's busiest corner," Madison and State Street.[19] Sullivan found himself idolized by a group of younger Chicago designers, and in 1901–2 he produced his lyrical *Kindergarten Chats*—pub-

lished serially in the *Interstate Architect and Builder*—to enlighten them. But this work proved his swan song. No important commissions followed the Carson Pirie Scott Store, and that organization itself employed Daniel H. Burnham when they extended their building down State Street in 1906. There was talk of alcoholism. In 1903 Sullivan lost the Larkin Company headquarters building in Buffalo to Wright because of doubts about his dependability.[20] In 1905 he proposed himself to head the architecture department at the University of Michigan only to see his young admirer Emil Lorch appointed instead.[21] The work that now came his way was smaller projects in the suburbs or the provinces: the Henry Babson House in Riverside of 1907–9, National Farmers' Bank in Owatonna, Minnesota, of 1906–8, the John D. Van Allen & Son Store in Clinton, Iowa of 1911–14—handsome projects but not the Loop skyscrapers he had been used to. He had married Mary Azona Hattabaugh in 1899, but in 1909 they separated and were eventually divorced.[22] He had to sell his property on Biloxi Bay in 1908, then in 1909 auction his books and furnishings.[23]

Sullivan became a strange, great, solitary figure alone in his spreading office at the top of the Auditorium tower, the subject of distant admiration and recrimination, but not of employment.[24] He would receive visitors, talk, and read them parts of his lengthy ruminations, *Democracy, A Man Search*.[25] In 1913 a room in the annual Chicago Architectural Club exhibition at the Art Institute was given over to a retrospective exhibition of his work as if, at fifty-seven, he was already a figure from the past.[26] In 1918 he had to give up his office in the Auditorium tower for a small space on the second floor facing Wabash Street. In 1920 he lost even that space. By now he was living on the charity of friends, eating at the Cliff Dwellers' Club above Burnham's Orchestra Hall. Yet Sullivan never lost his design touch, even in his last and most pitiful projects like that for the terra-cotta front of the Krause Music Store of 1922 (see figure 156). In one

last supreme display of undiminished imaginative power he wrote his *Autobiography of an Idea* and drew the twenty plates of his *System of Architectural Ornament*. Shortly afterwards, on the morning of April 14, 1924, he died.

Sullivan's Thought and Writing

Louis Sullivan was so skillful in shaping the romantic monument to his art that was his career that one is not surprised to find as well a poetic Sullivan, one expressing himself not only in buildings but also metaphorically, rhythmically, in a characteristic prose-poetry.[27] His themes were clear. First, art is work and work is life; thus, building is an emanation of frank human thought, progressive and self-justifying, untrammeled by rules or precedents. Second, human history is emerging from a "feudal" past of classes, hierarchies, and systems into a "democratic" future of the free exercise of man's imaginative powers. Third, any description of the new architecture can only be of its intellectual method, of a blossoming from the democratic mind, and not of any concrete details because its expressions will be as various as its makers and its situations—like any natural creation such as flowers or the times of day.

Sullivan's ideas were neither complex nor new, as Sherman Paul demonstrated a generation ago, but what is interesting is exactly what Paul's subtitle—"An Architect *in* American Thought"—indicates: that Sullivan absorbed the Transcendental tradition and spoke directly to Whitman, Emerson, and Dewey.[28] What distinguishes his thinking is what he did with his ideas, the writing in which he expressed them, and the audiences he chose to address. He started with his stentorian evocation of the seasons and states of nature in his four-thousand-word poem "Essay on Inspiration," read before the Western Association of Architects in 1886. It begins:

When birds are caroling, and breezes swiftly fly, when large abundant nature greets the eye, clothed in fresh filigree of tender green, when all is animation and endeavor, when days are lengthening, and storm clouds smiling weep, when fresh from every nook springs forth new life,—then does the heart awake in springtime gladness, breezy and melodious as the air, to join the swelling anthem of rejuvenated life,...

After evocations of other seasons, a storm and the sea, it softens to:

And thus my song, declining, now sinks to its rest through the peaceful sky. Whereafter prolonging thought arises, following close, as a harvest moon, shining with milder, reflected light.

The thought that dawn, noon and twilight are ever linked with the coursing sun; that invisible tomorrow is even now its gliding companion, and will appear with it anon, dawning our day in urgency.

Whence I believe that action thus ever attends on flushed and procreant purpose, continually mounting with it toward the shifting summit of desire.

Without the sun, no dawn; without sustained desire, no fruitful or efficient action.[29]

In his *Kindergarten Chats* of 1901–2 (reedited by him in 1918) he depicts in fifty-two short chapters a young architect's reeducation by a patient, older guide. The language is less hackneyed, the periods less ornamental, the substance didactic rather than evocative.

Let us pause, my son, at this oasis in our desert. Let us rest awhile beneath its cool and satisfying calm, and drink a little at this wayside spring....

You mean, I suppose, that here is a good piece of architecture for me to look at—and I quite agree with you.

No; I mean, here is a *man* for you to look at. A man that walks on two legs instead of four, has active muscles, heart, lungs and other viscera; a man that lives and breathes, that has red blood; a real man, a manly man; a virile force—broad, vigorous and with a whelm of energy—an entire male.

And further:

To my own statement that the true function of the architect is to initiate such buildings as shall correspond to the real needs of the people, I now add your statement, that he must cause a building to grow naturally, logically and poetically out of its conditions. Now all of this means... I take it, in a few words, that the real architect is first, last and all the time, not a merchant, broker, manufacturer, business man or anything of that sort, but *a poet who uses not words but building materials as a medium of expression*; Just in the same sense that a great painter uses pigments as *his* medium of expression, a musician, *tones*; a sculptor, *the marble block*; a literatus, *the written word*; and an orator, *the spoken word*— and, like them, to be truly great, really useful, he must impart to the passive materials a subjective or spiritual human quality which shall make them live for other humans—otherwise he fails utterly and is, in a high sense, a public nuisance instead of a public benefactor. Isn't that so?

It is indeed so.[30]

Around the *Kindergarten Chats* clusters a mass of shorter essays that he read at gatherings of young designers or published in more popular journals, beginning

with his "Emotional Architecture Compared with Intellectual" of 1894 and continuing with parts of what became his manuscript *Democracy, A Man Search* in the early 1900s. The culmination was his *Autobiography of an Idea*, written in 1922–23 just before his death. It is the story of his life up to his establishment in practice—that is, the part that he shared with other young men, and it recalls when his naive attentiveness to his surroundings—social and natural—was most acute. By the time of its writing Sullivan's rhetoric had softened to an amber reminiscence of the simplest things justified only by the reader's experience of sharing them.

Nineteenth-Century Conceptualizations of Ornament

One thing common to all three of our Sullivans is his ornament. It seems a metaphor for his architecture, the enterprise of his life, and the design equivalent of his poetry.

In nineteenth-century art and design, ornament was the sign of mind—of intention and thus of art.[31] As such, however, it was understood in very different ways. Ornament could constitute merely a citation of a previous, authoritatively certified model, as it was for White and McKim and for their Chicago admirer (and Sullivan's great rival) Daniel Burnham, who became impatient when too much effort was devoted to details and who later insisted that his draftsmen copy their ornament directly from historical precedents.[32] For these ornamental purposes, compendia and glossaries of ornamental models were available, such as Owen Jones's *Grammar of Ornament*, César Daly's *Motifs historiques d'architecture et de sculpture d'ornement*, Antonin Raguenet's *Matériaux et documents d'architecture*, and J.A. Habert-Dys's *Fantaisies décoratives*.[33]

This cool attitude of selection, however, could not satisfy a period so fiercely moralistic and scientific, so a par-allel conception of ornament evolved as an honest emanation of the material and structure of the surfaces it articulated. ("Ornament is not … principal; it must … be secondary to the thing decorated." … "The best age is the simplest,—the decline is marked by the increase of ornament."[34]) Today we consider this the grand, truthful tradition—subordinating ornament to structure—that led to "modern" functionalism, that of Pugin, Ruskin, and Morris.[35] The conventional history of nineteenth-century architecture favors this argument and thus sets up Sullivan's Wainwright Building as his exemplary accomplishment because its ornament most faithfully articulates its structure. But there was at least one further understanding of ornament: ornament as the expression of the artist's or architect's imaginative power or *virtù*.

There were two particular proponents of this proposition, both design teachers: Christopher Dresser, active in Britain from around 1860 to 1900, and Victor-Marie-Charles Ruprich-Robert, at work in France from around 1840 until his death in 1887.[36] Sullivan had connections with both, with Dresser through Sullivan's much-admired former employer, Frank Furness, in Philadelphia; with Ruprich-Robert by the evidence of his surviving drawings copied out of the plates of the massive *Flore ornementale* (1866–76, plates 8 and 9) as well as Ruprich-Robert's proximity to him while Sullivan was studying in Paris, teaching at the Ecole Gratuite de Dessin across the street from Sullivan's lodgings on the corner of the rue Racine and the rue Monsieur-le-Prince.[37] Both Dresser and Ruprich-Robert produced impressive volumes of model designs with explanatory texts (figures 6 and 8). It is not the patterns and strategies Sullivan might have borrowed directly from either that are of concern here, however, but rather the interpretation that Dresser and Ruprich-Robert placed upon their exploding, highly stylized imaginings. To Dresser, writing in the earliest of his several design books, *The Art of Decorative Design*

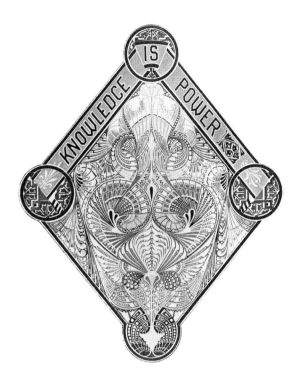

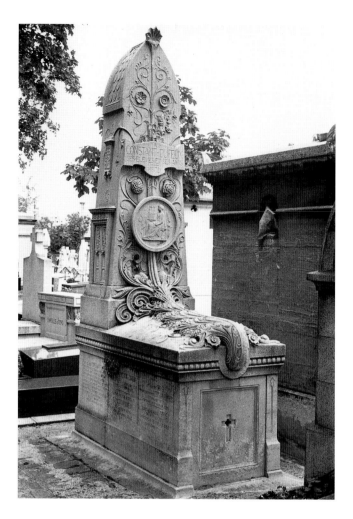

(1862), "The amount of pleasure derivable from the contemplation of an ornament will be largely dependent on the extent to which mind is embodied in it."[38] Thus direct imitation of either nature or historical models is to be avoided while the abstraction of natural forms is better. Nevertheless, "Purely ideal ornament is that which is most exalted, it being wholly a creation of the soul; it is utterly an embodiment of mind in form, or an offspring of the inner man...."[39] To Ruprich-Robert, whose volume was a progressive demonstration of the generation of decorative designs from a wide array of botanical species, ornament was more the exploration of a superior natural geometry than that of function—that "*géométrie aimable* de Dieu," the *humane geometry* of God, "[a] geometry which is also that of utility, but at the same time that of beauty, and of which the elements [are to be found] in flowers which every day, without thought, we trample beneath our feet."[40] Ruprich-Robert ends the introduction to his *Flore ornementale* by quoting Goethe in a manner that Sullivan would embellish and extend in his own writing:

Should not each [design student] be able to exclaim with Goethe: "As you pour your ardor over me in the morning, beloved Spring! A thousand ineffable sensations awaken in my heart where penetrate the sacred sentiments of your eternal fire, beauty everlasting!," and carried away by this love of art, might not each of us thus obey his own impressions and listen at last to the beating of his own heart?[41]

Behind the entire concept of elaborating a design through a sequence of graphic and intellectual moves lay the broader compositional strategies taught at the Ecole des Beaux-Arts and the geometric strategies framed by the architectural polymath E.-E. Viollet-le-Duc, whom Ruprich-Robert assisted from 1843 to 1850 as professor of ornamental design at the Ecole Gratuite de Dessin

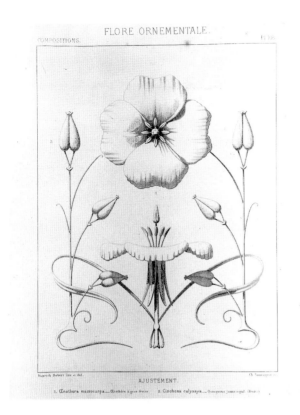

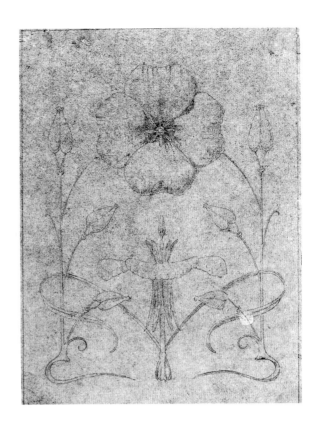

before succeeding him in that post. Sullivan knew the tradition of these schools directly; his decorative collaborator, Louis J. Millet, was a family friend of Viollet-le-Duc.

The particular motif used by both Dresser and Ruprich-Robert was the arabesque, transformed by the first into a starburst and by the second—in at least one highly visible and sincere instance—into a pulsating tendril-like efflorescence (figure 7). This is the tomb that Ruprich-Robert designed in 1872 for his teacher in Paris, Simon-Claude Constant-Dufeux, upon the latter's death in 1871. (The tomb is in the Cimetière Montparnasse, a twenty-minute walk from Sullivan's student mansard.) From its sarcophagus an eerie tendril emerges and climbs the tall headstone to divide and flower and to hold—seemingly hung from its tendrils—models of Constant-Dufeux's work, like flowers. Here, it is inspiration that is important, not "influence"; unmistakable in Dresser's and Ruprich-Robert's work is the idea that ornament was the manifestation of the artist himself and thus personal, intensely expressive, and independent as an element in architectural composition. Furthermore, to return to the

left to right

FIGURE 6.
Christopher Dresser, "Knowledge Is Power,"
The Art of Decorative Design, Day & Son, 1862, plate 24.
(Northwestern University Library, Special Collections)

FIGURE 7.
V.-M. Ruprich-Robert, tomb for S.-C. Constant-Dufeux,
Montparnasse Cemetery, Paris, 1872. (Author)

FIGURE 8.
V.-M. Ruprich-Robert, *Flore ornementale*, Dunod, 1866–76,
plate 108. (Author)

FIGURE 9.
Louis Sullivan, tracing of plate 108 in Ruprich-Robert's
Flore ornementale. (Art Institute of Chicago)

Wainwright solution with which we began, the recognition of this tradition of ornamentation, subsumed in the work of Dresser and Ruprich-Robert, tells us that Sullivan's art was about growth and change—if the solution to problems, then the solution repeatedly, as physical contexts change and the artist's mind evolves and displays its imaginative power.

The Sullivan Histories Have Given Us

These three Sullivans—architectural, biographical, and poetic—constitute the material that creates our memory of that peculiar sort of historical character an architect is. We must seek a Sullivan further within that links these three together. The existing literature only begins to help us because, until recently, it has focused exclusively on one or another of these alternate Sullivans. The first Sullivan, historiographically, was a proto-modernist rationalist architect addressing the problem of the steel-framed skyscraper with the Wainwright Building. This appears definitively in Hugh Morrison's scholarly monograph of 1935, interpreting the building through Sullivan's uncharacteristically flat article of 1896, "The Tall Office Building Artistically Considered." By 1941 the Swiss modernist Sigfried Giedion could praise Sullivan's skyscrapers in his influential *Space, Time and Architecture* exclusively in terms of the weight of terra cotta (or absence of it) covering the steel frame, never mentioning his ornament.[42] Carl Condit subsequently applied this functionalist measuring rod to Sullivan's entire oeuvre.[43] By 1956 Philip Johnson declared only the simplest of Sullivan's skyscrapers—the Wainwright and the Guaranty—worthy of admiration and his ornament a sad distraction.[44]

No significance was attached to Sullivan's poetic ornament in these interpretations, and his later works and writing (if even mentioned) were treated as secondary. A fierce protest to this arose, first from Sullivan's professional friends, then from the eloquent historian Vincent Scully. Frank Lloyd Wright had reviewed Morrison's book contentiously when it first appeared and focused his ire on the "functionalist" interpretation:

> The real Louis Sullivan in his relation to time, place, and man is thrown entirely away to make a case for him as the fore-runner of a functionalism for which neither then—no, nor now, would he have ever had more than a curse. His biographer foolishly takes pains to defend him against the very thing that he was and that no critic has yet been able to see as his true greatness.[45]

Ten years earlier Wright had written the evocation of Sullivan's ornament heading this introduction: "Ah, that supreme, erotic, high adventure of the mind that was his ornament!"[46]

In 1959 Johnson's remarks inspired a short, brilliant reply from Vincent Scully, carefully examining how Sullivan's ornament on the Guaranty Building adheres to the architectural surfaces to bring out their structural tensions and render construction empathically expressive.[47] He removed Sullivan from the context of Gropius to that of his contemporaries, specifically Geoffrey Scott and his *Architecture of Humanism* of 1914, in order to evoke a humane Sullivan measuring his buildings by their users. It was at this moment that Sullivan's writings were rediscovered and linked to Emerson's philosophy and Whitman's poetry, first by Sherman Paul in 1962. A revived and rich series of interpretations has followed, for example in the work of Lauren Weingarden and Narciso Menocal, reading Sullivan's work as a synthesis of Ruskinian and Transcendental thought manifested ornamentally.[48]

This view of a poetic Sullivan, however, lacks the one thing that is quintessentially architectural: a sense of design in its spatial and volumetric aspects as well as in

its surface. Historians recently have been trying to treat him more completely, the late William Jordy placed his work in the continuum of American architectural form, Joseph Siry in the precise social and technical context of Sullivan's time.[49] In 1977 the architect Thomas Beeby published a suggestive essay on the parallels between Sullivan's ornament and Frank Lloyd Wright's planning.[50] For me, the mystery remains: why was Sullivan's ornament so important to him? Why did Sullivan's ornament get better, more subtle, and more powerful as he got older, in spite of the evaporation of his practice? Why did it detach itself from the constructional organism of his later buildings—modestly at the Carson Pirie Scott Store; decisively in the Grinnell bank and the Van Allen Store? What faith had he in it and what power had he in him to end his career at sixty-eight with an autobiography of his childhood and twenty sheets of ornamental designs?

Historicism in architecture, like period imitation in ornament, worked by the modification of a predictable model, while Dresser's, Ruprich-Robert's, or Sullivan's elaboration of a principle produced a solution predictable only from the problem engendering it. Such solutions could thus surprise and their production could be an imaginative performance in itself, a display of artistic *virtù*. But much more importantly, working out of such solutions could take into account the specifics of each problem and so be humane and democratic. The intensity of involvement in form required to imagine such solutions was balanced by an equal intensity of involvement in the framing of the problem to be solved—in other words, in the social content that the architectural form encapsulated.

Design, for Sullivan, was a process, a performance, something that he did carefully and progressively to display and enjoy his creative *virtù*. As such, Sullivan found theaters for its performance in successively different contexts: first in academic planning as taught at MIT and the Ecole des Beaux-Arts and evident in his early theater interiors; later in architectural articulation as his skyscraper and bank commissions (but not his house designs) left little room for spatial elaboration; finally in pure, functionless ornamental fantasy when real building of any sort was denied him.

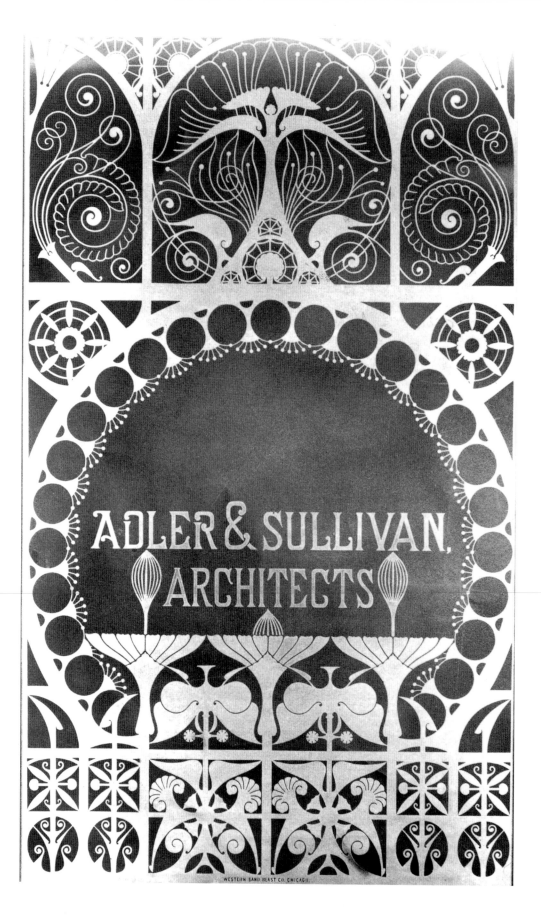

FIGURE 10.
Adler & Sullivan office
door glass pane (Borden
Block), Western Sand
Blast Manufacturing
Company, 1883.
(Chicago Historical
Society)

1

ENTRY ON THE STAGE: 1881-1890

Adler led off with a new style this spring and last winter [1880–81]. It is strongly Oriental. J. M. Van Osdel, Jr., told me he thought it was architecture run crazy. It certainly is a departure in the Jewish direction such as I have never seen before, and has features belonging to the ancient Egyptian.
—letter from architect D. Davis to George Mason, May 22, 1881

LOUIS SULLIVAN made a dramatic appearance on the Chicago architectural stage at the beginning of the 1880s. Just what he was doing, however, people found hard to grasp, so strong was his "signature" ornament and so obscure were his words of explanation. He had joined Adler's office around May 1880, was given a partial partnership around May 1882, and emerged as a full partner in May 1883. He worked from the top floor of Adler's 1880–81 Borden Block (see figure 14), behind an etched-glass door designed by him that was recently acquired by the Chicago Historical Society (figure 10).[1] Adler's work changed immediately upon Sullivan's arrival, startlingly according to the reaction expressed in the above letter of May 22, 1881, from the Chicago draftsman D. Davis to his old employer George Mason in Detroit[2]. A year later the *Daily Inter-Ocean* discovered the reason for the change in a review of Adler's recently completed Hooley's Theater and interviewed a young Louis Sullivan:

> Mr. Sullivan is a pleasant gentleman, but somewhat troubled with large ideas tending to metaphysics, and a deprecation of the non-development of the

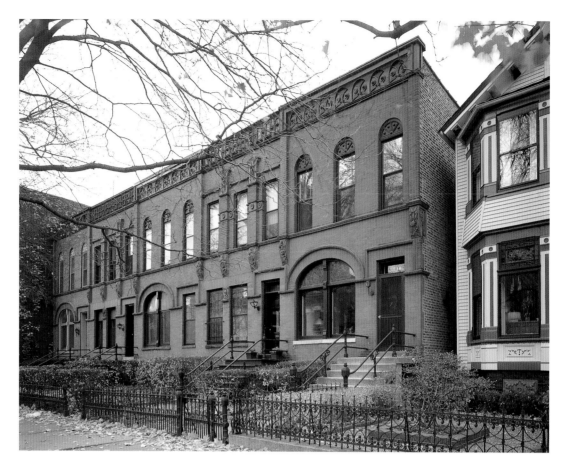

FIGURES 11, 12, 13.
Row houses for
Ann Halsted,
1826–34
North Lincoln
Park West,
Chicago, 1884–85.

opposite
FIGURE 14.
Borden Block,
Chicago, 1880–81.
(Adolphe Levy)

FIGURE 15.
E. Rothschild &
Brothers Store,
Chicago, 1880–81.
(Adolphe Levy)

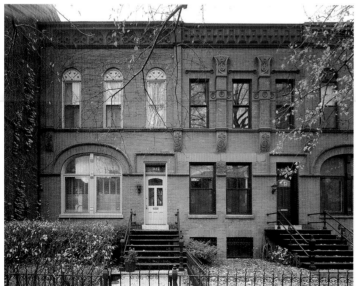

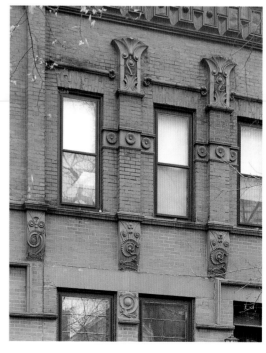

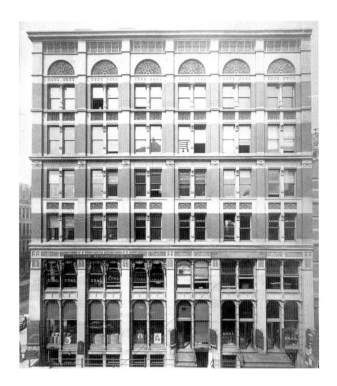

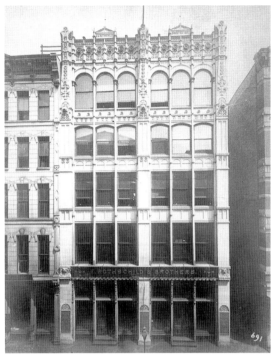

art protoplasm dormant in this city. It is therefore difficult to learn from Mr. Sullivan just what he has done. He refers to that work you will see about the stage opening as the differentiation of an absolute truth having something to do with Spencer's first principles and Darwin's doctrine of evolution, with the predicate of a flower and an ordinary staircase for an hypothesis. "I have no words to characterize what you see," said Mr. Sullivan, gazing upon the iron and plaster outgrowth of a primate [sic] of beauty. "I have not given study to the nomenclature of the peculiar art forms developed in these boxes or carried out in that proscenium crown. These are unclassified forms, and stock terms will convey no adequate idea of the successful treatment under a formula that is a new phase in

THE ART VIEW OF ARCHITECTURE.

"But above that brace marking the superior lines of the opening, I see light columns with peculiar arch [sic] and spaced with some pretty effects in plaster y [sic] Byzantine [sic] in general effect. How do you define that in words?" [the reporter asked].

"That is an exceedingly difficult question to answer. I cannot give it in words. I prefer that you speak of it as the successful solution of a problem."[3]

Solving Problems: The Early Loft Façades

A peculiarity of Adler & Sullivan's work is that among their numerous, small projects of the 1880s, only certain types seem to have attracted Sullivan's focused attention. Industrial buildings, railroad stations, and most of the rental blocks like the Ann Halsted row houses on Lincoln Park West of 1884 (figures 11–13) were conventional (except for bits of decorative terra cotta) and not of interest to him; in contrast, a remarkable series of loft façades and theater interiors show more thought.

The loft façades were extraordinary for their decorative consistency, forming together what contemporaries recognized as a family,[4] and were also practical and efficient (figures 14–21). It was surely their practicality and efficiency that opened the way for decorative consistency:

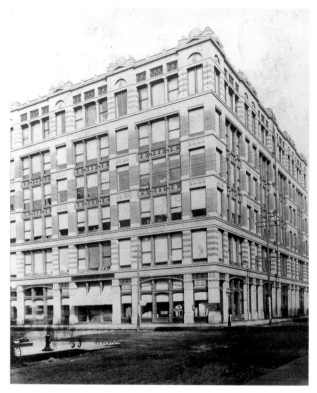

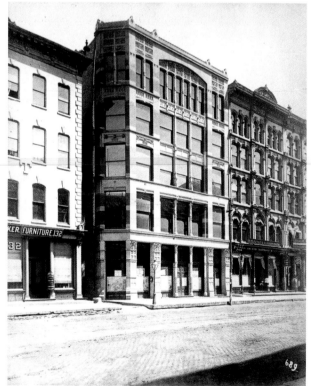

FIGURE 16.
E. Rothschild & Brothers Store, Chicago, 1880–81. Fragment of
cast-iron cornice. (Graham Foundation, Chicago)

FIGURE 17.
Revell Building (earlier A. S. Gage & Company Store),
Chicago, 1881–82. (J. W. Taylor, author's collection)

FIGURE 18.
Jewelers' Building (earlier S. A. Maxwell & Company Store),
19 South Wabash Avenue, Chicago, 1881. (Adolphe Levy)

opposite
FIGURE 19.
Troescher Building, Chicago, 1884–85. (Northwestern
University Department of Art History, Carl Condit Collection)

FIGURE 20.
Jewelers' Building, Chicago, 1881, cornice detail.

deep buildings for light manufacturing or for wholesaling and covering most of their sites, all but two had light entering principally at the street fronts. As contemporaries observed, Adler & Sullivan concentrated the façade supports in narrow, deep piers to make the windows as broad and unencumbered as possible[5]. By the time of the design of the Ryerson and Troescher buildings (both of 1884, figure 19) the façades had become skeletalized into sheets of glass, encouraging later historians to characterize them as almost steel-framed skyscrapers before the fact.[6] But the important point for the young and self-conscious Louis Sullivan was that this skeletalization gave him the chance to shape the narrow vertical supports not in conventional architectural forms, but as continuous pillars, floral and efflorescent (to use Sullivan's own word coined later), pushing upward as animating decorative expressions of support and imagination. Façade by façade, from the Borden Block and the E. Rothschild & Brothers Store of 1880 to the Troescher loft of 1884, Sullivan's façades simplified and refined themselves as if seeking a "solution" in the terms that Sullivan used with the *Inter-Ocean* reporter.

Only one of these lofts, the Jewelers' Building, survives today (see figures 18, 20–21), saved from intrusive restoration by the honest poverty of modern Wabash Street. Most important, it survives in context among a scattering of similar retail stores of the 1880s, one by Wheelock & Clay next door, another two by John Van Osdel directly across the street, and others a block north including a Ruskinian example.[7] This context permits us to grasp the model Sullivan sought to transform: a five-story thirty-foot-wide block of building divided into a two-story base (continuous plate-glass shopfront below, broadly-windowed office floor above) below a three-story loft opened to the light by a broad cast-iron sheet occupying the whole of its center. Van Osdel treated each floor and each window in his building as a separate com-

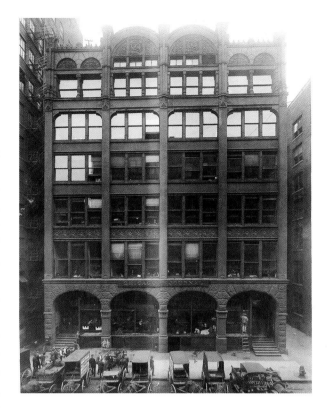

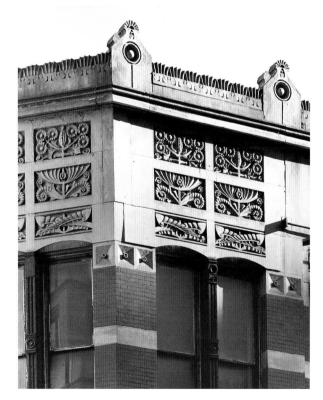

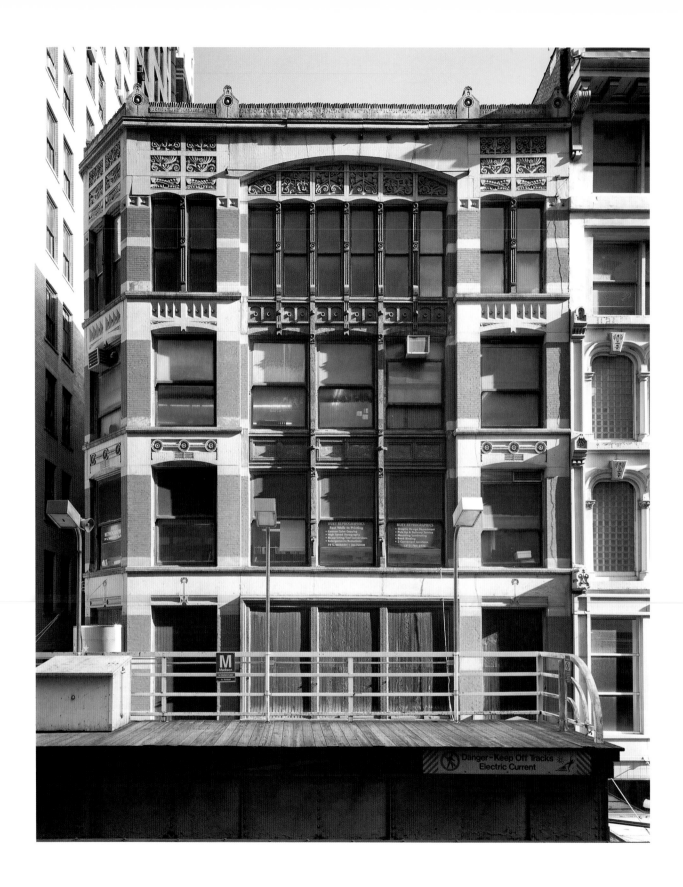

positional passage, defined by a grid of conventional pilasters and cornices; the Ruskinian façade became a flat brick plane with the windows bored through. Sullivan transformed these types by combining their parts into a single composition around the three-story iron-and-glass central panel gripped by brick and limestone piers and linked at the top by an embracing arch. The piers and the arch push in against the iron-and-glass plane, and in response a strange ornament emerges from the constructive surfaces. The piers at the first floor are carved into abstracted sunflowers. Flat floral patterns emerge out of a grid across the surfaces of the top-floor piers, deeper with each floor—decorative strategies that Sullivan would take much further in the Rothschild Store, the Troescher Building, and the Ryerson Building. In the Jewelers' Building the ornament is not as dramatic, but by observing it carefully we can see how subtly Sullivan has elaborated it, from the hard-and-soft of the execution of the carved motifs to the extraordinary cornice cresting divided into two zones—one decorated in cutout patterns, the other contrastingly in three-dimensional scoops. Looked at from the fifth story across the street, one also sees that the blocks punctuating the cresting are repeated behind it, endowing a three-dimensionality to the composition that only God (and a few stenographers) would have been able to appreciate (figure 20).

The result of Sullivan's design work was the gallery of self-proclaiming loft façades shown in figures 14–21, slices of Chicago five-story real estate texture opened into increasingly diaphanous efflorescences of overscaled, exotic floral motifs. In the case of the Rothschild Store and the Troescher Building, these motifs embrace the whole façade in one pulsating blossoming. They take us back to Sullivan's interview in the *Daily Inter-Ocean* but also forward to his retrospective depiction of his discov-

FIGURE 21. Jewelers' Building, Chicago, 1881, top four floors.

ery of architecture and the architect-man in his 1924 *Autobiography of an Idea*. As a student at Boston English High School, Sullivan gloried in his discovery of his personal power of concentration and achievement under the stern teaching of Moses Woolson. In the early 1870s Sullivan records him announcing at the first class:

The discipline here will be rigid. You have come here to learn and I'll see that you do....The first rule of discipline shall be SILENCE....The second rule shall be STRICT ATTENTION....The third rule shall cover ALERTNESS....The fourth rule: You shall learn to LISTEN; to *listen* in *silence* with the *whole* mind, not part of it;...Finally you are to learn to OBSERVE, to REFLECT, to DISCRIMINATE,...

Louis was amazed, thunder-struck, dumb-founded, over-joyed!...He knew now that through the years his thoughts, his emotions, his dreams, his feelings, his romances, his visions, had been formless and chaotic; now in this man's utterances, they were voiced in explosive condensation, in a flash they became defined, living, real. A pathway had been shown him, a wholly novel plan revealed that he grasped as a banner in his hand, as homeward bound he cried within: *At last a Man!*[8]

Then, in 1874, his encounter with the Parisian architect-mathematics tutor, Christian-Victor Clopet, when he showed him the textbook he had been advised to purchase:

Now observe: Here is a problem with five exceptions or special cases; here a theorem, three special cases; another nine, and so on and on, a procession of special cases. I suggest you place the book in the waste basket; we shall not need of it here; *for here our demonstrations shall be so broad as to admit of* NO EXCEPTION.[9]

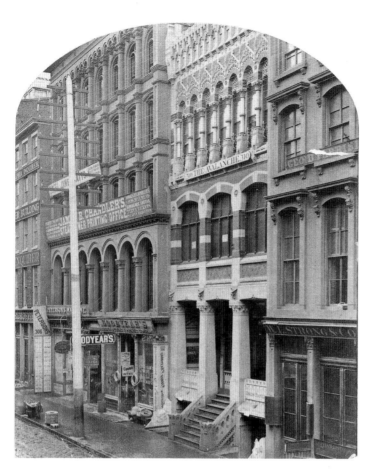

FIGURE 22. Frank Furness, Union Banking Company Building, 310 Chestnut Street, Philadelphia, 1873–74. (Philadelphia Free Library)

Louis replied, modestly enough, that he had just come from the Massachusetts Institute of Technology in Boston. This answer was the detonator that set off the mine which blew up in fragments all the schools in the land and scattered the professors headless and limbless to the four quarters of earth and hell. Louis, he said, was a fool. He said Louis was an idiot to have wasted his time in a place where one was filled with sawdust, like a doll, and became a prig, a snob and an ass. . . .

The other members [*sic*] of the firm was George Hewitt, a slender, moustached person, pale and reserved, who seldom relaxed from pose. . . . He was a clean draftsman, and believed implicitly that all that was good was English. Louis regarded him with admiration as a draftsman, but with mild contempt as a man who kept his nose in books. Frank Furness "made buildings out of his head." That suited Louis better. And Furness as a freehand draftsman was extraordinary. He had Louis hypnotized, especially when he drew and swore at the same time.[10]

Finally (although chronologically before Clopet) was Sullivan's delighted discovery of all this mystery, logic, and power combined into one man, architect Frank Furness of Philadelphia:

He wore loud plaids, and a scowl, and from his face depended fan-like a marvelous red beard, beautiful in tone and with each separate hair delicately crinkled from beginning to end. . . . Louis's eyes were riveted, in infatuation, to this beard, as he listened to a string of oaths yards long. For it seems that after he had delivered his initial fiat [that Furness should take Sullivan on as a draftsman], Furness looked at him half blankly, half enraged, as at another kind of dog that had slipped in through the door. His first question had been as to Louis's experience, to which

Furness had given Sullivan the job of tracing the plans for "a Savings Institution to be erected on Chestnut Street," the Union Banking Company (figure 22).[11] When two years later Sullivan set himself up in Chicago with his partner John Edelmann, he proclaimed himself a student of Furness.[12] The newspapers had inquired about two schemes of interior decoration the partners had executed in 1876 for Moody Church at Chicago Avenue and La Salle Street, and for the Sinai Temple at Twenty-first Street and Indiana Avenue. Only preliminary sketches for these survive,[13] but they permit us to see the free, exotic, floral motifs of Furness's façades exaggerated and exploded to cover broad interior surfaces, foretelling the efforts Sullivan would make from 1880 on to transform glass loft façades into fields of huge ornamental patterns.

Manifest in the family of loft façades with which Sullivan announced his arrival on the streets of the Loop is the point that architecture must be made from a designer's head. But this must be done in several senses: first, passionately, as Furness did it (in a cloud of profanity); second, logically, as Clopet demonstrated by seeking solutions with no exceptions; lastly, as a demonstration of what an individual can do when he commits himself completely to project, as Sullivan depicted Moses Woolson teaching him. The unmistakableness of his loft façades proclaims the first; their relation to the need to open the façade in glass the second; and their fixated development and variation of a consistent ornamental theme the third. Nonetheless, these façades were basically two-dimensional. If we are to see how Sullivan was formulating architecture in all its aspects, we must examine a second genre: his theater interiors.

Decorative Imagination: The Early Theater Interiors

Adler & Sullivan's theater interiors of 1880–86, before the Auditorium Building commission, were their greatest and most lucrative accomplishments. However, since all have been destroyed, they constitute the one accomplishment we cannot study in the flesh today. They are recorded only in (often unsatisfactory) photographs, written descriptions, and schematic plans.[14]

When Sullivan was hired by Adler in 1880, Adler was already building the Central Music Hall, including what was then the largest theater space in the city behind an office wing facing State Street (figures 23 and 24). It had been commissioned by a syndicate of leading Chicago businessmen: George Carpenter backed by Levi Leiter (president of the association), George Pullman (treasurer), Marshall Field, Martin Ryerson, and Ferdinand Peck.[15] The hall was intended to raise the cultural tone of the city, and its acoustical, spatial, and decorative success led to Adler & Sullivan receiving a series of commissions

for theater interiors that by 1885 constituted virtually all of the Loop's establishments: the Grand Opera House facing City Hall on Clark Street of 1880 (figures 25, 26), Hooley's Theater facing City Hall on Randolph Street of 1882, McVicker's Theater on nearby Madison Street of 1883–85 (redecorated by the firm in 1890) (figure 27), Haverly's Theater façade and art gallery on Monroe Street of 1884, and the Opera Festival Auditorium inside the Inter-state Industrial Exposition Building on the lakefront of 1885.[16] They were all basically decorative commissions, albeit on a grand scale. Although the firm was not able to do more than rebuild the boxes and the proscenium area in each case, these were key, both for Adler to display his evolving genius in acoustics manifested in funnel-like sounding boards around the stage openings, and for Sullivan to produce remarkable three-dimensional compositions of interlocking spaces and ornament in the box tiers. Sullivan's talent was displayed most impressively in the iron cage of boxes flanking the stage of Hooley's Theater which had so intrigued the reporter of the *Daily Inter-Ocean*, where the consistent use of poured metal permitted Sullivan's ornament full freedom. The ornament also appeared in the stepped, interlocking boxes of the McVicker's Theater—which we know only from a conceptual sketch by Sullivan (figure 27)—where it emerges from the walls to support the boxes, which in response dig into the wall plane behind.

The most striking quality of these spaces, however, seems to have been something unavailable to us through photographs and drawings: color and an experimental use of electric lighting. The *Building Budget* described the McVickers interior thus:

The features of construction, decoration, ventilation and lighting, are more novel in character than those of any other theatre we have seen, especially that of illumination, which is, not merely an addendum but a positive and integral part of the decoration. Hand-

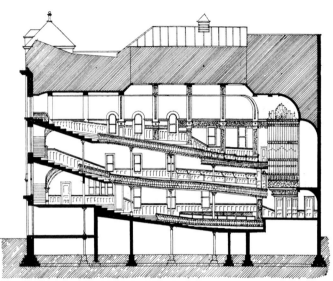

CENTRAL MUSIC HALL, CHICAGO.
[Longitudinal Section.]

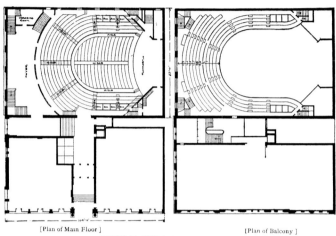

CENTRAL MUSIC-HALL, CHICAGO.

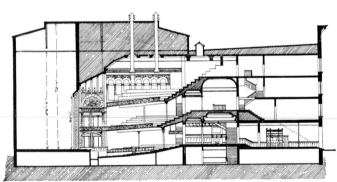

GRAND OPERA-HOUSE, CHICAGO.
[Longitudinal Section.]

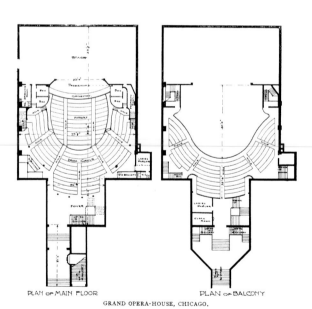

PLAN of MAIN FLOOR

PLAN of BALCONY

GRAND OPERA-HOUSE, CHICAGO.

somely moulded bosses and rosettes are profusely distributed over the walls, and are found in consecutive circles on the ceiling, and these being perforated are made the medium of admitting the softened light which permeates the house without the source of the combustion [of gas jets] being seen, not a bulb, not a jet, not a wick of any kind is visible, and yet so lavishly are the lights provided that the sounding board alone has 105 lamps behind and shining through the apertures concealed by its elaborate ornamentation.[17]

These theater fronts were performances of acoustical and architectural *virtù* at least as extraordinary as the theatrical and operatic presentations their proscenia enframed. In 1886, Sullivan, thirty years old, mounted another performance that set all his extravagant but controlled designing of the previous half-decade in perspective. It was a lengthy prose poem entitled "Essay on Inspiration," read out at the annual meeting of the Western Association of Architects—amid papers on technical subjects like "Architectural Grammar," (Nathan Ricker) "Architectural Freedom," (John Wellborn Root) and "Hints on a National Architecture" (Isaac Hodgson of Minneapolis).

The "Big" Office Building

In the mid-1880s Adler and Sullivan with their theater commissions (costing $40,000 or more) made a very good showing among their contemporaries who were otherwise engaged in lofts, "stores," and houses costing $5,000 to $15,000.[18] Theirs was an important practice—although not one on the level of the older, established practitioners such as John Van Osdel or the architect-engineer William Boyington; the latter had erected the Water Works, Crosby's Opera House, the Michigan Central

FIGURE 27.
McVicker's Theater (remodeling), Chicago, 1883–85, sketch dated January 9, 1883, by Louis Sullivan for the boxes flanking the proscenium.(Avery Architectural Library, Columbia University)

opposite
FIGURES 23, 24.
Central Music Hall, Chicago, 1878–80, cross-section of auditorium; plan. (*Engineering Magazine*, 1894. Center for Research Libraries)

FIGURES 25, 26.
Grand Opera House (remodeling), Chicago, 1880, cross-section; plan. (*Engineering Magazine*, 1894. Center for Research Libraries)

Railroad Station, and the Inter-State Industrial Exposition Building as well as the immense Joliet State Prison, and in 1885 was just finishing the Board of Trade Building at the bottom of La Salle Street.

Something new appeared in the Chicago architects' firmament in the mid-1880s, however, something that Sullivan's generation would make their own: the tall office building. In 1881 the Montauk (Burnham & Root, architects) and the First National Bank (Burling & Whitehouse) buildings were built beside each other on Monroe Street at Dearborn, looming ten and seven stories high, respectively, with their cornices almost even (figure 28). Contemporary journals were impressed; the *Real Estate and Building Journal* on September 3, 1881, declared the corner "one of the sights of the city." A new word was coined: "skyscraper." Other large office buildings quickly followed, especially the gigantic Pullman Building of 1883–84 on Michigan Avenue, supervised by S. S. Beman (who was brought uptown from his creation of Pullman's factory city at Lake Calumet), ten stories of red brick and terra cotta, of which the elaborate (and

sometimes bizarre) ornament was designed in part by Sullivan's friend John Edelmann.[19] Here and in such contemporary structures as Burnham & Root's Chicago, Burlington & Quincy railroad offices of 1882–83 (only seven stories tall but with an immense, sky-lit, interior court, built for Root's father-in-law), the corporate office building emerged, embodying both the isolated, all-powerful new world of office work (as Daniel Bluestone has documented), and a complicated new accomplishment in architectural engineering.[20]

In Chicago, the first scattering of these big office buildings coalesced in the mid-1880s into a small skyscraper citadel of consistent ten- and twelve-story blocks that rose within the space of three years on lower La Salle Street around the new Board of Trade as it neared its inauguration on April 30, 1885. Part of it can be glimpsed in figure 29, a view looking southwest from the corner of Quincy Street and La Salle taken just as the structures were being finished in 1884. We see the Mallers Building (Flanders and Zimmerman, architects) in the center, the Gaff and Counselman buildings to the left (Stephen V. Shipman and Burnham & Root respectively), and the Royal Insurance Company Building to the right (Boyington, architect), this last extending through the entire two-hundred-foot depth of the block and embracing a spectacular central court. This texture of construction continued up La Salle Street in the ten-story Rookery Building and the Home Insurance Company Building across Adams Street on the east (Burnham & Root, William Le Baron Jenney, architects, respectively), and by the Insurance Exchange (Burnham & Root) on the west. Behind the Board of Trade rose Burnham & Root's Rialto Building with their Phenix Building beside it. What is extraordinary in the photograph, however, is less the mere concentration of sheer ten- or twelve-story walls of brick than the suddenness, simultaneity, and unprecedentedness of these buildings that is brought home at the far right of the view where we see open sky and the old

city texture of two- or three-story stores beyond the end wall of the Royal Insurance Company Building.

What raised this remarkable citadel of office work was a large and complex real estate deal, the equivalent in Loop architecture of the Union Stockyards consolidation of twenty years before or Pullman's factory city of 1879–83 on Lake Calumet.[21] In 1880 a syndicate had bought land in front of the newly rebuilt Michigan Central (La Salle Street) Station and set about getting the city to vacate La Salle Street from Van Buren to Jackson Streets, opening Pacific and Sherman Streets a hundred feet east and west in order to provide a dramatic site for the Board of Trade which they proposed to move from its old location in front of City Hall, four blocks north.[22] A noisy controversy erupted as everyone knew that this would transform the economic geography of the emerging boom in Loop office construction. Aldermen were bribed; the State Supreme Court was appealed to on the issue of vacating La Salle Street; but in March 1882, the court decided for the syndicate and construction of Boyington's massive new Board of Trade building began. Soon after this, a crowd of office buildings began to grow around it, and an associated population of commercial agents, industrialists, and stock-jobbers moved in.[23]

The Auditorium Building

Adler & Sullivan, its theater monopoly notwithstanding, did not participate in the initial tall office building boom. The firm seems to have gotten typed, perhaps by Sullivan's self-presentation as a decorative impresario. Fortunately in 1886 they received the opportunity to build off of their theater reputation and obtain the commission for the Auditorium Building, the largest ten-story building of the decade, costing $3,200,000—a commission specifically snatched away from Burnham & Root (figures 30–33).[24] The reason for Adler & Sullivan's coup was the need to integrate a world-class opera house with revenue-pro-

FIGURE 29.
La Salle at Quincy Streets, Chicago, looking south, c. 1884. Mallers Building (Flanders & Zimmerman, architects, 1884) on corner; Gaff Building (Stephen V. Shipman, architect, 1884) and Counselman Building (Burnham & Root, architects, 1884) to left; Royal Insurance Building (William Boyington, architect, 1884) to right. (Author's collection)

opposite
FIGURE 28.
First National Bank (building in the foreground) (Burling & Whitehouse, architects) and the Montauk Building behind it (Burnham & Root, architects), Chicago, both 1881. (Chicago Historical Society)

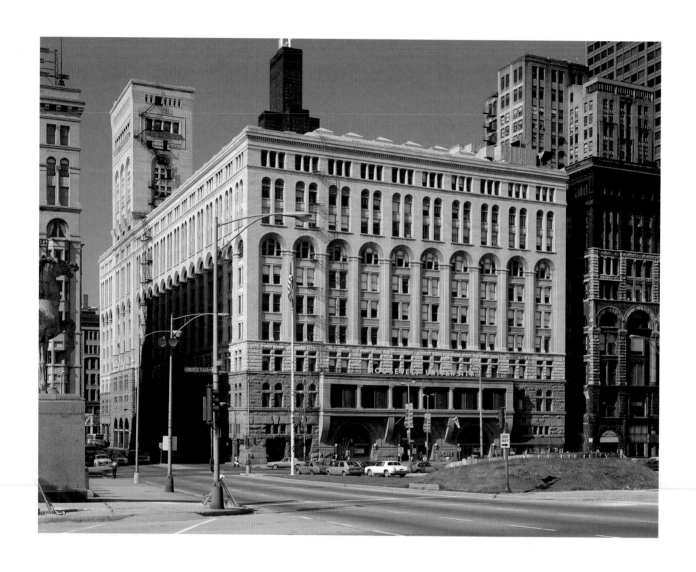

FIGURES 30, 31, 32. Auditorium Building, 1886–90, façade, masonry detail, and cross-section of auditorium. (Chicago Historical Society)

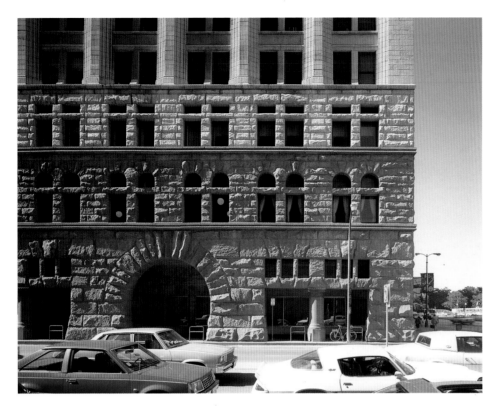

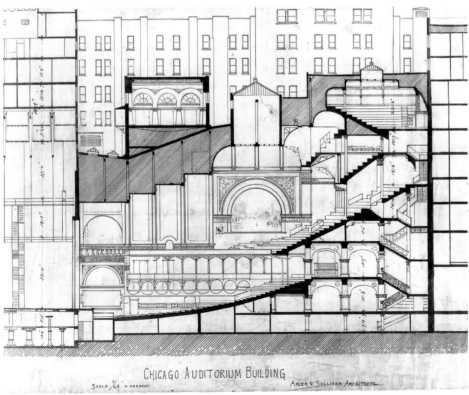

CHICAGO AUDITORIUM BUILDING

SCALE 1/64 = ONE FOOT.

ADLER & SULLIVAN ARCHITECTS.

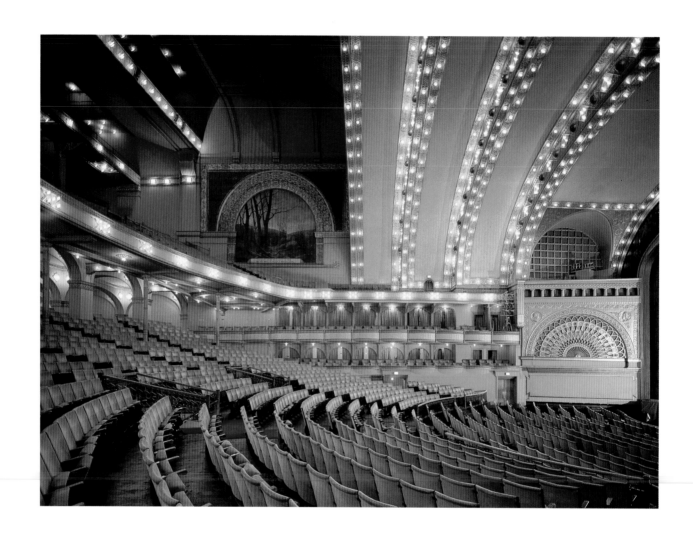

FIGURE 33. Auditorium Building, 1886–90, auditorium interior.

ducing office and hotel space; the result of their success was that the office building ceased to be unifunctional and emerged as a multifunctional, labyrinthine tour-de-force of planning and engineering that moved this type of building by 1890 to a new plane, that of the "city in itself."[25] Adler & Sullivan's unique collaboration created this transformation, and by working with the brilliant draftsman Frank Lloyd Wright and the engineer Paul Mueller they kept Chicago in the forefront of American progress through an organization that could solve complex new problems swiftly and easily.

The epochal story of the construction of the Auditorium has often been told, by both Morrison and Twombly, and originally by the newspapers that followed the projections, doubts, changes of plan, escalations of cost, crises in construction, and final triumphant inauguration on December 9, 1889. The speed of construction was extraordinary. The project was announced in December 1886, demolition of the older buildings on the site began in January 1887, the theater was ready for the Republican National Convention in the summer of 1888, and the whole structure opened to the public in December and January 1889–90.

A series of letters from the fireplace equipment manufacturer Louis Laflin to his wife in the country during the summer of 1889 reflect the speed and the spirit of the enterprise—as well as Sullivan's personal domination of it.[26] The first is dated June 8. Laflin had been asked by Sullivan to bid on the hotel fireplace contract. (That section of the building was to open the following January.) On June 15 Laflin was about to get the plans of the building and the architect's drawings of the mantels; on August 13 he received a "letter from the Auditorium Association requesting us to meet with other contractors in reference to hastening the furnishing of the Auditorium Building." The next day his shop drawings were done and at the Elgin Foundry. On August 19, "Adler &

Sullivan have just sent for me by telephone and I must away." The first mantel was installed almost immediately. On August 28, "The awful call has come and I must face Mr. Sullivan on the morrow"—the architect must give his approval of Laflin's first mantel. On August 29, "I am just leaving for the Auditorium to face Mr. Sullivan." On August 29, a second letter: "I have seen Mr. Sullivan and he is ours...." Laflin then had twenty days to install two hundred mantels.

It is interesting how the speed of the work blends with the commanding authority of Sullivan. While we lack a good contemporary delineation of his personality at that time, we learn later, "Those who knew Sullivan in the nineties say that never have they known such lightning speed in thought and action. Contractors didn't dare come to him with half-digested plans; his decisions on intricate points of design, of construction, were given instantly. Questions that apparently no one else could solve, he settled with the greatest ease."[27] Better known, although written more distant from that time, is Frank Lloyd Wright's account of his first encounter with Sullivan in 1888: "Mr. Sullivan was a small man immaculately dressed in brown. His outstanding feature his amazing big brown eyes. He took me in at a glance. Everything, I felt, even to my most secret thoughts."[28]

The Auditorium Building was a huge success. The acoustics of the hall were remarkable and were studied as embodying a new system in that art.[29] (Adler had already earned himself a consultancy at the new Carnegie Hall in New York in 1889.) The hotel filled and a matching hotel block was erected next door across Congress Street that repeated Adler & Sullivan's solution in everything except its architect.[30] (Clinton Warren was the architect but preparations had been made by Adler & Sullivan.) The newspapers trumpeted the opening of a new quarter for development similar to the Board of Trade area. Adler & Sullivan in 1887 had already received

the commission to build the Wirt Dexter loft south of the Auditorium development on Wabash Street.

The Mature Theater Interiors

It is amazing that the young firm got this huge project done at all. In accomplishing it they demonstrated that they constituted the best architectural organization in Chicago. Sullivan rested in January–February 1890 and left town to wander and think, discovering with his friends the Charnleys the town of Ocean Springs on Biloxi Bay, and he built himself a retreat there.

> Here in this haven, this peaceful quiescence, Louis's nerves, long taut with insomnia, yielded and renewed their life....
>
> 'Twas here Louis did his finest, purest thinking. 'Twas here that he saw the flow of life, that all life became a flowing for him, and so the thoughts the works of man....
>
> Arrived in Chicago, Louis at once went to work with his old-time vim...." [51]

Upon his return to Chicago in spring of that year, Sullivan was ready with an entirely new architecture.

Adler took the trouble to blame the surprisingly simple exterior of the Auditorium on the Opera Association directors' excessive respect for Richardson's just-completed Marshall Field Warehouse. The interior of the Auditorium, however, was new and demonstrates Sullivan taking off from his preceding theater renovations to shape within Adler's acoustical strictures a new kind of auditorium space. The conventional opera auditorium, like that of La Scala in Milan (the Auditorium's proclaimed competitor) or the Metropolitan Opera in New York (its real competitor), was a cylindrical well, with three-quarters of its inside surface walled up with boxes looking into the proscenium opening that occupied the

remaining quarter. In the Auditorium Building Adler's acoustical funnel was shaped by Sullivan into telescoping arches that forced the seating back and up as the arches projected the stage sound straight out from the stage and up a slowly rising hillside of seats that extended along an extraordinarily long axis, finally bleeding into deep first and second balconies (figure 32). In addition to Adler's acoustical model, the circumstance that enabled this type of construction was the developer Ferdinand Peck's resistance to boxes as undemocratic in what he wished to be a new, distinctly Chicagoan social space (as Joseph Siry documents).

Freed by these circumstances and given the opportunity for a string of new theater commissions, Sullivan got the chance for the first time in his career to plan space the way he had been taught in Paris. In 1888, before the completion of the Auditorium, Adler & Sullivan had built another opera house in its entirety, in Pueblo, Colorado, where Sullivan's enthusiastic discovery of spatial geometry emerged with a richness if also a certain lack of coordination (figures 34 and 35). In Pueblo the first balcony was brought entirely around the auditorium as an octagonal arcade, blending at the proscenium with the acoustic funnel. Over this balcony a groined cross-vault was erected, open to the stage and to lateral vistas of blue sky and trees in three equal semicircular arches —the fourth side abruptly cut out to open to the second balcony. It was a Beaux-Arts, Roman, centralized space launching axes in four directions (and suggesting diagonals in addition) and adapted to the necessities of Adler's acoustical model while setting the spatial-geometric "problem" that Sullivan sequentially "solved" in an eleven-month campaign of theater designing extending from March 1890 to February 1891. He had been taught at MIT and the Ecole des Beaux-Arts that space was the primary element of design. It was to be given articulate shape—for example, by being made octagonal around eight axes rather than square, as we see, for example, in Charles M. Baker's

1878 MIT student thesis project for a town hall (figure 41). In such a design individual volumes of space are pressed together and opened axially so that every increment of progress the visitor makes through the building offers a new visual tableau. The rich, compressed, spatial composition was embedded in a thick-walled carapace into which the shaped spaces could freely extend and secondary spaces could be excavated.[32]

In the case of the Baker student exercise, this meant making the main space—the meeting room—an octagon so that the secondary spaces—the library and the town offices—could be pressed close to an entrance hall serving all three, with service spaces (stairways, bathrooms, closets) filling the resulting triangular bits of pocketed wall (*poché*) left between. In the more concrete cases of Sullivan's theater interiors, this meant making the elements into squares, circle-segments, and octagons compressed together and set both horizontally and vertically, freed from producing practical prismatic shapes like those of the Central Music Hall by the thick *poché* surrounding them. Sullivan's vaults were thus not structural but acoustical surfaces artfully shaped.

The two secondary volumes and the entrance area in the Baker plan demonstrate a further step in geometric elaboration not possible in Sullivan's cramped theater spaces. The point of intersection of the building's main axis with the 45-degree axes of the secondary spaces is exactly as far in front of the meeting hall's wall as is the intersection with the hall's cross-axis behind it. The result is a rhythmic, modular coordination of the plan's geometry: the entrance space in front defines three sides of an octagon congruent with the octagon of the meeting hall centered at the first axial intersection rather than the second. Thus all the principal surfaces of the building—the faces of the meeting hall and the entrance façades of the secondary volumes—are the same width. Development of such a geometrical plan from measured intersections of axes, cross-axes, and 45-degree axes had been

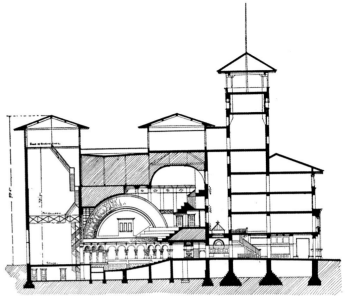

PUEBLO OPERA-HOUSE BUILDING.
[Longitudinal Section.]

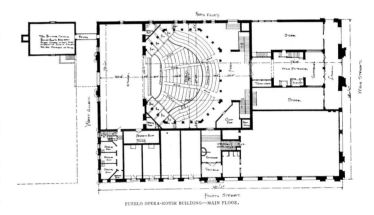

PUEBLO OPERA-HOUSE BUILDING—MAIN FLOOR.

FIGURE 34, 35.
Pueblo Grand Opera House, Pueblo, Colorado, 1888–90, cross-section, plan. (*Engineering Magazine*, 1894. Center for Research Libraries)

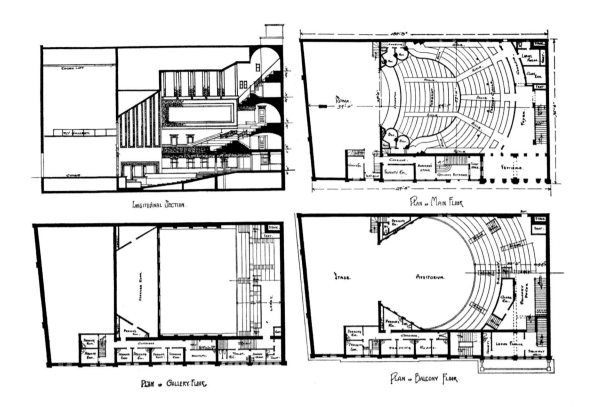

LONGITUDINAL SECTION.

PLAN OF MAIN FLOOR.

PLAN OF GALLERY FLOOR.

PLAN OF BALCONY FLOOR.

FIGURE 36.
Deutsches Stadt Theater, Milwaukee (remodeling), 1890,
cross-section and plans. (*Engineering Magazine*, 1894.
Center for Research Libraries)

opposite
FIGURES 37, 38.
Seattle Opera House, Seattle (project), 1890, cross-section, plan of
balcony level. (Northwest Architectural Archives, University of
Minnesota)

FIGURES 39, 40
Schiller Building, Chicago, 1890–92, cross-section, plan.
(*Engineering Magazine*, 1894. Center for Research Libraries)

the French Beaux-Arts method of plan development
since at least the 1820s. It will reappear (see chapters 3
and 4) in the work of Sullivan's employee William
Drummond and in Sullivan's own house designs.

In March 1890, immediately after Sullivan's return
from Ocean Springs, Adler & Sullivan rebuilt the interi-
or of the Deutsches Stadt Theater in Milwaukee, sim-
plifying and compressing the Auditorium model by leav-
ing the proscenium funnel as a smooth surface, harmo-
nizing with the barrel-vaulted orchestra space and the
continuous curve of the first balcony (figure 36). In
September 1890, Adler & Sullivan drew the final plans
for the Seattle Opera House where the funnel surface
now curved in plan to continue the semicircle of the first
balcony while the main vault is brought down in seg-
ments to repeat that semicircular shape vertically (fig-
ures 37 and 38). Unfortunately this was never executed.
At the same time a fire in the McVicker's Theater on
August 19, 1890, gave the firm the opportunity to re-
design that proscenium in a similar style with some of

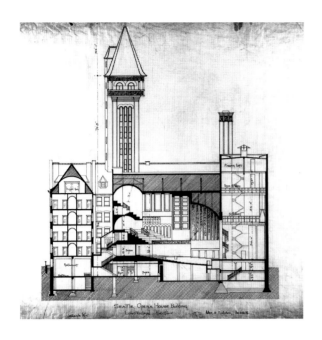

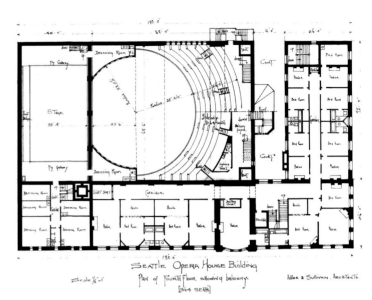

SEATTLE OPERA HOUSE BUILDING
Plan of Fourth Floor, showing balcony.
[864 SEATS]

Scale ⅛"=1' Adler & Sullivan, Architects

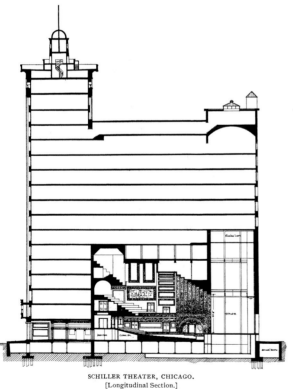

SCHILLER THEATER, CHICAGO.
[Longitudinal Section.]

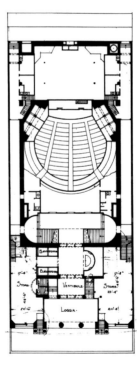

SCHILLER BUILDING.
FIRST STORY·

Scale ⅛"=40' Adler & Sullivan, Archt'd.

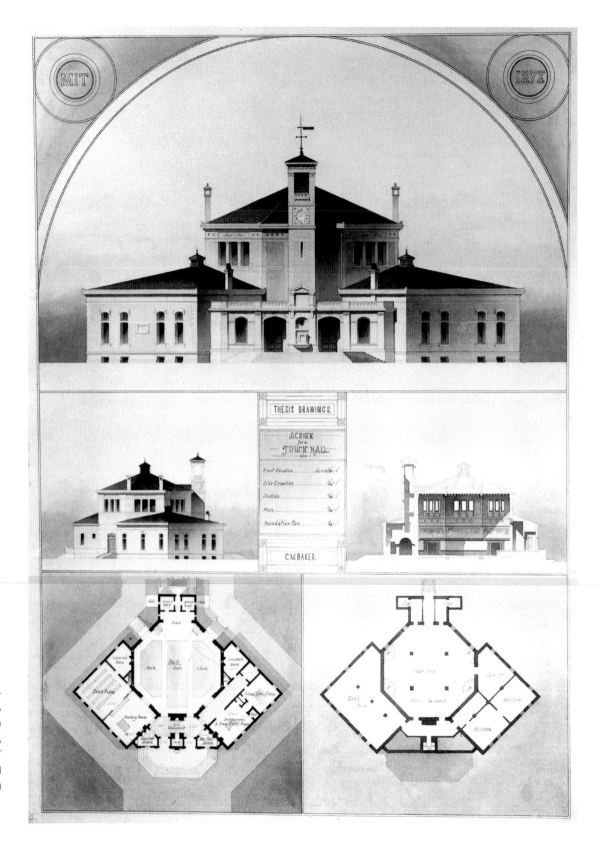

FIGURE 41.
Charles M. Baker,
thesis design for a
town hall, MIT,
1878. (MIT
Historical
Collections)

Sullivan's most concentrated decorative surfaces. And in February 1891 the firm shaped its plans for the Deutsches Theater in their Schiller Building, having the funnel surface ripple outward before blending into an embracing barrel vault that mediates to an upended half-octagonal segmental vault (a plan form boldly rotated to form a ceiling) opening over the tall, compressed space to expose the first and second balconies (figures 39 and 40). There was no functional necessity for each of these interiors to be shaped differently; they all were controlled by Adler's acoustical model. But Sullivan seems to have been less interested in developing a definitive model than in demonstrating multiple imaginative solutions to a single technical problem. In his *Autobiography of an Idea* he moves from his epiphany at Ocean Springs to a declaration of how he now understood that he should proceed:

> Louis welcomed new problems as challenges and tests. He had worked out a theory that every problem contains and suggests its own solution. That a postulate which does not contain and suggest its solution is not in any sense a problem, but a misstatement of fact or an incomplete one. He had reached a conviction that this formula is universal in its nature and in application. In this spirit he continued his aggressive research in creative architecture, and, simultaneously—it may seem a far cry—his studies in the reality of man. For he had reached the advanced position that if one wished to solve the problem of man's nature, he must seek the solution within man himself, that he would surely find the suggestion within man's powers.[33]

By the time he had finished this sequence of theaters with the Schiller project, Sullivan had abandoned the Roman and the Beaux-Arts of the Pueblo Opera House and set spatial geometry free to address each functional problem directly while molding it into shapes and counter-shapes suggestive of his later ornament. These theater spaces set free Sullivan's ornamental power, suggesting that a sheet of ornament might be elaborated like a building plan. Simultaneously the ornament helped him cleanse his still-historicist building vocabulary to solve design problems, like the Getty Tomb of 1890 or the Wainwright Building of 1890–91 (see figures 1, 56–62) by means of the animation of a single structural motif— an arch in the first instance, a pilastrade in the second— filling precisely each face of cubic volumes.

Multiple Solutions:
The Auditorium Banquet Hall Capitals

Upon his arrival back in Chicago from Biloxi Bay in March 1890, Sullivan was faced with many tasks, among which was a banquet hall that had to be added to the Auditorium scheme—suspended over the opera space itself at the seventh floor—and that needed to be decoratively elaborated (figures 42–49). He responded by running an arcade around three sides with heavy, splayed piers that carried the arches on a series of extraordinary wooden block capitals. (He was fortunate in his sculptors, R. W. Bates and Company.) These capitals were another manifestation of his "volcanic" (Sullivan's word) creativity at the time that produced his late theater plans and also the Wainwright Building and Getty Tomb designs. The capitals are significant, first, because each one is different, as if at this moment Sullivan simply delighted in solving the same design problem over and over again, as a display of imaginative *virtù*. Second, they are significant in showing how Sullivan eked his ornament out of the architectural situation so that, for example, the deeply shadowed horizontal soffits are now detailed so as to read through the dark (like the Wainwright cornice) while—even more perversely—the pattern is carried down the first eight inches from the top of several shafts to the point at which the room's lighting overcomes the

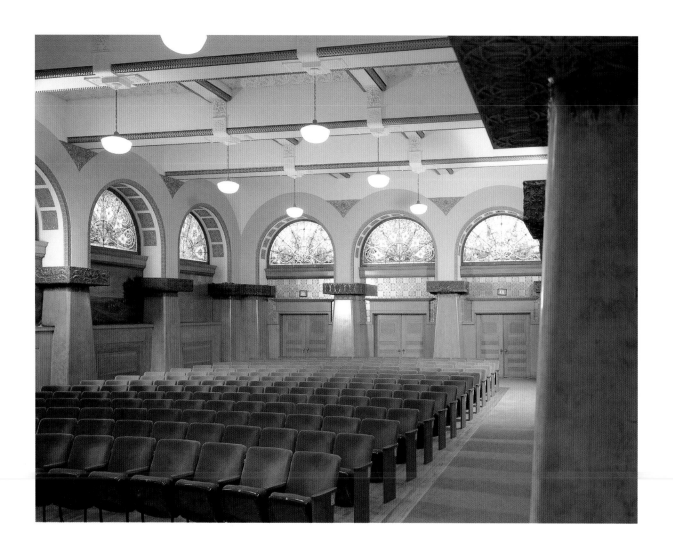

FIGURE 42, 43. Auditorium Building, banquet hall, 1890, interior and wall bay.

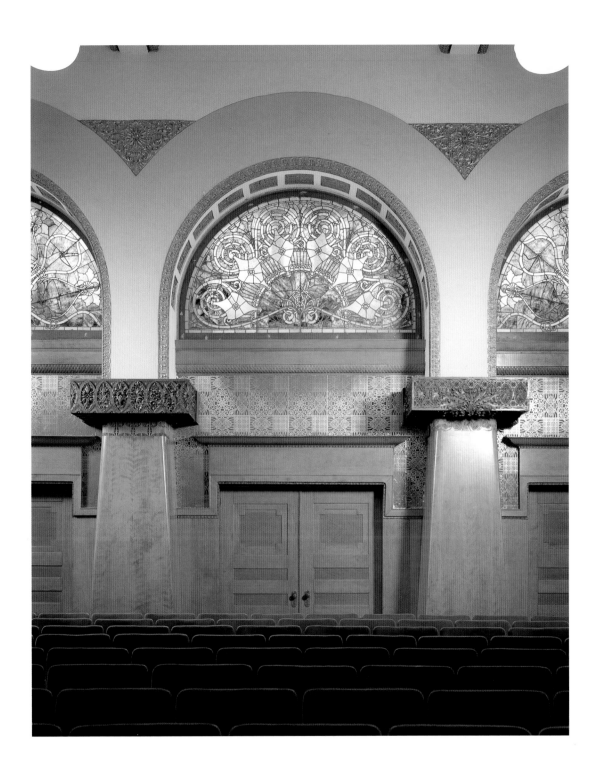

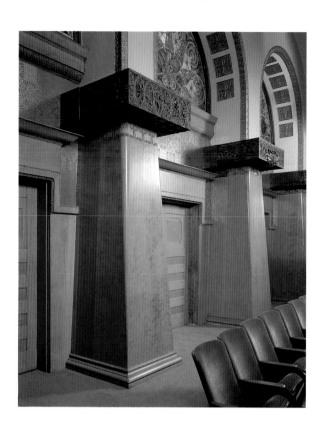

FIGURES 44–47.
Auditorium Building,
banquet hall, 1890, capital details.

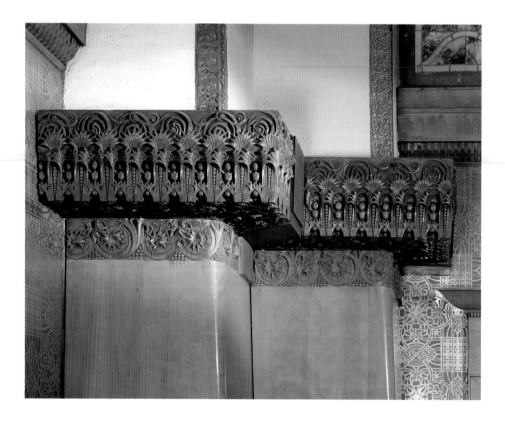

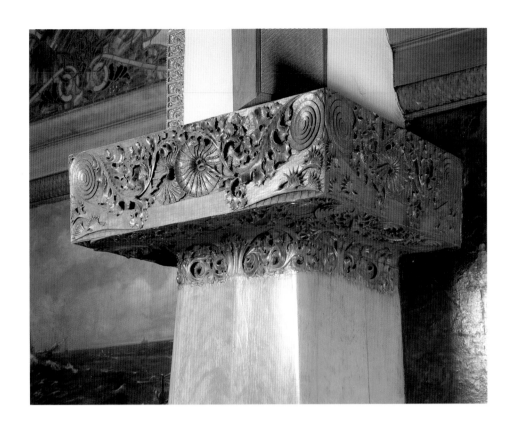

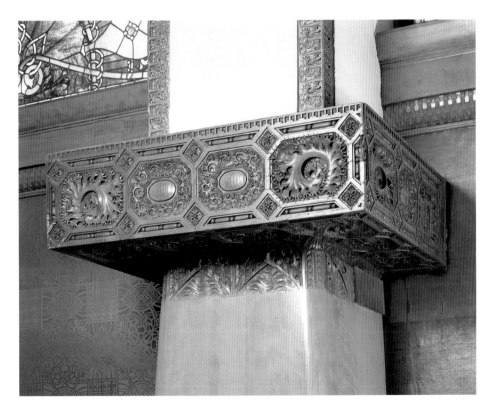

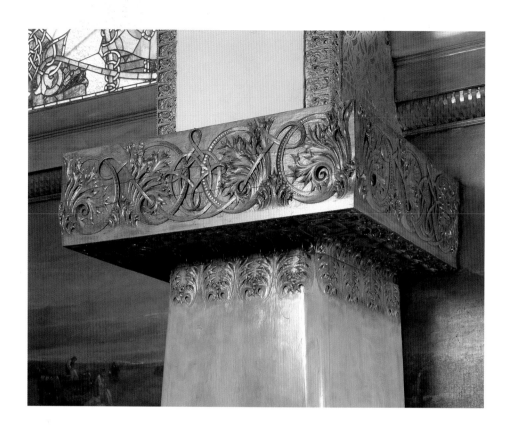

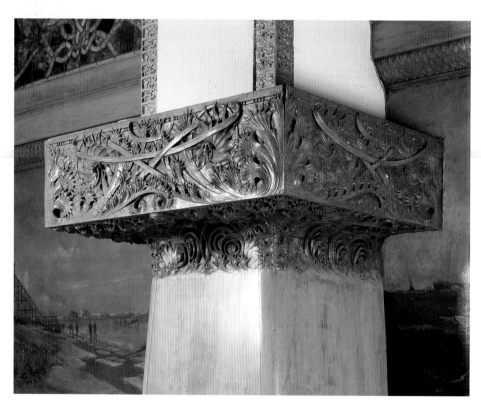

FIGURES 48, 49.
Auditorium Building,
banquet hall,
1890, capital details.

shadow. Several of Sullivan's preliminary design drawings that survive show how he evolved his patterns out of right-angle and 45-degree axes and grids, repeating on a small scale the Beaux-Arts planning strategies controlling his contemporaneous theater interiors.[34]

Not only are the capitals different from one another, but on what Sullivan would seem to have defined as the fundamental points of composition, they attempt diametrically opposed stances. Some use the acanthus motif; others use looser, wildflower motifs (as Ruprich-Robert taught). Some are deeply in-cut; some use shallow surface patterns. Some unite the field with a single motif; others divide it into four or eight. Most are symmetrical; a few are asymmetrical. Some interweave the capital face, soffit, and necking; others distinguish each. Some grow out of the shaft below; others are treated in static zones of pattern. But regardless of the principle followed, none of the capitals is weak. The capitals of a colonnade are traditionally all the same—Sullivan's were so in the Wainwright Building designed at about this time. But here he took every opportunity to design a capital sixteen different ways.[35] The academic challenge of the capital was to perfect a model. The challenge Sullivan seems to take up here was to flee the safety of one particular model into the pleasure of repeated imaginative performance, as in the string of theater interiors that was unfolding contemporaneously. In the banquet hall of the Auditorium Sullivan produced a seminar on ornamentation using the example of the capital so that, by directing one's gaze back and forth around the room, one might consider all the possibilities.[36]

Design, for Sullivan, was from the start a matter of solutions. We must, however, understand solution as a process. A problem—whether one of light in his loft façades, acoustics in his theater interiors, or decoration in his banquet-hall capitals—was a framework for the display of imagination, a way of evolving various solutions. A problem had no value if manifested as a single solution: that was "feudalism," a surrender to authority. What mattered was the solving, not the solution itself—the focused exercise of imaginative *virtù*. A design had the right to achieve any form as long as strong logic controlled it. Thus the spatial elaboration of an interior could move parallel to the decorative elaboration of a pier capital because the technique of elaboration would be similar: the establishment of a geometric framework and then the projection of axial efflorescences in counterpoint.[37]

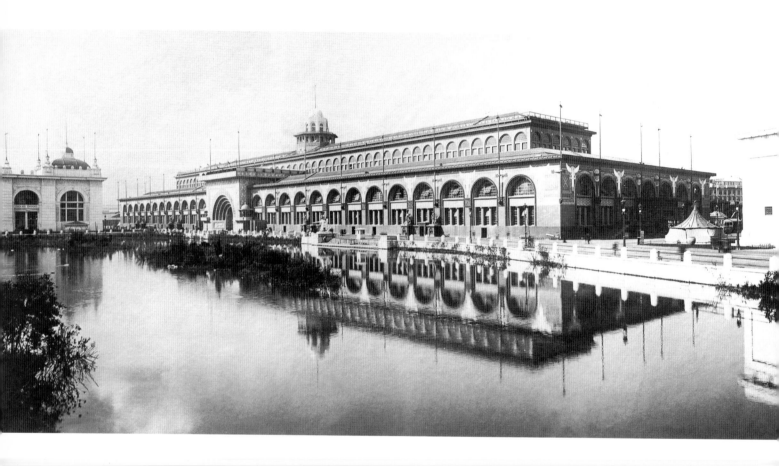

Transportation Building, World's Columbian Exposition, Chicago, 1891–93.
(Northwestern University Department of Art History, Carl Condit Collection)

2

THE NEW WORLD OF THE 1890S

The Columbian Exposition and the Schiller Building

Toy-Block Architecture seems the most suitable name for a species of design which appears to have originated in Chicago.... It is as though a child with an assortment of toy blocks had erected such a structure [as Sullivan's Fraternity Temple] as the fancy of the moment suggested.
—*Engineering Magazine* (New York), November 1891

IN the winter of 1890–91 Chicago architecture exploded. Structural invention and an economic boom set the Loop bristling with ten-, fourteen-, sixteen-, and soon twenty-two-story skyscrapers. At the same time the ivory-white domes and colonnades of the 1893 Columbian Exposition were first sketched by an architectural commission headed by Burnham and under the secretaryship of Sullivan (figure 51). Also during this time the city's elite conceived an array of cultural institutions of international scale and splendid architectural manifestation, especially the University of Chicago and the Art Institute. Newspapers, letters, diaries, and novels fixated on architecture.[1]

Our conventional historical account would have us see Sullivan as the poetic scientist of this revolutionary moment in Chicago building and Burnham as the pedestrian, hesitant insinuator of a spiritless academic classicism. Sigfried Giedion in his foundational *Space, Time and Architecture* deprecated Burnham as killing the brilliant promise of the city's spontaneous discovery of the skyscraper with his importation of "Eastern mercantile classicism" in the Columbian Exposition of 1893 and his firm's subsequent architecture.[2] Seventeen years be-

45

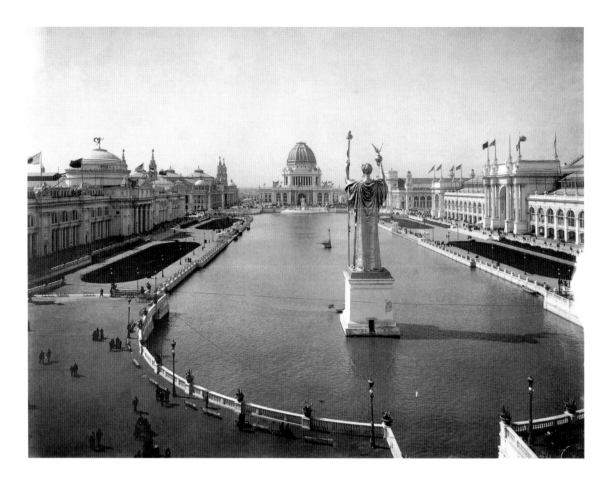

fore, Sullivan had ended his *Autobiography of an Idea* with a depiction of Burnham as dazzled by the huge corporate fortunes of the end of the century, meshing himself with their machinery that devoured humanity as their Chicago stockyards (organized by Burnham's father-in-law, John Sherman) did animals, and setting back American architecture fifty years.[3] Sullivan quoted Burnham as saying to him, " 'It is not good policy to go much above the general level of intelligence.' "[4] Yet in this same passage Sullivan felt obliged to add, "Burnham had also said, 'See! Louis, how beautiful the moon is, now, overhead, how tender. Something in her beauty suggests tears to me.' " Burnham's was a grand as well as a grinding vision, and we sense it clearly in a letter of 1901 to his friend and fellow hero of the Columbian Exposition, the orchestra conductor Theodore Thomas (whose music there was a tremendous success):

The Senate appointed us a commission to improve the park system [of Washington, D.C.] in March. As you know we went abroad to study and while there and since our return have been at it hot and heavy. Again has come the old joy of creating whole things and of men associating together in the work. Our happiness has at times seemed almost too full. When I come home [to Evanston] I want you to spend Sunday with me and let me tell you of the dream-visions. The parks, the roads, the great mall with its avenues, woods, fountains, and statues, the distant vistas in the hills, the monumental bridges and

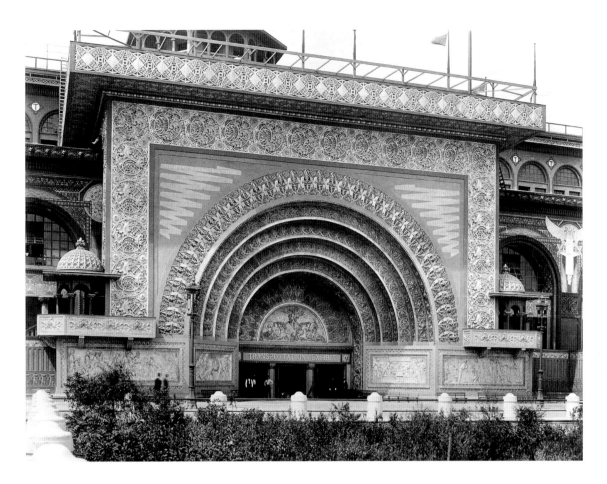

arches, all of which we are allowed to play with for the nation, have brought back the day dreams of youth and we stop at nothing, developing our themes to ever nobler heights, each man raising the thoughts of the others, and altogether we have risen where I never hoped to tread in this existence. And you have been with us. And we all think of how *much* of our power to dream truly we owe to you, dear friend and comrade.[5]

Just as we have given ourselves an earth-bound classicist Burnham, we have insisted on an abstract, rationalist Sullivan, but both were created by the great adventure that was Chicago. Sullivan's two great Chicago buildings conceived in the late winter of 1891—the Transportation Building at the Columbian Exposition (figures 50 and 52) and the Schiller Building in the Loop (see figure 65)—help us to see the subjective underpinning of Sullivan's problem solving. Only after these designs (and

in spite of such later ones as the Chicago Stock Exchange Building and the Carson Scott Pirie Store) did critics—and Sullivan himself—adopt the rhetoric of the single, rational model.

The Transportation Building
as an "Architectural Exhibit"

The idea of Burnham as retreating into borrowed academic classicism and Sullivan advancing into cool rationalism pretends that such a clear choice existed and thus robs us of the sense of sheer chaos and exhilaration that characterized Chicago building during the winter of 1890–91. It was this exhilaration that carried both Burnham and Sullivan forward to their most important work.[6]

The economic boom of 1890 had Adler & Sullivan busy with work like the Kehilath Anshe Ma'ariv Synagogue and the Getty Tomb (figures 53–58) and now also provincial skyscraper commissions: the Wainwright

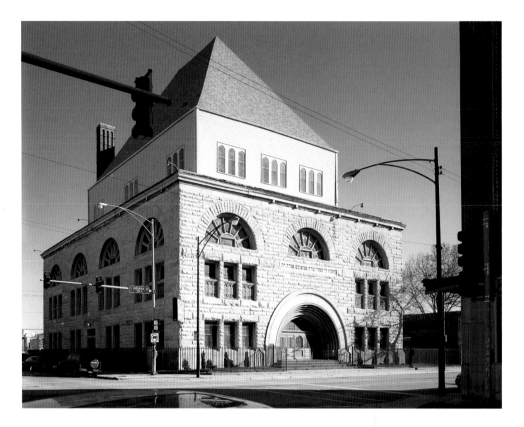

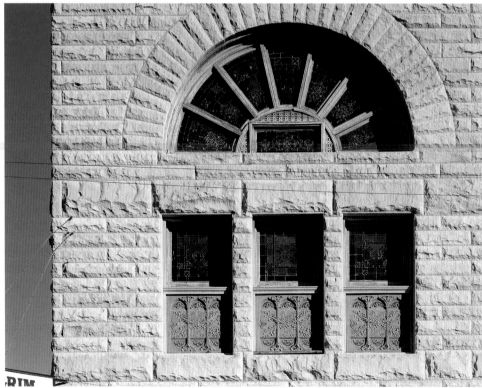

FIGURES 53–55.
Kehilath Ansche
Ma'ariv Synagogue,
3301 South Indiana
Avenue, Chicago,
1890–91, exterior,
window detail,
interior.

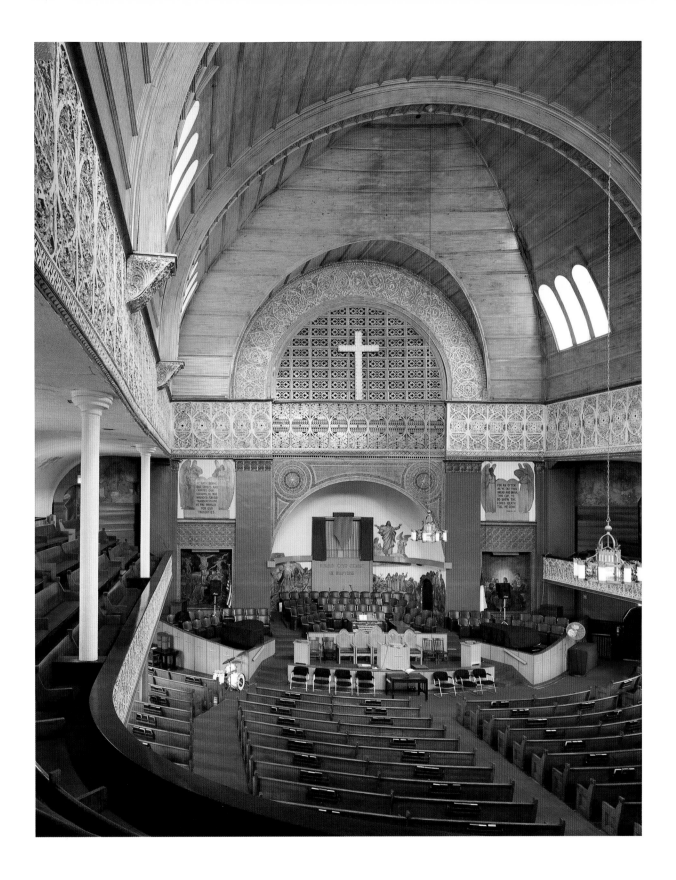

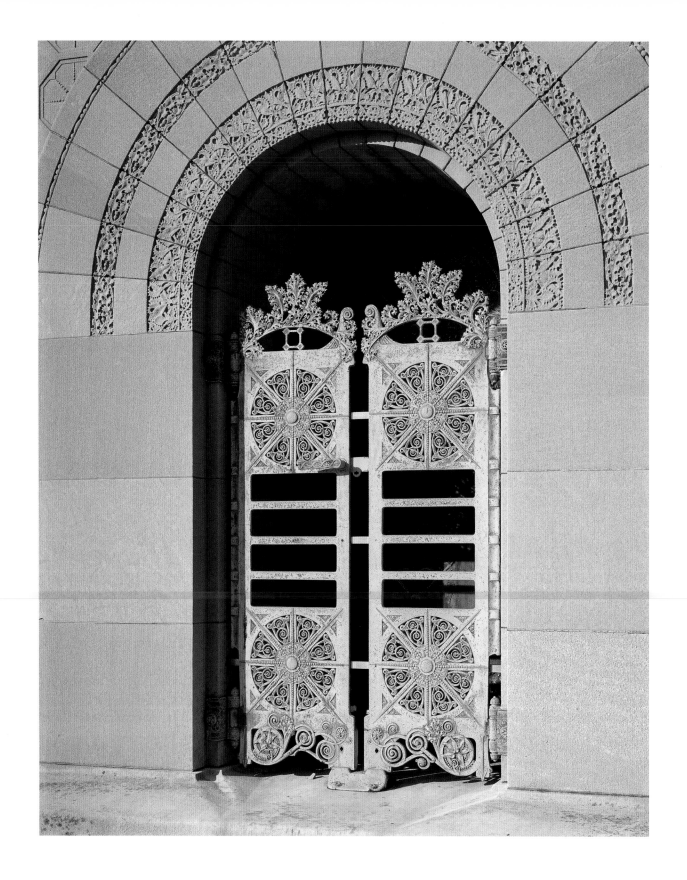

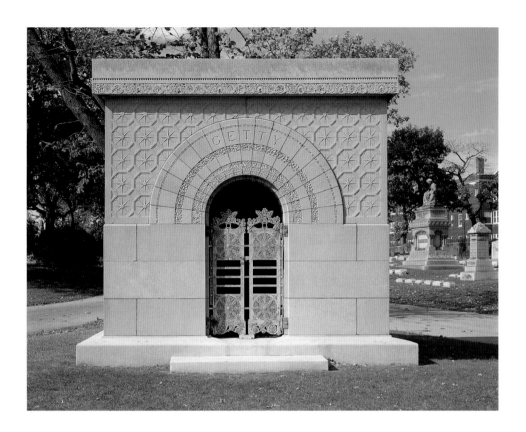

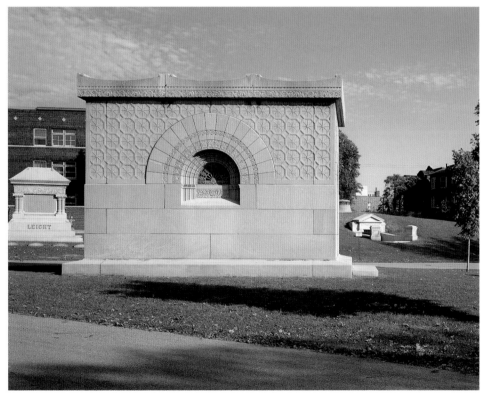

FIGURES 56, 57, 58.
Getty Tomb,
Graceland
Cemetery,
Chicago, 1890–91.

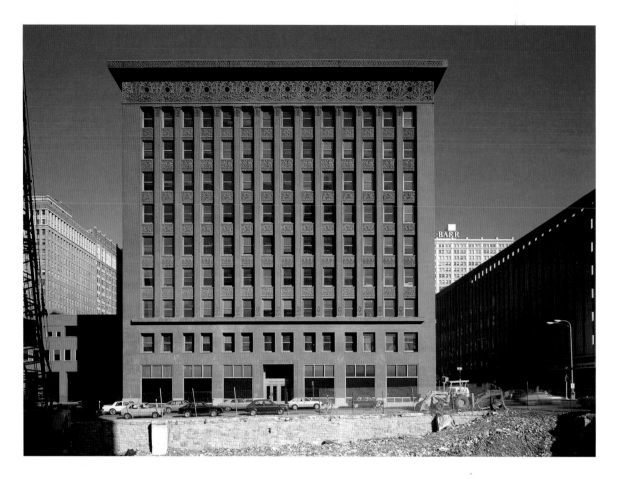

Building in Saint Louis and the Dooly Block in Salt Lake City (see figures 1, 59–62).[7] These were, however, relatively simple projects compared to the Transportation and Schiller buildings. The Transportation Building was detached from the general ensemble of the Court of Honor and designated for the firm in January 1890, and its design made public in March.[8] The Schiller Building was commissioned by the directors of the German Theater at their meeting of January 1891, and the firm's preliminary design published in *Inland Architect* in June 1891, although newspaper descriptions make it clear that the design had been basically fixed by mid-February.[9]

Set against the conventional Richardsonianism of the Auditorium Building exterior, the Transportation Building was exotic and riveting.[10] It stood just off the Court of Honor, continuing the court's cross-axis northward to the Wooded Island and the Fine Arts Building, balancing George Post's huge Manufactures and Liberal Arts Building lakeward from it. Instead of continuing the colon-

naded, ivory-colored classical style uniformly applied around it (figures 50 and 52), Adler & Sullivan's building presented itself as an arcaded box with broad surfaces elaborately layered and colored in brilliant red, blue, green, and especially gold. The firm had proposed an even more richly sculpted decoration, but Burnham rejected it as too expensive. Thus, Adler & Sullivan concentrated its labor on the main entrance, soon dubbed the "Golden Door."

How Adler & Sullivan came to this project perhaps helps explain their design's emphatic refusal to fit into the ensemble. On December 13, 1890, Burnham, as director of construction for the fair commissioners, invited by letter five architectural firms to design what became the Court of Honor: four Eastern (Richard Morris Hunt; McKim, Mead & White; George Post; and Peabody & Stearns) and one Kansas City firm dominated by an Easterner, Howe & Van Brunt. Only later in December, after the Easterners had met in New York and settled on

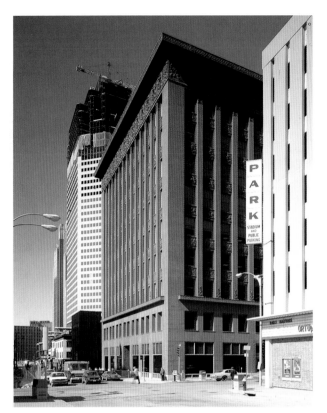

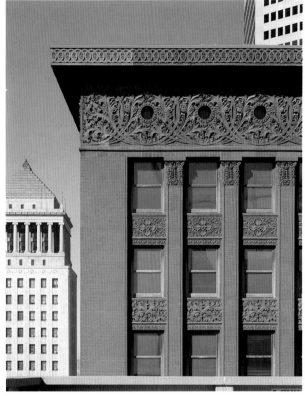

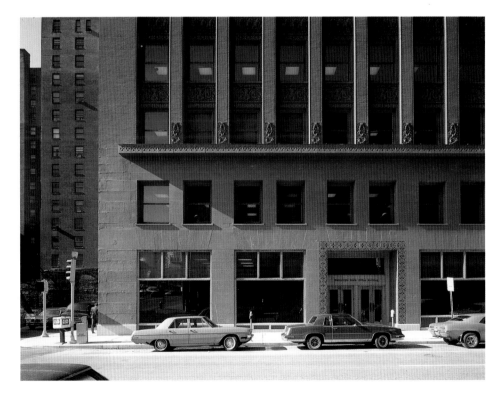

FIGURES 59–62.
Wainwright Building
(Charles K. Ramsey,
associate architect),
Saint Louis, 1890–91,
cornice detail, lower
stories.

building volumes and a uniform classical style, did Burnham invite five Chicago firms to join them: Jenney; Cobb; Beman; Burling & Whitehouse; and Adler & Sullivan. Adler & Sullivan at first hesitated to come in, Burnham later told his biographer Charles Moore.[11] On January 10, 1891, the ten architects met in Chicago and elected Hunt as chairman and Sullivan as secretary (the latter either out of respect or in order to balance the preference shown the Easterners). Burnham proposed an allocation of buildings, suggesting to Adler & Sullivan the Temple of Music (where in 1893 Theodore Thomas would display his symphonic talents to great acclaim). Again Adler & Sullivan demurred and, after discussions, it was decided that transportation should be given a separate pavilion and that Adler's firm would design it. As Burnham confided to Moore, Sullivan and Adler were prickly.

Aside from competition with Root and Burnham, what might the Transportation Building have been about architecturally?[12] It has frequently been observed that the design did not express its construction in the steel, wood, and plasterlike "staff" of which its exterior was made any more than the other buildings of the Fair did. The frank, rationalist critic Montgomery Schuyler was convinced that Adler & Sullivan's design was about working in the "plaster" (as he called it), and thus still rationalist in comparison to the lithic forms adopted by the other architects.[13] Others were puzzled. We must ask just how literally Sullivan sought to manifest "form" in expressing "function." It seems helpful to remember Frank Lloyd Wright's admonishment in 1924:

As to materials, the grasp of the Master's imagination gripped them all pretty much alike. As to relying upon them for beauties of their own, he had no need—no patience. They were stuff to bear the stamp of his imagination and bear it they did, cast iron, wrought iron, marble, plaster, concrete, wood. In this respect he did not live up to his principle. He

was too rich in fancy to allow anything to come for its own sake between him and the goal of his desire. It would have been to him like naturalistic noises in the orchestra.[14]

Sullivan himself produced the most direct statement of his intentions in a letter to Burnham dated November 11, 1893. "The thought we sought to express in the Transportation Building was this: "*An architectural exhibit.*" He proceeded to list ten purely formal qualities:

1. A natural, not historical, exhibit. 2. To be expressed by elementary masses carrying elaborate decoration. 3. All architectural masses and subdivisions to be bounded by straight lines or semi-circles, or both in combination, to illustrate the possibilities of very simple elements when in effective combination. 4. The decorations to be of a very elaborate nature and chiefly in color. 5. The combination of 3 and 4 to show how easily and quietly large simple masses carry elaborately and minutely worked out "ornamentation." 6. The chief object of 4 being to show that the farther the process of systematic subordination be carried the quieter and more dignified becomes the structure as a whole. 7. The use of colored decorations to show the possibility of sequence combination, and repetition when a great many colors are used:—hence the true nature of polychromy. 8. The use of a symbolic human figure in color to show its great value in architectural decoration. 9. A long series of minor considerations, entering too minutely into detail to be here enumerated.

And so on, ending "10. The summarizing thought, that all this should be done in a natural and easy way,—as willing to teach while searching for beauty."[15]

To make it even more puzzling, this "architectural exhibit," seemingly conceived without material or func-

tional expression, was later trumpeted by the younger generation of Chicago architects as their central inspiration—something we shall explore in the next chapter. Thomas Tallmadge began both his 1908 article "The 'Chicago School' " and the Sullivan-Wright chapter of his 1927 *Story of Architecture in America* with images of the "Golden Door."[16] While less-enlightened Americans responded to the Transportation Building with confusion, European professionals visiting the Fair picked it out for special praise as the most powerful and individual design of the event.[17]

With Sullivan's red, blue, green, and gold Transportation Building shouldering against the ivory-white Court of Honor, the Columbian Exposition suddenly went technicolor. This made at least two impressions that thread their way through subsequent accounts of the Fair and of Sullivan: first that the whole ensemble might also flash into color—that Sullivan's passage in the composition was the real model for the variations that this almost musical ensemble might inspire; second, that Sullivan stood forth, personally manifested in his building, as an individual—a theatrical, even bizarre one—and as the real artist of the design team that produced the Fair ensemble.

On the first point, there was a powerful urge to see the Court of Honor as colored, an urge that finally was brought to fruition in the Panama-Pacific Exposition of 1915 in San Francisco where three of Burnham's younger collaborators—Willis Polk, Jules Guerin, and Louis Christian Mullgardt (together with Bernard Maybeck and others)—produced an ensemble of courtyards painted in reds and ochres, illuminated with concealed spotlights and detailed for shadow and distant glimpses. In an important sense Sullivan hijacked the Columbian Exposition chromatically; his presence in the ensemble moved it mentally toward the fragmentary "demonstration" he offered by sheer force of his artistic personality—a demonstration that composition in form and color, not functional construction, was the issue.

On the second point, we must ask: what else would one expect of Sullivan?—the author of the lotus-decorated lofts of 1880–85; the reciter of "Essay on Inspiration" before the Western Association of Architects in 1886; the creator of the Auditorium Building with its invented, reinvented, and re-reinvented capitals in the banquet hall? Was the array of pavilions at the Columbian Exposition anything to him except a challenge, a place to perform, an opportunity to outdistance the competition? His "exhibit" was thoughtful, as his letter to Burnham explains, but never less than an exhibit, a demonstration, a performance.

The Schiller Building and the Shaping of the Skyscraper

Balancing this challenge at the Columbian Exposition was another in the Loop. It is fascinating to watch the evolving reaction of architects, on the one hand, and investors, on the other, to the gradual recognition that some extraordinary release, magnification, and transformation of building development was occurring in Chicago around 1890. We have seen that the ten-story rental office building had appeared in 1881 with Burnham & Root's Montauk Building for the Boston Brooks estate, a brick box generating twice the usual rent from its site on Monroe Street through innovations in elevators, foundations, fireproofing, and economic space needs. This was followed by a decade's worth of often broader but still ten-story brick boxes. The newspapers wondered at these creations—at how safe they might prove in the case of fire, whether the highest floors might rent, whether the city streets might be completely robbed of sunlight.[18] They called the buildings merely "big"—that is, they were struck by their wideness as much as by their height—as indeed the boxy forms suggested.[19] Adler & Sullivan's Auditorium Building was the biggest and boxiest of all.

Around the winter of 1890–91, the situation changed.

The implications of the steel skeleton were grasped: remarkable height might now be achieved—twenty stories, thirty stories, even fifty.[20] Laboriously laid brick need not enclose these structures; instead lighter terra-cotta sheets or even aluminum plates might be used as cladding.[21] Investors perceived that a striking silhouette, exotic detailing, or a cultural gimmick of some sort might make an anonymous rental block stand out and attract high-paying clients. Corporate institutions understood that a tall and distinctive structure dominating a downtown might establish them in the public mind (even if much of the building was not occupied by their own corporate operations but instead was merely rented out). Holabird & Roche, who could be unceremonious designers if the budget was tight, in 1890 conceived the Old Colony Building for the Boston Bartlett estate and the Marquette for the Brookses as ventures into high-class space.[22] Also, in 1890 Henry Ives Cobb produced both the Venetian Illinois Athletic Club design (drawn, in fact, by his assistant Mullgardt[23] and built next door to where Sullivan's Gage Building would soon rise) fronting on

Michigan Avenue and the eccentric Owings Building. That same year the elderly Boyington framed the contorted Columbus Memorial Building of 1891, consciously citing the approaching Columbian Exposition and decorated with a gigantic statue of the explorer over its door.[24] Burnham & Root, however, got the last word with the Woman's Temple, castlelike with bulging corners and projecting wings, and the Masonic Temple, at twenty-two stories the tallest building in the world upon completion, internally open from top to bottom in a vertiginous light court, and provided with a rooftop terrace and a restaurant (see figure 64).

These developments were not restricted to Chicago. In 1888 the Minneapolis architect L. S. Buffington had publicized a project for a twenty-eight-story, steel-framed, castlelike skyscraper (rendered memorably by his draftsman Harvey Ellis) and had attempted to patent such construction.[25] The following year George Post in New York was called upon by Joseph Pulitzer to give an equally memorable form to his eighteen-story tower to represent his newspaper *The World*.[26] (Its extensive publication in

the world's professional as well as recreational journals amply repaid Pulitzer's effort.) In 1890, Colonel Pabst in Milwaukee announced a competition to design a twelve-story corporate tower to symbolize his beer empire, to be erected at a crook in the city's main street, Wisconsin Avenue; the challenge was smoothly met by George Pullman's Chicago architect S. S. Beman with a shaft culminating in an elaborate explosion of Hanseatic gables and dormers (see figure 63).[27] In August 1891, Frederick Dinkelberg—soon to join Burnham's office in Chicago—presented plans in New York for a twenty-six-story, towered office building for lower Broadway. By the late 1890s New York surpassed Chicago in extravagant projects.[28]

Amid this mass of architectural declarations Adler & Sullivan brought forward its Schiller Building design in February 1891 (see figure 65). Among the projects we have just reviewed, theirs seems exotic in silhouette and detail only to the degree necessary to hold its own as the declaration of German-American accomplishment in Chicago, the hopes of which were stated in *Der Westen* (the literary supplement of the *Illinois Staats-Zeitung*): "If this German Temple of the Muses amid Anglo-American sentimental theater can rise in its full majesty it will constitute a rock cliff upon which German culture may build."[29]

It is fascinating to see how Sullivan and Adler participated in the *élan* of this moment, but how they also managed to control themselves and master a superheated situation. They had the task of combining a large theater space with a skyscraper office building, something they had already accomplished in the Auditorium Building (and Cobb had at his contemporaneous Chicago Opera House) by building the auditorium in a courtyard behind an office block facing the street. The result was that there were no back offices on the lower floors and a wastefully large light court above the theater space on the upper stories. Adler solved this spatial problem in the Schiller Building with a bold structural innovation: the erection

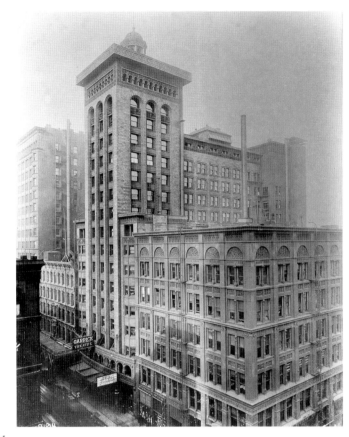

FIGURE 65.
Schiller Building, Chicago, 1891–92 (Borden Block in foreground). (Northwestern University Department of Art History, Carl Condit Collection)

opposite
FIGURE 63.
Solon Spencer Beman, Pabst Building, Milwaukee, winning (and executed) competition drawing, *Inland Architect and Building News*, March 1891. (Author)

FIGURE 64.
Masonic Temple, Chicago, 1890–92 (Burnham & Root, architects). (Northwestern University Department of Art History, Carl Condit Collection)

of the theater space directly under a fourteen-story wing of offices supported over it on an elaborate steel trusswork, the office wing stepped back from the lot lines to create two deep, narrow, lateral light courts. These courts at the ninth-story level carried through to the street over the shoulders of the building and the office block continued up as a freestanding tower.[30]

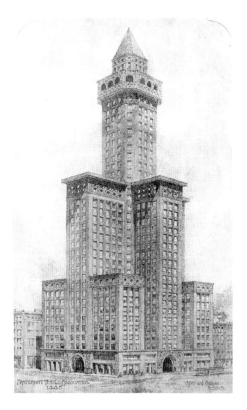

FIGURE 66.
Fraternity Temple (project), 1891. (Art Institute of Chicago)

FIGURE 67.
"The Street of the Future" (woodcut), illustrating Sullivan's article
"The High Building Question," *The Graphic* (Chicago), December
19, 1891. (Chicago Historical Society)

The shoulders of the Schiller Building (especially at Adler & Sullivan's initially projected seven-story height) acknowledge and make use of the existing city building texture, continuing the cornice line of the firm's own Borden Block next door to set the signature tower high and free. This solution was magnified by the firm in a project made public in September 1891 for a thirty-four-story rental building for the Odd Fellows, Fraternity Temple, to be built in the Loop, stepped back in three stages from a cluster of projecting wings, to a cross-shaped trunk at the tenth floor, and finally to a slim shaft at the twenty-second, terminating in a thirty-fourth-floor lookout (see figure 66).[31] Shortly after this Sullivan published an article, "The High-Building Question," in the Chicago *Graphic*, projecting an entire city built up in such thirty-story three-tiered structures, illustrated with a woodcut showing such an array down a canyonlike city street with individual, exotic shapes given to the ultimate tower stages (see figure 67).[32] In December 1891 an anonymous New York critic responded to Sullivan's recent work as "Toy Block Architecture": "It is as though a child with an assortment of toy blocks had erected such a structure [as the Fraternity Temple] as the fancy of the moment suggested."[33] The critic said he would prefer Gothic. Yet it is a telling outburst: he sees Sullivan as working outside the canon of historical precedent, in a naive and overscaled manner—all of which was true but could only be expressed so neatly by a disconcerted contemporary.

The late William Jordy, in the most careful formal analysis of Sullivan's skyscrapers we have, insisted that one grasp the "cubelike" quality of the Wainwright Building rather than some purported "soaring" verticality.[34] I would push this one step further, keeping in mind Sullivan's contemporaneous Getty Tomb (see figures 56–58): that at his moment of illumination Sullivan brought the mass of his buildings precisely to a cube, then worked a pattern of articulation outward from the

center of each face which stops short of the edges to leave them pristine and primitive in their silhouette. When Sullivan's design drawings start to survive later in his career, we can see that this is how he worked, for example in his first project for the Bradley House of 1909 (see figures 124–125). It is interesting that in the drawings from 1890 and 1891 by his own hand that do survive—which are exclusively of ornament—this is Sullivan's procedure: the indication of a volumetric outline, the subdivision of this surface into a grid fixed by the meeting points of 45-degree diagonals, and the elaboration outward from these intersections of geometric and floral patterns both obeying and, calculatedly, violating the framework. This was what Sullivan said that he was trying to do in the Transportation Building design: explore a new architectural geometry, stated in the "Golden Door" and echoed across the building surfaces by "systematic subdivision." Frank Lloyd Wright noted the problem in the Transportation Building design for Sullivan: "The Transportation Building at the Columbian Exposition cost him the most trouble of anything he ever did. He got the great doorway 'straight away,' but the rest hung fire. I had never seen him anxious before, but anxious he then was."[55]

The result of Sullivan's application of ornamental construction to building design was to free scale relationships, to produce one large motif on each building elevation to make it seem toylike while leaving the traditional parts (like the cornice) to negotiate relationships ornamentally with building members once treated as entirely different entities. The challenge, however, in both ornamental and architectural composition is not the single motif but the ensemble. As the *Engineering Magazine*'s writer perceived about Sullivan's Fraternity Temple scheme, it was remarkable for taking a handful of little Wainwright Buildings and piling them up in rhythmically responding ten-story tiers. Sullivan achieved such rhythmic elaboration in the Schiller Building and again in the Union Trust Building of 1892–93 (see figures 65, 68, and 69) as well as in his revision of the Getty Tomb paradigm, the Wainwright Tomb of 1892–93 (figures 71–73).

Sullivan's Chicago Tribune *Interview*

Before these projects of 1891 there was a lengthy interview with Sullivan about skyscraper design published in the *Chicago Tribune* on April 27, 1890, soon after his return to Chicago from Ocean Springs. "My deductions are necessarily of universal practicability," he began, citing Chicago's leadership in high building construction and introducing his particular vocabulary of problem solving. But he kept his own, as yet unfinished, solution to himself, "although I am not prepared at the present to give the result of my researches I may state that the problem [of skyscraper design] is probably capable of a satisfactory solution." (His oft-cited "Tall Office Building Artistically Considered" was still six years in the future.) He defined the problem as being one of light. "What will occur when entire business streets are covered with a double row of these lofty edifices? When these thoroughfares resemble a mountain cañon will not the lower stories be almost valueless for lack of sufficient light?" But he then went on to insist that the situation would be more exaggerated than the *Tribune*'s public imagined:

> While on the subject of high buildings I may as well puncture an error which even so well informed a journal as *The Tribune* has endorsed. It has been repeatedly stated that the altitude of buildings is limited by the condition of the foundation subsoil. This is entirely incorrect. With proper expenditure and construction the foundations to support buildings of twenty, thirty or even fifty stories could be built here.

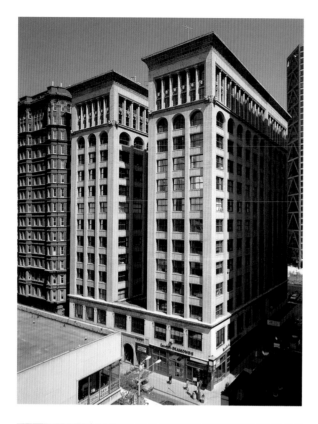

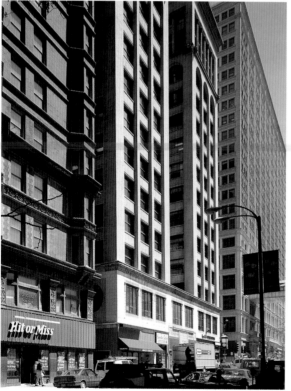

The real restriction on height, Sullivan explained, was the space needed by elevators—two must be provided for every five floors, disproportionately consuming the building's floor area as its height increased. But concerning building foundations in the Chicago mud, Sullivan was confident that a new system was at hand. "It is almost certain that in the near future an entirely new method will be brought into operation and buildings (especially large ones) will be constructed to remain immoveable during and after construction." Indeed, after confronting serious settlement problems in both the Auditorium and the Schiller buildings, Adler solved this problem soon afterward by introducing caissons in the Stock Exchange Building of 1893–94.[36]

Sullivan continued in the interview to one last consideration: the lightening of the whole building mass by the utilization of new materials. "Architects are anxiously awaiting the advent of the new building material—aluminium. A perfect compound of that light-weight metal, properly alloyed, would be of incalcuable value and might change the whole aspect of the constructive branches."[37] He ended with a disquisition on the need for precise results in the systematic testing of materials.

Here in the interview are the two sides of Sullivan (and the two sides of his Chicago as well)—a willingness to contemplate the most dramatic transformation of human surroundings in scale and material, but at the same time an extremely self-confident (if not arrogant) belief in calculation, rationalization, and yet-unformulated "solutions." Here was a man who in 1890 faced Daniel Burnham as an equal. By 1891 Chicago was as much Sullivan's city as it was Burnham's.

FIGURES 68, 69. Union Trust Building, Saint Louis, 1892–93, lower two stories altered.

The Skyscraper Problem and its Solution

As noted, the conventional Sullivan—the Sullivan framed by his first systematic historian, Hugh Morrison, in 1935—was a rationalist, a "prophet of modern architecture" (to quote his title) as then understood at the Museum of Modern Art, which helped in the publication of that book.[38] Morrison considered the Wainwright design as Sullivan's "break-through" and analyzed it parallel to Sullivan's 1896 essay, "The Tall Office Building Artistically Considered." In examining the context of Sullivan's simultaneous Columbian Exposition and Schiller projects we have qualified this to suggest purely artistic aims motivated Sullivan as well.

The massive published response to the appearance of the skyscraper documents a slow change in the 1890s from enthusiasm to rationalism as the economic impact of these buildings was grasped. On the popular level, newspapers focused on the skyscraper, ambitious architects encouraging them with startling projects such as those by Buffington and Dinkelberg, and with clients like Pulitzer and Pabst requesting such. The *Chicago Tribune* moved from a scattering of articles troubled at the fire and health problems of "The Growth of Cities Upward" in 1887 and 1888[39] to a fascinated presentation of an illustrated gallery of the first steel-framed, fourteen-story (plus) skyscrapers underway in January 1889—the Chamber of Commerce, Owings, and Tacoma buildings —and extending in the following months into an increasingly breathless account of the real estate boom, especially along Dearborn Street, spawning a whole line of behemoths week by week the following summer: the Manhattan, Pontiac, Monadnock, Monon, and Unity buildings and others.[40] By 1892 the illustrated announcement of new skyscraper projects had become the Chicago papers' stock-in-trade and had spread to the suburbs and provinces.[41]

The professional journals kept pace in their manner.

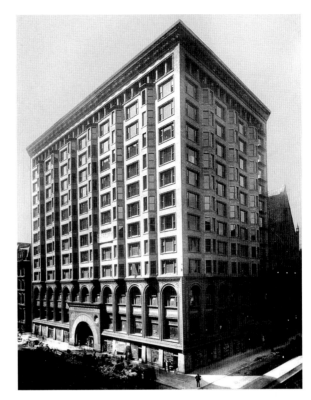

FIGURE 70.
Chicago Stock Exchange Building, 1893–94. (Northwestern University Department of Art History, Carl Condit Collection)

The *Engineering News* pursued the details of steel-framed construction with special care beginning in its issue of December 5, 1891.[42] Books soon followed, including William Birkmire's *Skeletal Construction in Buildings* in 1893 and Joseph Freitag's *Architectural Engineering* in 1895.[43] Architecture critics were not far behind, led by Montgomery Schuyler in his *American Architecture* of 1891 and his treatment of Sullivan and Burnham in the *Great American Architects* series of 1896.[44]

All of this, however, was just background noise to what at least one critic, Barr Ferree, understood skyscrapers to be: "The largest and most costly structures now being built." They were a problem of total organization involving the whole community—and a problem that, in his opinion, Adler & Sullivan best satisfied. "Some few monumental undertakings of foreign governments may, indeed, exceed them [skyscrapers] in price, as many a smaller building exceeds them in monumental effect; but in no other group of structures are the expenditures so

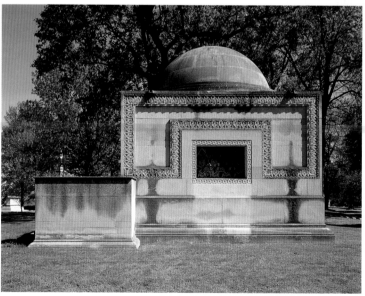

FIGURES 71–73. Wainwright Tomb, Bellefontaine Cemetery, Saint Louis, 1892–93 (Charles K. Ramsey, associate architect).

large, the responsibility of the architects so great, or the opportunity of profit to the designer so handsome."[45] Barr Ferree, thirty-eight years old in 1890, was a journalist of ancient Philadelphia social connections who focused on architecture, first the "skyscraper problem" in the 1890s, then the "City Beautiful" around 1900.[46] From 1892 to 1894 Ferree was editor of the New York *Engineering Magazine*'s very active Architecture Department. Afterward he branched out to provide a string of summaries of the "skyscraper problem" for the popular journals of the moment: *Lippincott's* (1893), *Scribner's* (1894), *The Brickbuilder* (1894), and especially the Philadelphia *Journal of the Franklin Institute* (1896).[47] In 1896 –1902 he headed the Department of Architecture under William H. Goodyear in what is today the Brooklyn Museum, lecturing and lobbying for municipal beautification.

Engineering Magazine was a newly established monthly presenting technical advances to a broad audience. The wonder of the metal-framed building had already been suggested in the 1891 numbers by the architect-critic John Beverley Robinson in a piece called "The Tall Office Buildings of New York."[48] In 1892 came Ferree's editorship and articles by John Edelmann ("Pessimism of Modern Architecture"), Sullivan ("Ornament in Architecture"), and Adler, the last providing a series of lucid technical surveys, "Tall Office Buildings— Past and Future," "Light in Tall Office Buildings," "Theatre-Building for American Cities" (presenting the firm's theater structures systematically and focusing on the Schiller Building), and, finally, in 1897, "The Stimulus of Competition in Architectural Construction."[49] This gallery of the firm's opinions was interspersed with technical and aesthetic pieces by other engineers, architects, and critics, and articulated by essays of Ferree's praising Chicago practice in general and Adler & Sullivan in particular as the leader in this medium. The opening of the Schiller Building in 1893, for example, is trumpeted by Ferree as "[a]n event of more than local impor-

tance…. It is a thoroughly American attempt to provide an elegant and costly pleasure palace at a minimum cost to the investors accomplished by building the theater as part of an office building."[50]

It is nonetheless an 1896 essay published in the Philadelphia *Journal of the Franklin Institute*, coming at the end of Ferree's involvement with the skyscraper, that is most telling. He starts with a sketch of the size and complexity of these new skyscraper projects, comparing them to the largest architectural projects on the earth and exploring the opportunities they offer to architects and investors. Such structures may have three thousand inhabitants who require space, light, clear communications in corridors and elevators, protection from fire, and abundant plumbing. They pose a practical business problem but one that, if elegantly and frankly solved, will draw tenants through economic and aesthetic attractions:

> The office building is a commercial venture, undertaken, not with the objective of beautifying the city, or of satisfying the aesthetic ideas of its owners, but as a commercial investment…. But though the modern office building is as yet scarcely more than in its infancy, the commercial value of a really artistic building has already been recognised by investors…. Of any two, one of good design and one of bad, the former will prove the most attractive to the better class of tenants, and, therefore, the more remunerative.[51]

Ferree goes on at length to enumerate the factors that must be balanced, insisting that the engineers and architects must collaborate intimately; he then proceeds to a close examination of recent Chicago examples. In terms of simplicity of plan, provision of light, and expressive exterior appearance he signals Adler & Sullivan's Stock Exchange and Saint Louis Union Trust buildings (see figures 68–70) as well as Holabird & Roche's Marquette,

deprecating Burnham & Root's Masonic Temple and Reliance Building. But his warmest praise is reserved, as before, for the Schiller Building, which manages to incorporate a large theater in its base, to provide ample light by the lateral light courts that break through to the street façade above the shoulders, to achieve simplicity and symmetry of layout, and to shape its exterior simply and powerfully to express its vertical extension.

> We have, therefore, a very great artistic success. The building has a beginning, a middle and an end; its design is structural, for the great vertical lines correspond to the columns of the frame which are contained within the facing piers; the window space is ample and sufficient; the plan is employed in a natural manner as an important element of the design; the festal nature of the structure is sufficiently indicated in the ornamental balcony and belvedere; finally, the whole has been carried out with a consummate artistic feeling and appreciation of the problem, which is not only rare to find in works so utilitarian as this, but which we often look for in vain in structures of purely artistic and ornamental nature.[52]

With Ferree's arguments in our ears, Sullivan's celebrated "The Tall Office Building Artistically Considered" published in *Lippincott's Magazine* in Philadelphia the following March comes as less of a surprise. In the article Sullivan is not the Chicagoan presenting the Schiller design amid the exhilaration of the spring of 1891, but now a national figure solving what has come to be recognized as a great economic problem—one then embodied in his Guaranty Building in Buffalo (figures 2, 74–76)—returning to and perfecting the pre-Schiller solution of the Wainwright Building, urbanistically merely a square box.

What is puzzling, as William Jordy has shown in his painstaking studies of Sullivan's skyscraper "solutions" of these years, is that they were originally, in fact, quite various.[53] Focusing on the Union Trust Building in Saint Louis of 1892–93 (figures 68 and 69), one sees Sullivan breaking the block into two almost separate, vertical towers suggesting the grand "toy-block" composition of the Fraternity Temple design. Examining his Stock Exchange Building of 1893–94 (figure 70)— at the head of La Salle Street before it was destroyed, diagonally opposite to City Hall and one of Sullivan's most puzzled-over designs of this time—one finds a horizontal mass, broken up with oriels, floating above two floors of elastically articulated arches that float in turn above a ground floor made up almost entirely of glass shop fronts, with an arched entrance that itself seems to float in the midst of it all. The ground floor permits optimal shop rental while the grand arcade signals the Exchange trading floor behind them and the door gets the visitor past the first to the second. In this contextual sense, the Stock Exchange Building is the second most brilliant of the firm's designs after the Schiller Building, but framed within different parameters, namely those of a street-defining plane.[54] As with Sullivan's theater interiors and the capitals of the Auditorium Building banquet hall, it was not one solution, but constantly renewed multiple solutions that he produced, and it was their very multiplicity that seemed to please him in manifesting his ability to perform the art of architectural composition. In contrast the arguments of rationalization Sullivan and Ferree adopt in Philadelphia in 1896 seem an afterthought.

Burnham Pulls Ahead

Two things happened in Sullivan's work in the late 1890s after Wright and Adler left: first, he produced a series of increasingly beautifully ornamented repetitions of the Wainwright-Guaranty model—the Bayard Building in New York (1897–99, figures 77–80), the Gage Building

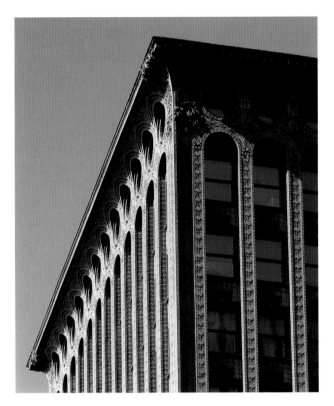

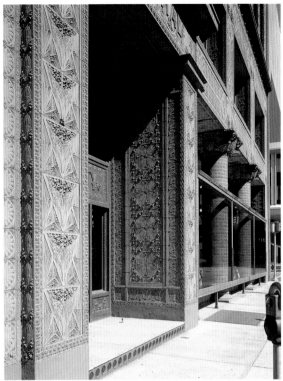

FIGURES 74–76.
Guaranty Building,
Buffalo, 1894–96,
cornice and lower
floor treatment.

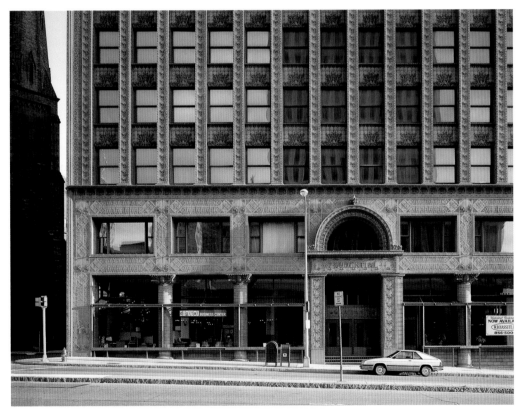

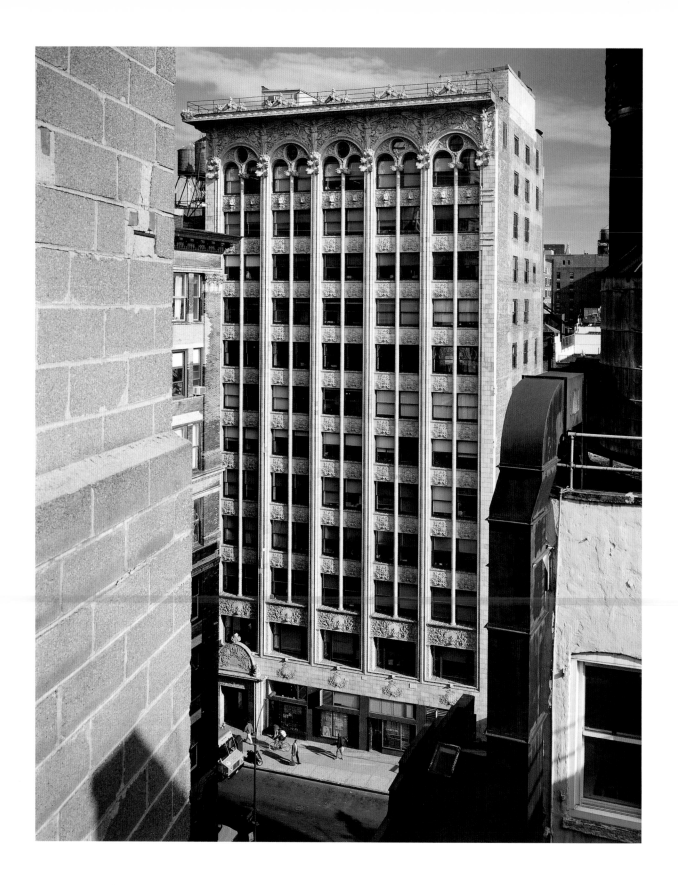

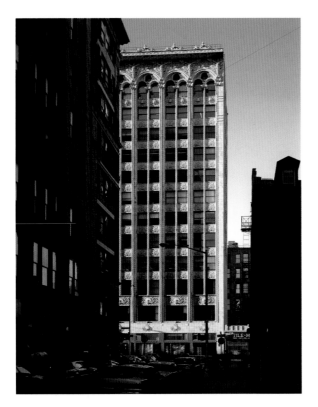

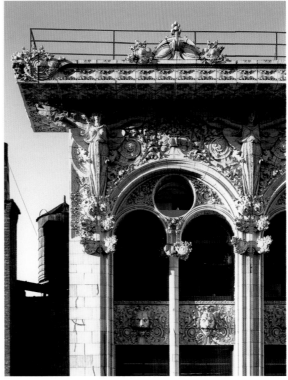

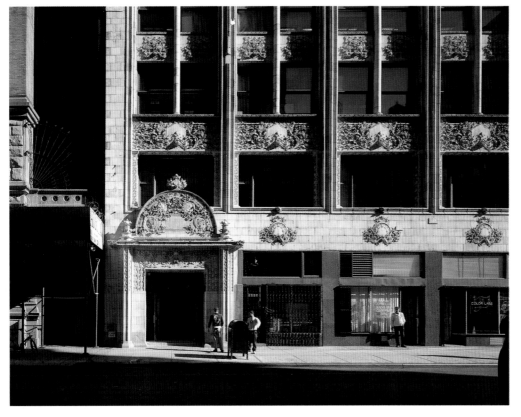

FIGURES 77–80.
Bayard (later Condict)
Building, 65–69 Bleecker
Street, New York,
1897–99 (Lyndon
P. Smith, associate
architect).

façade (1898–1900, figures 81 and 82), and the Carson Pirie Scott Store (1898–1904, figures 3, 83, 84) the latter two in Chicago. Second, with the exception of Carson Pirie Scott, these projects raised decreasingly complex problems of space, engineering, and organization. Ultimately, in the Gage commission, Sullivan was employed merely to apply a front to a structure being erected by Holabird & Roche at the insistence of one client, who believed that he would do more business behind a Sullivan-ornamented front.[55] As Sullivan's ornament firmed up aesthetically, his architecture—in the broad sense of embracing a complex problem with an individual, lucid solution—withered. In 1890 Adler & Sullivan had moved their practice to the sixteenth floor of the Auditorium tower with windows on four sides commanding a panora-

ma of the most vital city in the world. This was their command post for what should have been their intervention in its transformation. Instead, with Wright's departure in 1893 and Adler's in 1895, it became an empty aerie for Sullivan's private soliloquizing.

What happened? Traditionally, a simple reason has been given: Sullivan's separation from Adler in 1895. It was said that Adler brought in the work—which contradicts the impression of the Laflin letters and Sullivan's statement that it was he, not Adler, who traveled and met with clients.[56] It is clear from the glimpse of the firm at its height offered in the 1890 *Tribune* interview and in Ferree's proselytizing that this was a team, that Sullivan took as much pleasure in problems of plan, structure, and materials as did Adler. In 1895 Sullivan lost his sounding

FIGURES 81, 82.
Gage Brothers & Company, 18 S. Michigan Avenue, Chicago, 1899–1900, Sullivan façade on Holabird & Roche building complex; heightened four stories in 1902 by Holabird & Roche. (Northwestern University Department of Art History, Carl Condit Collection)

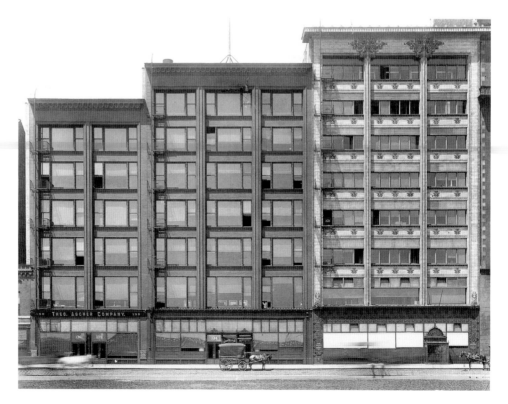

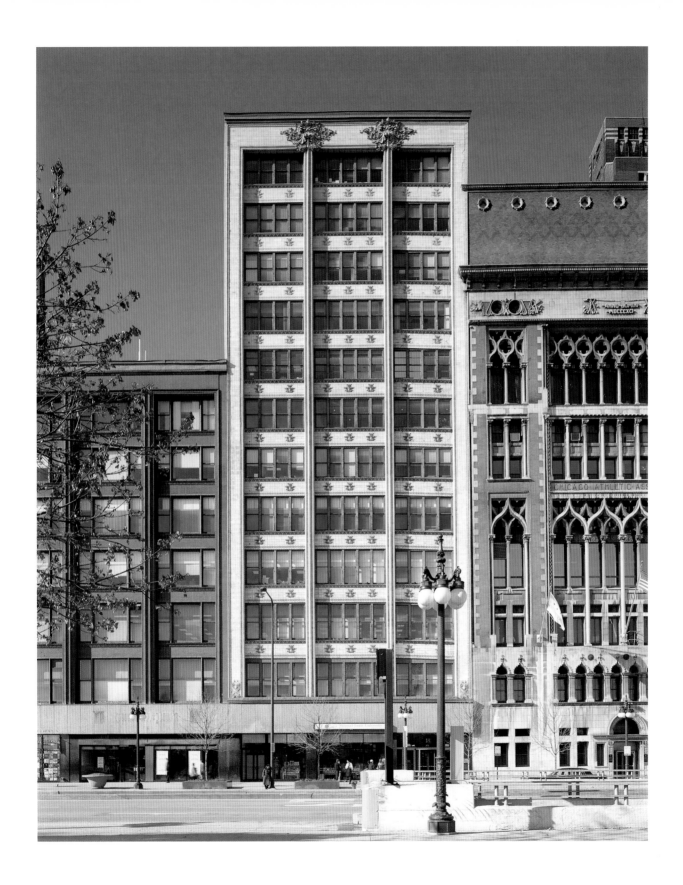

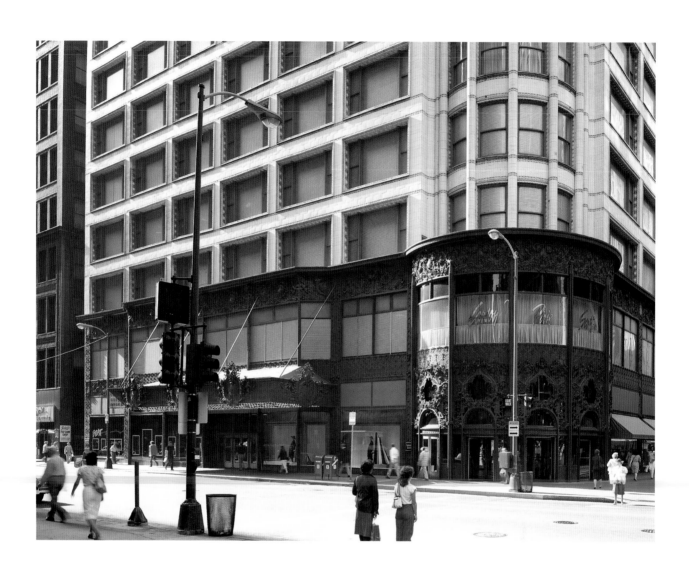

FIGURES 83, 84. Carson Pirie Scott Store, Chicago, 1898–1904.

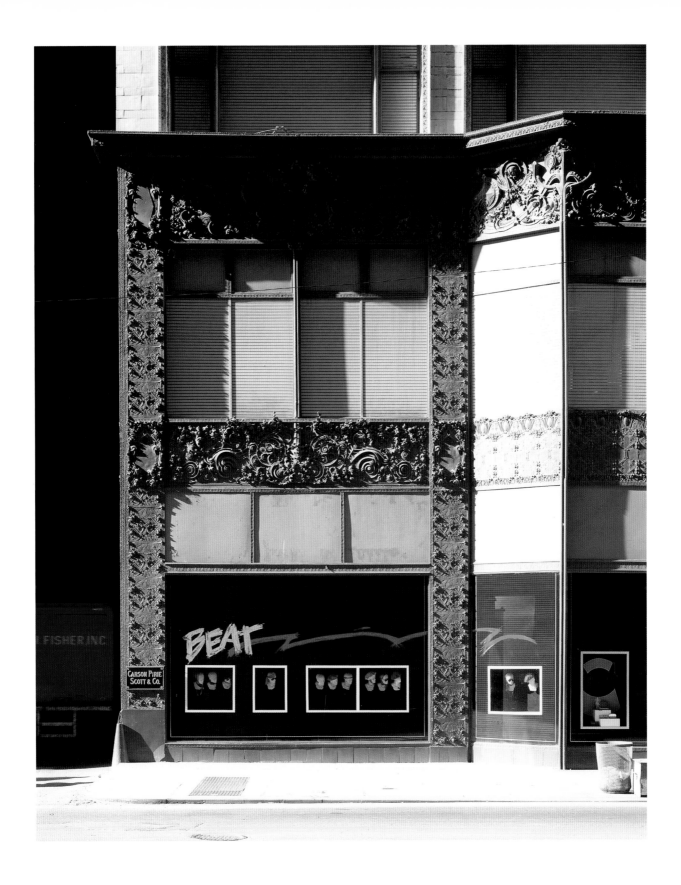

board, his team member—as indeed in 1893 he had lost his chief artistic associate, Frank Lloyd Wright (whom Burnham, Wright says, promptly tried to hire for himself).[57]

This was when Daniel Burnham pulled ahead. He had had to replace John Wellborn Root after Root's death in January 1891 with a jumble of technicians like Ernest Graham and Edward Shankland as well as designers like Charles Atwood, Frederick Dinkelberg, the younger Dwight Perkins and Willis Polk. Cass Gilbert and Frank Lloyd Wright spurned his offers. But Burnham grasped organization in the broadest Chicago sense; he knew what was needed and when. He had mobilized the spirit—and, more importantly, the people, institutions, and techniques—that rebuilt Chicago after the fire and accomplished the Columbian Exposition.[58] After a pause in the mid-1890s to reestablish his practice and to replenish his personal coffers, Burnham addressed himself to the problem of the modern American city as a whole, first in Washington, sensing again the *élan* of 1890 as we saw in his letter to Theodore Thomas, then in Cleveland, San Francisco, and finally in Chicago with his Plan of 1907–9.

By 1909 it had been six years since Sullivan had executed his last Loop building. Adler had died in 1900. Sullivan was now designing houses and small-town banks. Since his step-back city project of December 1891, he had been silent about what had become the issue of the day: the shaping of the American metropolis—an issue to which by 1900 Ferree had turned his attention. All the power of strategy and organization Sullivan had commanded in the great days of the Adler-Sullivan-Wright team he now had to turn to the creation of ornament. But, as he marked the few buildings he had been able to contribute to the city with his personal ornament, Sullivan left hidden in it traces which taken together constitute another, more passionate and humane urban vision of the cityscape. Here the Carson Pirie Scott Store addresses its street corner and window shoppers; the Stock Exchange floats above a band of cigar stores; the Schiller Building pushes up from the cornice line of the Borden Block; the Gage Building responds to the grandeur of the Michigan Avenue façade (while competing with Cobb's and Mullgardt's Athletic Club next door). As happened through Sullivan's use of color at the Columbian Exposition, when one sees his buildings the view of the whole city changes focus and momentarily goes technicolor—it refocuses from a grid of boxes with doors punched in the center of each ground floor to an inflected landscape where corners inspire one response (as in the Carson Pirie Scott Store), levels of ascent another (as in the Schiller), and rental demands a third (as in the Stock Exchange).

In addition, in the sheer *virtù* of their ornament, these buildings describe a different order, in counterpoint with the urban one: that of stylistic evolution. Sullivan's ornament changes steadily. In each composition it shows itself as a new step in his maturing ornamental sense. The history of "modern architecture"—the canon of its pioneers—was set down in the 1920s and 1930s by discovering those buildings in the world cityscape that identified themselves by their progressive "rationality," as the Ariadne thread that Sullivan paid out through his subsumption of ornament in mass in his Wainwright-Guaranty model was taken up and followed. This history was based on the belief that artistic evolution stemmed from a single, intellectual series of conceptualized forms that certain enlightened designers could glimpse and develop further. But in the case of Sullivan this distorts his pleasure in the simple doing of the thing, his satisfaction with multiple solutions, and his sensitivity to specificities and context.

3

FORM AND REFORM C. 1900
Sullivanism as a Design System

There is nothing whatever in [Sullivan's] ideas that he does not believe any person, having poetic tendencies, cannot find expression for in building. He is not the only Sullivan.
—Dwight Perkins addressing the first convention of the Architectural League of America, 1899.

AROUND 1900, at the height of the Progressive Era, there came a new twist in Chicago architecture: Sullivan's work was taken up as a cause.

Sullivan's architecture was seen as encapsulating an illuminating and general system of design, as Dwight Perkins declared in the quotation above.[1] The young draftsmen of Chicago—including Frank Lloyd Wright—tried to shape this system into an alternative course of architectural design and design education. Within what they imagined were its strictures, they framed important innovations from domestic design to city planning. Their work carried Sullivan's ideas onto a spatial plane in generalizing the implications of the geometry of his theater interiors as well as of his skyscraper façades. On the moral plane, their work assumed that a good design solution on whatever scale was a powerfully shaped and memorable one worked out elastically from its requirements—that architectural reform must manifest itself as form.

The Chicago Architectural Club and "Pure Design"

The young draftsmen of Chicago began meeting together in 1885, first as a sketching club and then, from around 1895, as an informal school to set, solve, and discuss model design problems, officially named the Chicago Architectural Club.[2] In 1898 a series of ateliers was instituted, conducted by Robert C. Spencer, Max Dunning, and Dwight Perkins.[3] They had rooms in the building of the Art Institute, and they held annual, month-long exhibitions in the Arts Institute's galleries. In 1904 the club fixed up a suite in the Dexter Building at 84 Adams Street (down from the Art Institute door near Dearborn Street) with a dining room and a club room chastely fitted up in mild Arts and Crafts style (figure 85).[4] The club's officers were the people Frank Lloyd Wright later described as his early friends and lunch associates, "The Eighteen" and its subset the Steinway Hall group: Robert C. Spencer, Myron Hunt, Dwight Perkins, George Dean,

FIGURE 85. Chicago Architectural Clubroom, c. 1904. (Author's Collection)

Richard E. Schmidt, Hugh Garden, Webster Tomlinson, Walter Burley Griffin, Birch Burdette Long, and Allen B. and Irving K. Pond.[5] The first was an informal lunch group of draftsmen; the second, neighbors renting space in the office building of that name. Modern historians designate them the first generation of the "Prairie School."[6]

The Chicago Architectural Club was meant to balance the professional body of older practitioners, the Western Association of Architects, founded in 1884 and joined with the East-coast American Institute of Architects in 1889.[7] The organization also tried to balance more prosaic associations like the Architects' Business Association or the Builders' Club. In contrast to these groups, the Chicago Architectural Club's concern was design—the solution of social or functional problems by architectural forms. Design became very important in America during the years around 1900 and Sullivan was picked out by this younger generation as their exemplar. Starting in 1898 and extending for a decade, what looked like a general Sullivanesque technique was formulated, applied, mixed, twisted, and earnestly mutilated by the draftsmen of the club to proclaim a new principle that might revolutionize architectural design—a principle they named "pure design."

Similar architectural sketch clubs developed in most large American cities: the Architectural League of New York (founded in 1881), the T-Square Club in Philadelphia (1883), the Boston Architectural Club (1889), the New York Society of Beaux-Arts Architects (1894), and the Cleveland Architectural Club (1894), as well as organizations in Detroit, Pittsburgh, Saint Louis, Toronto, and Washington, D.C. These corresponded and displayed one another's designs in their exhibitions to create a national dialogue. In 1899 representatives of these clubs gathered in Cleveland and founded a national association, the Architectural League of America, devoted to the advancement of design—specifically modern, national

design—under the motto "Progress before Precedent."[8] A progressive Philadelphian, Albert Kelsey, was elected president,[9] Webster Tomlinson (then briefly Frank Lloyd Wright's partner) secretary. Two older designers were treated as heros for their exemplary work: Ernest Flagg in New York (about to design his iron-and-terra-cotta Singer loft on Broadway)[10] and Louis Sullivan in Chicago. Sullivan addressed the delegates through a short exhortation, "The Modern Phase of Architecture," which was considered "the event of the convention…" "so thoroughly did it embody the thought and feelings of every draftsman present."[11] It was published in the *Architectural Annual*[12] and, enwreathed with a Sullivan-ornament border, in the *Inland Architect*.[13]

The second meeting of the Architectural League was held in Chicago, in Fullerton Hall in the Art Institute of Chicago and in the Auditorium Hotel dining room. Sullivan addressed the delegates (twice) as did several young Midwestern liberals: Elmer Grey, George Maher, and Frank Lloyd Wright (also twice).[14] By the time of the next convention in May 1901, held in Huston Hall at the University of Pennsylvania in Philadelphia, design discussion had come to focus on the term now familiar in the Chicago club's discussions—"pure design"—with its exegesis by the then-secretary to the director of the Art Institute, Emil Lorch, and further explanation by Robert C. Spencer.[15] For a moment the term was everywhere. Then it disappeared. Thomas Tallmadge (a student during those years) would use it as the keystone of "The 'Chicago School,' " his obituary of Chicago architectural liberalism in 1908. " 'What is pure design?' The answers filled the columns of the architectural papers for some little time, until it was pretty well demonstrated that nobody knew what it was, but that pretty near everybody was willing to produce a pet theory on the subject."[16] In Lorch's papers, its meaning is clear: "pure design" was a pedagogical system to free young artists from adopting ready-made historical solutions because of the lack of a system for thinking design through from first principles.[17] This had been the traditional objective of the principles of composition taught at the Ecole des Beaux-Arts (which Flagg, Sullivan, and Lorch had all attended). But now this was generalized with reference to elementary pedagogical systems paralleling kindergarten teaching. Adopting the techniques of the Boston art pedagogues Denman Ross and Alden Wesley Dow, Lorch would have students start with two-dimensional patterns of lines and the analysis of visual effects, move on to three-dimensional exercises in modeling form in specific materials, and finally (a step Ross and Dow did not take)[18] on to architectural elements like columns, before combining these into complex compositions. Lorch's innovation was that he sought architectural bedrock in patterns and conventionalizations of nature rather than in function or statics. It is less rational knowledge than imaginative force that "pure design" was to release in the student artist.

In architectural design instruction—how to strengthen and draw out the analytical power, the appreciation and invention of the architectural student, to healthfully develop his imagination, [to] train him to represent his ideas clearly in order that he may convey them to others for execution, [to] teach him the terms or materials of his own art and the fundamental principles of all art—and thus give him means for individual artistic growth; how best to prepare this student that he may build beautifully as well as soundly—finding for each problem a personal and appropriate solution, or, in other words, how to make him *not* an *adaptive* but a *creative* worker, or an artist-builder—an architect; is not, or should not, this be the highest and ideal end of architectural design study?[19]

"Pure design" was a vision of something free and

great but heretofore unimagined. It could not really be glimpsed in Ross and Dow's illustrations, for when extended to architecture it had a sublimity that sought manifestation in something like Sullivan's "toy block" architecture or, even more powerfully, in the rhythmic pronouncements Sullivan had started to write and to read to the Chicago draftsmen. "The beauteous art of architecture, as a once living presence in the heart of man, is dead and gone, —…if there is to be a new art, there must be a new birth.…It awaits only the coming of a great, an intense, personality: —a man of passion: —with a great and beautiful architecture in his heart."[20] In 1901–2 Sullivan published his *Kindergarten Chats* for these draftsmen to lead them back to first principles.

Lorch, in his extension of the Ross-Dow method to architecture, used it as a means of concretizing Sullivan's exhortations. In Lorch's teaching we find the meaning of the most basic idea in "pure design," its enabling a primitive release of creative force that will surprise and shock at first but then slowly achieve an order of its own. Lorch ended his paper:

> Crude at first, such designs would soon grow in strength and significance, and the student enjoying his personal mastery and solution of the problems would work with ever-increasing love and interest—really launched in creative work; discovering that within each problem lies its solution, that proportion is not fixed but relative in its nature—[so that such designs would] lead him to a true understanding of established forms and a much greater respect for their use, and above all help him to *work with a fuller consciousness and realization of the completed or carried-out appearance of his design,* thus better preparing him for a mastery of his art.[21]

It is interesting to compare these declarations with the *Chicago Journal*'s mildly caustic summary of Lorch's intentions in its June 15, 1901 issue:

> Instead of teaching the students to draw the "Orders of Architecture" and fill their minds with every ancient pattern, detail and molding used since houses were lived in and temples raised to the gods, he proposes that the first year of study shall be devoted to efforts at inventing new designs. He would spread a net to catch every vague, fleeting idea that the novice's brain has acquired on the home farm.
>
> He would, certainly, keep to instruction in construction, timber frames, brick and stone walls, steel trusses, capacity for carrying weights, or restraining thrusts, just as it is done at present. But in the matter of making this practical construction a pleasing object to look at and live with, he would give the fresh, unwarped mind of the student an opportunity to let loose all its original conceptions—if any such exist.

Lorch's notes for an introductory architecture course at the Art Institute School survive among his papers at the University of Michigan, dated March 1901. These start with a page of sketched tree species and historical architectural types such as elm, ash, oak, and pine; a Greek temple, the Roman Pantheon, a Gothic cathedral, Richardson's Austin Hall, a skyscraper. The page is annotated "proportions of low trees as like low houses—high trees—high buildings…Branches of elms, apples and other trees proportioned to truth and function of carrying foliage, fruit, resisting wind and storm, an outgrowth of the force of nature, under conditions of ground, wind, air, sun." Another page is headed "Unity" and describes the decorative principle of deriving a pattern from a single point. A third page is headed "Germinal Forms— Exercises in Pure Design" and shows the elaboration of

compositions from primary shapes and combinations. The last two pages distinguish "pure design" from "applied design," the latter "in material, for a purpose…as a chair…a gateway." This passes from a discussion of flat patterns to that of a wooden balcony design and—abruptly and without inscription—to the sketch of an office building façade (figure 86). This façade sketch is a cubic, rhythmic design following Sullivan's Wainwright paradigm, with an open bottom and closed top levels defining a shaft of attenuated pilasters. Lorch elaborated it by making the thick corner piers reappear twice across the façade panel, the pilasters pushed up against the edges of the resulting three indentations in the façade (open as glass?) while the piers themselves are pierced with frameless windows in syncopated relation to the whole. Lorch thus suggests a fascinating interweaving of readings: three bays across (taking the glass openings) or seven? One monumental story between cornice and plinth or five stories (reading the windows)? It is Sullivan's simplifying and overscaling (his "toy-block architecture") that the Wainwright Building systematized.

The "Chicago School of Architecture"

The program at the Art Institute that Lorch was attempting to redirect was a sympathetic one, led, in fact, by Sullivan's best friend and closest collaborator, Louis J. Millet.[22] Millet had studied at the Ecole des Beaux-Arts, entering at the same time as Sullivan in the fall of 1874, not in the Americanized atelier of Vaudremer, but in the more radical one of Viollet-le-Duc's son-in-law, Eugène Train.[23] Frank Lloyd Wright would later describe Millet and his business partner George Healy as Sullivan's "comrades." "The three men knew one another in Paris. Sullivan spent much of his time in their company. . . ."[24] Millet was the son of Emile Millet, a French musician in

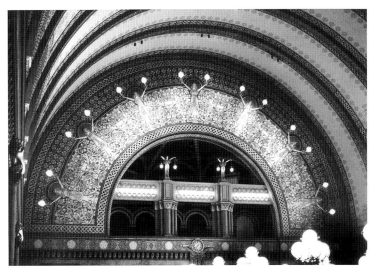

FIGURE 86.
Emil Lorch, sketch of a building façade among teaching notes for course at the Chicago School of Architecture, 1901. (Bentley Historical Library, University of Michigan)

FIGURE 87.
Louis J. Millet, main hall decoration, Saint Louis Union Railroad Station, 1894. (Author)

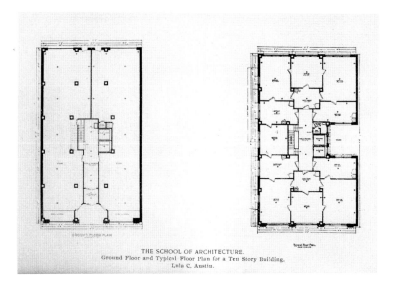

THE SCHOOL OF ARCHITECTURE.
Ground Floor and Typical Floor Plan for a Ten Story Building.
Lula C. Austin.

New York who had been Viollet-le-Duc's traveling companion in 1833 and who remained his lifelong friend.[25] Emile Millet's brother was the Parisian sculptor Aimé Millet (with whom Louis Millet is supposed to have lived while a student at the Ecole), also a friend of Viollet-le-Duc, making it even less surprising that Louis Millet should enter Train's atelier.[26] As we have noted, Viollet-le-Duc had been Ruprich-Robert's master and predecessor teaching ornamental design at the Ecole Gratuite de Dessin.

In 1880 Louis Millet set himself up in Chicago as an architectural decorator, from 1881 to 1899 in partnership with Healy who had also entered the Ecole as a student architect in 1874 in the atelier of the Néo-Grec decorator Ernest-Georges Coquart. Sullivan employed Healy & Millet to execute his interior designs beginning with the Auditorium Building. Practicing on their own in the Saint Louis Union Station hotel in 1891–95 and in Fullerton Hall at the Art Institute itself, they produced elaborate work paralleling Sullivan's own (figure 87).[27]

Initially Millet was employed teaching decorative design at the newly founded school of the Art Institute by its director, W. M. R. French (the sculptor Daniel Chester French's brother), who was trained in engineering at MIT and was formerly the partner of the landscape and city planner Horace Cleveland. In 1889 a School of Architecture was founded at the institution with Millet teaching architecture and design, specifically based on the Beaux-Arts–derived programs of MIT and Columbia.[28] In 1893 an agreement was made with the newly founded Armour Institute of Technology (now the Illinois Institute of Technology) to create joint two- and four-year architecture degree programs under the name of The Chicago School of Architecture, of which Millet was appointed dean. By the time Emil Lorch arrived at the Art Institute in 1899 the students included Alfred Alschuler, George Eich (to be important in Howard Van Doren Shaw's office), Horace Powers (R. C. Spencer's future partner), Vernon Watson (Thomas Tallmadge's future partner), George Willis (chief draftsman in Wright's Oak Park Studio), and Charles Tobin (Frank Lloyd Wright's brother-in-law and Griffin's replacement in the Oak Park Studio in 1906). The faculty now included William K. Fellows (trained at Columbia, George Nimmons's design partner, then in 1911 Dwight Perkins's design partner)[29] teaching design and drawing and Albert Fleury, another Beaux Arts–architecture trained Frenchman and Sullivan collaborator, teaching watercolor rendering—later replaced by Wright's Steinway Hall collaborator, Birch Burdette Long. In October 1901 the Art Institute school also opened a Normal Department to instruct art teachers, with Millet in charge and able to apply "pure design" more directly. However, he was at the same time being pushed out of the architecture program as it was reorganized on more conventional lines after an internal struggle.[30]

The student productions illustrated in the catalogues of the Chicago School of Architecture and of the Chicago Architectural Club exhibitions and in the School's jour-

nal *The Sketch Book* show that the generic exercises formerly comprising the school's production abruptly vanished in 1900, coincident with a pointed blast by Emil Lorch published in the Chicago art journal *Brush and Pencil*.[31] In their place appeared small, more realistic programs: suburban houses, a bank, a suburban railroad station, an automobile "stable," an architect's office, a ten-story office building on a city lot (published in plan only, figure 88), rendered in a variety of advanced styles, including the Sullivanesque (figure 89).

The Chicago Architectural Club Embassy Competition

Contemporaneously, among the young practitioners it is not surprising to see imitations of Sullivan's ornament appearing in premiated Chicago Architectural Club designs for a terra-cotta column and lintel of 1898 by George Dean, Alex Sandblom, and Birch Burdette Long, or to encounter such imitations even earlier from the hand of Frank Lloyd Wright beginning with his Winslow House of 1893–94. In 1898 the Luxfer Prism Company mounted a competition for architectural suggestions for the use of their light-projecting glass, publishing two model designs for eleven-story office towers provided by Frank Lloyd Wright in a negotiated Sullivanesque idiom.[32] The jury, consisting of Daniel Burnham, William Le Baron Jenney, William Holabird, and Frank Lloyd Wright himself together with the physicist Henry Crew, premiated an arcade office building by Robert C. Spencer (figure 90) and an extravagant glass office tower by the recently arrived Italian Adamo Boari, both in the Steinway Hall group.[33] In 1900 the Chicago Women's Club led by Lucy Fitch Perkins, Dwight Perkins's artist wife, held a competition for a bus pavilion won by Birch Burdette Long with a Japanese design, executed and still standing on Rush Street.[34]

It is especially enlightening to see what happened among the group with a full-scale monumental design,

THE SCHOOL OF ARCHITECTURE.

A Bank Building—A. Arthur Guilbert.
Perspective Problem—G. W. Carr.

109

FIGURE 89.

A. Arthur Guilbert, "A Bank Building," student design executed at the Chicago School of Architecture, published in the *Catalogue of the School of the Art Institute of Chicago*, 1902. (Art Institute of Chicago)

opposite

FIGURE 88.

Lulla C. Austin, "Ground Floor and Typical Floor Plan of A Ten-Story Building," student design executed at the Chicago School of Architecture, published in the *Catalogue of the School of the Art Institute of Chicago*, 1902. (Art Institute of Chicago)

FIGURE 90. Robert C. Spencer, competition project of a commercial building for the Luxfer Prism Company, 1898. (*Inland Architect and Building News*, September 1898)

one systematically elaborated during the winter of 1900–1 for the Chicago Architectural Traveling Scholarship competition, on the subject of "A United States Embassy in a European Capital."[35] The competition unfolded in five design steps, each taking a month: first a block plan of buildings and grounds; second the entrance gates; third the building plans and elevations; fourth the interiors of a ball room and a grand hall; fifth a bird's-eye perspective of the whole. A separate jury judged each stage: Perkins led that analyzing the block plan; Dean the gates; Rogers and Wright the plans and elevations; Millet, Sullivan, and Hugh Garden's architect brother, Edward, the interiors; Sullivan and Spencer with Seth Temple (of the University of Illinois) the perspectives. The four frag-

mentarily published submissions are all Sullivanesque (figures 91–98), the winning project by John H. Phillips decisively so in its dependence upon the Auditorium dining room. But William Drummond's design seems more effective and interesting in its extension of Sullivanism to its plan and spaces. At this point Drummond (recently studying at the University of Illinois) had just finished a stint in Sullivan's office and would soon enter Frank Lloyd Wright's Oak Park Studio, where he would prove himself one of Wright's most understanding and sympathetic assistants.

Drummond's plan, as published in the club's catalogue, must be carefully read (figure 94). The front line of piers of the entrance court have been cropped off in this photograph, as is immediately evident in comparing the plan to the aerial perspective. The principal space, the ballroom, is on a higher level, up the staircase continuing the entrance court axis, and only appears in outline. A secondary group of spaces, evidently the ambassador's private residence, complicates the primary composition to one side. Still there is no mistaking Drummond's dependence upon Sullivan in the heavily ornamented surfaces and the "toy-block" scaling of the parts.

To analyze the design, we must start with the heaviest accents marking the plan sheet, the square piers. These delineate two concentric rectangles of pergolas, a smaller one defining the entrance court and a larger one embracing the whole chancellery but only stated in two foursomes of piers flanking the ballroom. Interwoven with these rectangles are the design's major axis—from the entrance court to the ballroom—and cross-axis, 45-degree lines drawn from their intersection fixing the position of the larger pergola-piers.

Thin walls and pilastrades (their construction suggests wooden or steel construction) define the interior spaces with no more emphasis than do the embracing pergola spaces, producing such a blending of spaces, of interiors and exteriors, that one's eye wanders over the whole sur-

AN AMERICAN
EMBASSY, BY
J. H. PHILLIPS

FIGURES 91, 92.
John H. Phillips, "A United States
Embassy in a European Capital,"
Chicago Architectural Club compe-
tition, 1900–1, aerial view, plan.
Published in the *Chicago
Architectural Annual*, 1902.

FIGURES 93, 94.
William Drummond,
"A United States Embassy in a
European Capital", Chicago
Architectural Club competition,
1900–1. Published in the *Chicago
Architectural Annual*, 1902.
Aerial view, plan.

opposite

FIGURES 95, 96.
John H. Phillips (above) and
William Drummond (below), "A
United States Embassy in a European
Capital," Chicago Architectural Club
competition, 1900–1, ballroom. Pub-
lished in the Chicago Architectural
Club *Book of the Fourteenth Annual
Exhibition*, 1901.

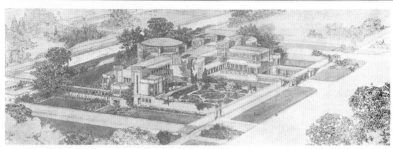

AN AMERICAN EMBASSY, BY WM. E. DRUMMOND BIRD'S EYE

THE DRAWINGS ON THIS PAGE, THE PRECEDING PAGE AND THE TOP DRAWING ON THE FOLLOWING PAGE ARE SOME OF THE DRAWINGS
SUBMITTED IN LAST YEAR'S SCHOLARSHIP COMPETITION. THE COMPETITION THIS YEAR CLOSED TOO LATE FOR PUBLICATION. THE
COMPETITION THIS YEAR WAS VERY SUCCESSFUL FROM THE STANDPOINT OF THE NUMBER OF COMPETITORS AND GENERAL EXCELLENCE
OF WORK PRODUCED. THE AMOUNT OF MONEY (ONLY THREE HUNDRED AND TWENTY-FIVE DOLLARS) FURNISHED THE CHICAGO
SCHOLAR IS ENTIRELY TOO SMALL. WHEN WE CONSIDER THAT EVERY LARGE CITY IN THE EAST HAS FROM TWO TO FOUR
SCHOLARS IN EUROPE ALL THE TIME, WHO ARE FURNISHED ONE THOUSAND DOLLARS EACH, IT WOULD SEEM THAT THE CITIZENS
OF CHICAGO SHOULD TAKE INTEREST ENOUGH IN THE ARCHITECTURE OF THEIR CITY TO KEEP ONE MAN AT LEAST PERFECTING
HIMSELF IN HIS ART ::

PLAN BALLROOM

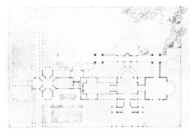 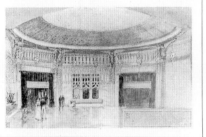

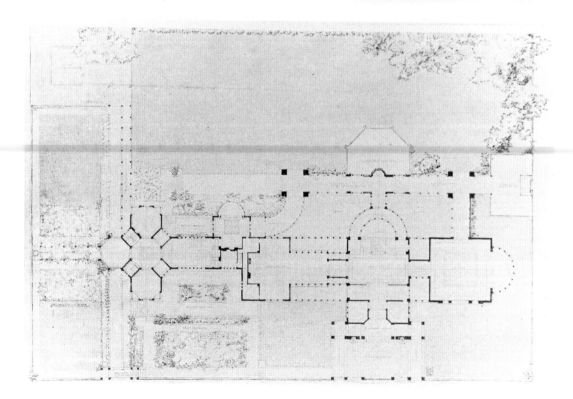

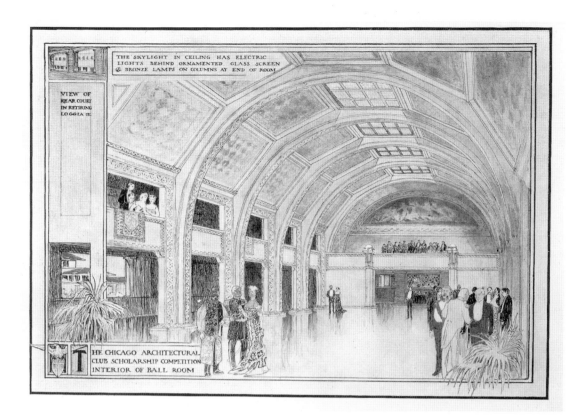

THE SKYLIGHT IN CEILING HAS ELECTRIC
LIGHTS BEHIND ORNAMENTED GLASS SCREEN
& BRONZE LAMPS ON COLUMNS AT END OF ROOM

VIEW OF
REAR COURT
IN RETIRING
LOGGIA ℅

THE CHICAGO ARCHITECTURAL
CLUB SCHOLARSHIP COMPETITION
INTERIOR OF BALL ROOM

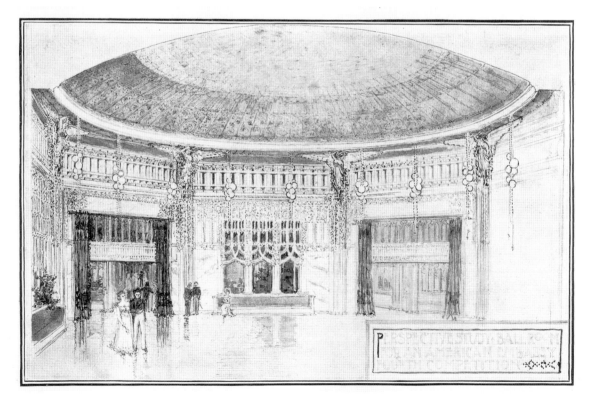

PERSPECTIVE STUDY BALLROOM
FOR AN AMERICAN BUILDING
CLUB COMPETITION

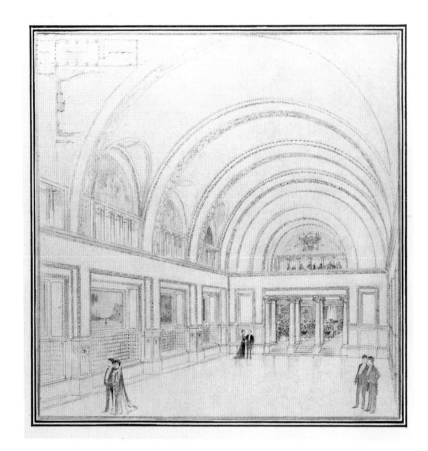

AN AMERICAN EMBASSY. THE ENTRANCE
BIRCH BURDETTE LONG

face of the plan sheet as over a map or a Sullivanesque ornamental composition. (A conventional volumetric design like Phillips's, on the other hand, emphasizes the primary spatial axis, embracing it in the molded volumes of thick—presumably masonry—walls, so that the building floats boatlike in its surroundings.) Drummond's enclosed spaces are incidents in a broader pattern spread across the whole site, elaborated from the rectangular shape of the lot (and of the plan sheet itself). This sort of generation of free interrelationship across a flat surface was Sullivan's central illumination in 1890–91 in his creation of a "toy-block" architecture.

One might compare Drummond's design to the radical Beaux-Arts "compositionism" of Ernest Flagg, most impressively in his 1892 project for the New York Tilden Trust Library, discussed in chapter 1, that had been on display in the Chicago Architectural Club exhibition of 1895 (figure 99).[36] This is simultaneously an arrangement of distinct functional elements—an octagonal catalogue room at the center, stack wings extending from it along its major and cross-axes, four separate reading rooms tucked into the crooks on four diagonal axes—and an even geometric pattern elaborated out of these rhythmically responding quadraxial forms. It is a multiplication of the effects described in chapter 1, manifested in Charles Baker's MIT thesis design for a town hall (see figure 41).

Similarly, the difference between Phillips's and Drummond's designs is in the latter's subsumption of pattern. In Drummond's design each architectural element is made to do two different things simultaneously: to respond rhythmically in shape and position to the entire pattern of the plan and through slight but decisive characterizing inflections, to state its distinctive function. Phillips's design is a building defined in an open space;

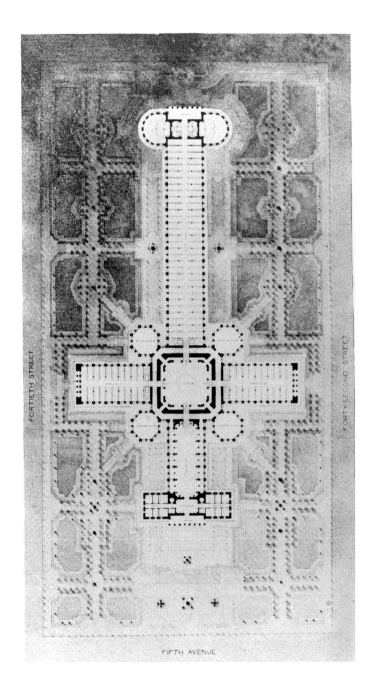

Drummond's is one in which building and space balance each other in a reciprocating pattern. It is the equivalent in planning of the flat, interweaving of readings that Lorch had elaborated from Sullivan's Wainwright model in his Art Institute class sketch.

Frank Lloyd Wright's Oak Park Studio

The pedagogy of the Chicago School of Architecture as well as that of the ateliers and design competitions among the young draftsmen of the Chicago Architectural Club are contemporaneous with the most dramatic embodiment of Chicago progressive design proselytizing, Frank Lloyd Wright's Oak Park Studio of 1898 (figures 100 and 101).[37] It claimed to be at once an architect's office, a school, and a community meeting place—not to mention an example of how a new architecture might appear in the center of one of Chicago's elite suburbs. As Wright relates in his *Autobiography*, his consultancy for the Luxfer Prism Company at that time provided the money for him to build this structure next to his house with a two-story drafting room, a private office, and an octagonal library (marked a "free circulating fine art library" on a published plan)[38], all linked by a monumental entrance hall opening to a terrace leading to Chicago Avenue. Wright's objective, he explained, was to integrate his practice with the more natural atmosphere of the suburbs, and thus not to exploit but to nurture his draftsmen. These included many familiar names: Willis and Tobin from the Chicago School of Architecture, Mahony and Griffin from Steinway Hall, and Drummond and Long from the Chicago Architectural Club embassy competition. Wright's wife conducted an informal kindergarten elsewhere in the house, a microcosm of the kindergarten school Wright's aunts conducted in Wisconsin, and a parallel to Wright's conception of the training he was giving his assistants.

The building at first glance appears Sullivanesque in its rhythmic geometry and exaggerated proportions. It is not really a domestic design: the single, low story of its pilastraded front is as overscaled in its parts as Lorch's lecture sketch of an office building (figure 86). There is a central monumental entrance hall at the meeting of the interior cross-axes, but the spaces are now cut off and imply no actual processional route. These spaces have also moved apart to constitute a harmonic array of characteristic volumes externally. Approaching the entrance terrace, one's eye goes to the exotic pier capitals, but instead of finding surfaces of Sullivanesque efflorescence, one discovers strange symbolic objects: a tree with dangling fruit, a book with an open page marked by a bookmark and seal, and a scroll of architectural plans depicting an open columnar stoa from which extends a closed octagonal chamber—the whole framed by guardian secretary birds (figure 101).[39] Taken as a collection of objects, the capitals suggest what would, around 1900, free Wright's work from superficial resemblance to Sullivan's: the dematerialization of decoration into a grid with, not ornament, but real objects of nature and real spatial vistas brought in across terraces and through strip windows on all sides. The capital design also can be seen as making a series of analogies: the fruit is the product of the fertility of the tree; the marked page is the essence of the book as a whole; the thick-walled inaccessible octagon is the spatial heart of the otherwise open architectural composition. The capital becomes an essay on artistic creation that reiterates the germinal theme of Sullivan's efflorescence or Lorch's "pure design" but, when manifested by Wright as a symbol in architectural form, shows a troubling detail: the place of fructification is secret, in a closed chamber filled with mantric objects of genius. This might lead to a further level of interpretation: just as Sullivan emphasized the panoptic in his domestic designs (as will be shown in the next chapter), Wright emphasized the separateness of such spaces, as if seeking to cut himself off and protect himself from Sullivan's

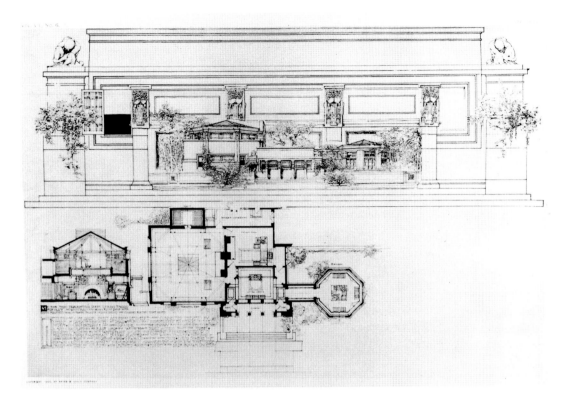

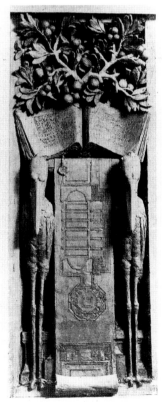

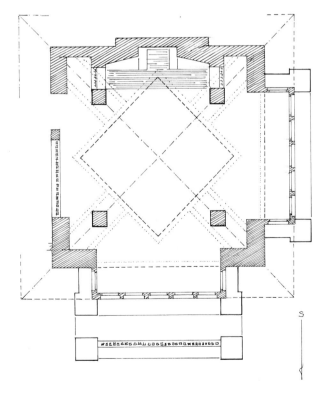

FIGURES 100, 101. Frank Lloyd Wright, studio wing added on to his house, Oak Park, 1898, loggia capital. (*Architectural Review*, Boston, 1900)

FIGURE 102. Frank Lloyd Wright, Hillside Home School, Spring Green, Wisconsin, 1901–2. Plan of living room wing redrawn by author.

artistic domination. The octagon that Wright actually built onto the Studio, depending by a short corridor from the Oak Park Studio, is accessible but of a peculiarly uncertain function: a space for meeting with clients in its everyday use, but a private *Wunderkammer* in its contents and high-windowed construction.

In the Oak Park Studio Wright created his "Prairie Style" in 1900–2. One of the style's salient characteristics is its progressive restriction (and ultimately dismissal) of Sullivan's ornament; another is the "pinwheel" plan extending in four directions from a central fireplace stack that cuts off each room from the other. Both of these strategies marked a rejection of Sullivan and are presaged in the Studio capitals.

A third characteristic was a tight pattern of modular, responding masses and spaces in plan that carries us back to William Drummond's embassy project elaborated contemporaneously during the winter months of 1900–1 (figure 94). A few months after that plan had been completed, displayed, and discussed, Wright himself designed the Hillside Home School near Spring Green, Wisconsin (figure 102), in a context parallel to Drummond's pedagogical exercise—his aunts' formulation of kindergarten education applying a Dow- or Lorch-like elementarism to the whole process of juvenile upbringing.[40] (Wright himself was sending his sons to school there.) In Wright's plan for the school's principal wing, the pattern of pier-blocks that controlled Drummond's design shifts and reorganizes itself into a powerful, syncopated configuration that stakes out the principal masses but also shakes free from them at one point to march southward down the hillside. The walls between the pier-clusters are reduced to screens admitting a flood of light. A balcony floats in this space, drawn back from the window walls and open through a diagonal cutout at its center. In the elevations, Sullivan's ornament is finally completely gone, replaced by surfaces of rough local stone and glass and timber paneling. The challenge Wright had inscribed in the Studio capitals has been met in this second place of education designed two years later. Wright's "Prairie Style," still struggling to emerge in his suburban houses of 1900–2, is fully achieved in Spring Green. Drummond's embassy project provides a glimpse of an intermediary step in this move from Sullivanesque ornamental composition to Wright's personal counter-achievement.

The Griffins and the Design of Canberra

Focusing on the Chicago Architectural Club and its design competitions has deflected attention from a very important aspect of architectural progressivism among the young Chicago draftsmen: the concern for reform as well as for form, for creating in the social sense a better Chicago, a model for the American city as a type.[41] Sullivan's general idea that an architectural design should be elaborated out of a functional problem here assumes the nature of a city plan taking shape from the details of social organization. This enterprise was at least as important for the Architectural League as was the regeneration of architectural education. Among the Architectural League leaders, Albert Kelsey was concerned chiefly with urban amenity, using an 1898 traveling fellowship to produce a graphic analysis of "The Science of Cities" that led to his pamphlet *The City of the Future* (1902), the agitation for the Benjamin Franklin Parkway in his native Philadelphia from 1899 on, and helping to organize a municipal infrastructure section in the 1904 Louisiana Purchase Exposition in Saint Louis.[42] Kelsey's concerns manifested themselves in Chicago in an organization—the City Club—that carried on the progressive architectural program in a broad and more focused manner than had been permitted by the framework of the Architectural Club.[43] Several leaders of the Club group, especially Dwight Perkins, were motivated to make important national contributions.

The City Club, founded in 1903, numbered among its members several of the same younger, progressive architects as the Architectural Club and Wright's Oak Park Studio: Richard E. Schmidt, the Pond brothers, Jens Jensen, Dwight Perkins, Hugh Garden, and William Drummond. In 1905–6 the club erected a building for their meetings and public lectures in the Loop, at 315 Plymouth Court across from the Union League Club. There was an architectural competition for its design that the Ponds won and in which Walter Burley Griffin competed with what we are told was a startling advanced design.[44] In 1912–13 the club sponsored another competition, this time for a model design for a city neighborhood, attracting submissions from Wright (which he labeled "non-competitive"), the Ponds, Kelsey, Drummond, and Griffin and won by Wilhelm Bernhard, a sometime member of both Griffin's and Wright's offices.[45] In 1914–15 the club sponsored a second competition, this for a "neighborhood center" to serve as the social focal point of such a city neighborhood.[46]

The City Club, in fact, had its origin in the Evanston living room of Dwight Perkins where around 1900 he gathered the self-proclaimed "Committee on the Universe," including George Hooker (later secretary and animus of the City Club), Jens Jensen, Charles Zueblin, Louis Post, John Montgomery, Edwin Winston, and Perkins's wife Lucy Fitch Perkins.[47] Dwight Perkins had been raised in the ethos of public service and in Jenkin Lloyd Jones's socially active Unitarian congregation, sharing with Jones's nephew, Frank Lloyd Wright, the responsibility in 1898 for designing its Abraham Lincoln Center (a partnership that failed by 1906; they were replaced by the Ponds).[48] Perkins and his wife pursued municipal improvement on several fronts, including the institution of school playgrounds, city parks, the selection and reservation of the state forest preserves around Chicago, and school architecture, Perkins serving as architect of the Board of Education from 1905 to 1910.[49] The

Perkinses were close friends of Harold Ickes and his wife, designing houses for them in 1911 and 1915–16.[50]

The culmination of this progressive architectural program was the powerful plan for Canberra, the new capital for Australia (figures 103 and 105), won in competition in 1912 by Griffin and his wife of one year, Marion Mahony, Perkins's cousin and sometime collaborator (as well as Wright's longest-standing assistant).[51] Here form returned to support reform. Griffin and Mahony addressed their problem by dividing it into functionally distinct parts, giving each an expressively distinct shape, then tightly linking them together in an hieratic, axial configuration. To this they added a brilliant accommodation to an accidented site. Examining the map of the area included in the competition materials, the Griffins perceived two visual axes linking the surrounding mountain peaks and intersecting fortuitously at a low hill, Kurrajong, in the valley of the Molonglo River where the city was to be centered. They proposed to place the capital buildings on this rise of ground, with a Cambodian domical national monument at the apex, and to embrace this with a five-lobed lake enframing a monumental tableau formed by damming the river. Around the capital group they elaborated an octagonal starburst of streets whose eight axes extended out to organize the tableau as well as to reach into harmonizing octagonal and hexagonal starbursts of streets occupying the surrounding valley floor and accommodating different quarters of the workaday town: a commercial district, a cultural area, a manufacturing quarter and a series of self-contained garden suburbs.

If we compare Griffin's and Mahony's design to a conventionally monumental one like that of Henry Van Buren Magonigle (figure 104), we realize that what sets the former apart is not its manipulation of axes but its interweaving of different sorts of axes through a rich and ornamental pattern. In fact the Griffins' major and cross-axes—those between Mount Ainslie and Bimberi Peak and down the lake chain to Black Mountain—are not tra-

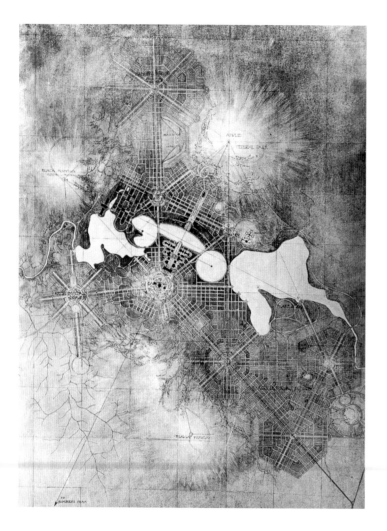

versable. Instead, they function as a visual orienting arm-
ature within which a secondary, smaller scaled hexago-
nal and octagonal system of streets is elaborated, pat-
ternlike with multiple foci and spread across the whole
plan sheet. Interwoven with these first two layers of orga-
nization is the accidented array of natural features: the
shining surfaces of the lake chain balancing the moun-
tain heights. It has always seemed puzzling (if not churl-
ish) that the Griffins claimed to have gotten more from
Sullivan than from Wright. The strategies they were fol-
lowing in this plan, however, were based on the octagonal
elaboration of axes implicit in Sullivan's planning and
explicit in his ornament.

When Chicago progressive design is elaborated to pro-
vide a framework for a whole city, its rhythmic geometry
becomes exaggerated. It is noticeable in the struggle
Griffin and Mahony make here to achieve this frame-
work in real topography for a soon-to-be real population.
The selection of their design was controversial and large-
ly intuitive on the part of the government minister in
charge, the immigrant North American King O'Malley.
The Griffin's was much more tightly composed than the
competing designs (with the exception of the runner-up,
Eliel Saarinen's). It is assumed that Marion's glorious ink-
wash rendering style as well as the plan's decorative leg-
ibility attracted O'Malley. In its construction of com-
pressed nodes and axial efflorescences embedded in a pic-
turesque topography, the plan starts to resemble a spread-
ing sheet of Sullivan ornament, one that actively requires
the observer to look closely, to focus on its distinct pas-
sages, and to follow its intertwining axes. The Griffins's
puckering of the Midwestern grid into functional nodes
and the consequent accommodation to topography ap-
peared as a visual metaphor for the integration of mech-
anical rationalism and democracy.[52]

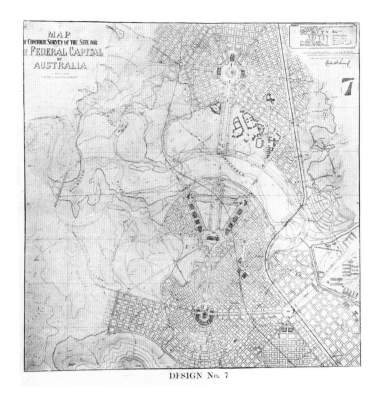

DESIGN No. 7

FIGURE 104.
Henry Van Buren Magonigle, competition project
for the plan of Canberra, the new capital of
Australia, 1912. (*Report of Board Appointed to
Investigate and Report to the Minister for Home
Affairs in Regard to Competitive Designs…*)

FIGURE 103 (*opposite*) and 105.
Walter Burley Griffin and Marion Mahony, competi-
tion project for the plan of Canberra, the new capital
of Australia, 1912, plan, elevation of Parliament
group. (National Archives of Australia)

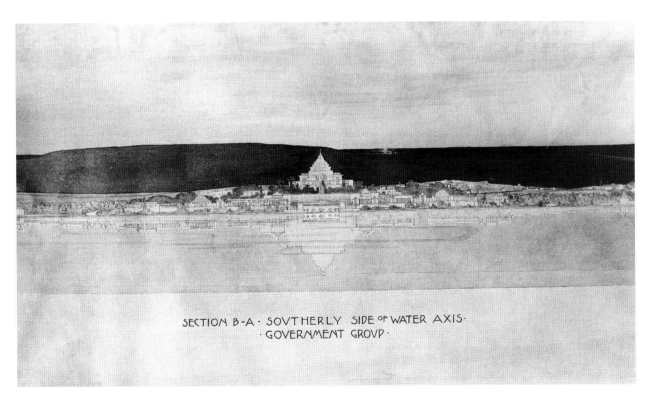

SECTION B-A · SOVTHERLY SIDE OF WATER AXIS·
· GOVERNMENT GROVP ·

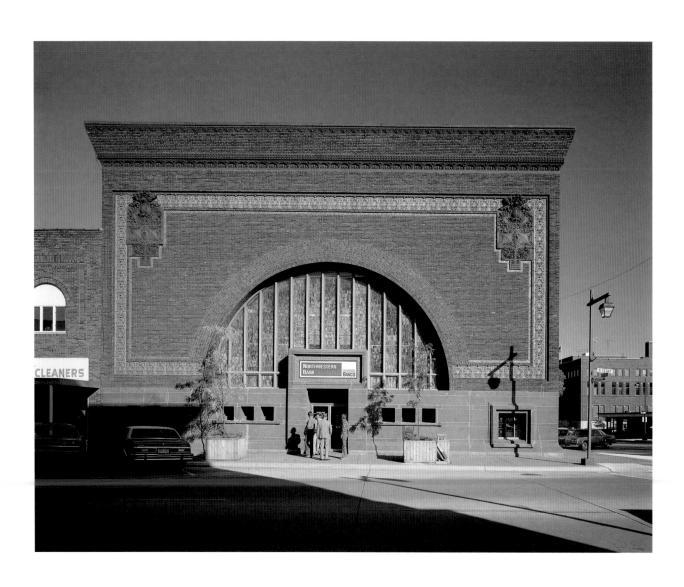

FIGURE 106. National Farmers' Bank, Owatonna, Minnesota, 1906–8.

4

WHY SULLIVAN'S HOUSES ARE AS IMPORTANT AS HIS BANKS, C. 1910

There is no denying that a new work by Louis Sullivan is the most interesting event which can happen in the American architectural world to-day. There has been nothing like the professional interest which his works inspire since Richardson ceased to produce, a quarter of a century ago.

—Montgomery Schuyler, *Architectural Record*, 1912

THE IDEA that design exercises might realize innate human powers meant that form became reform in Chicago at the turn of the century, whether in Sullivan's *Kindergarten Chats*, Lorch's design pedagogy, Wright's Studio practice, or the Griffins's Canberra plan. Sullivan himself was denied the opportunity to frame large-scale spatial plans for public institutions or cities but he did receive a series of house commissions of sufficient complexity to permit him to hint at his powers in this area. These commissions posed the fundamental problem of composition in interrelated spaces that the rest of Sullivan's oeuvre did not. If he was the great composer that his theater interiors and his impact on the younger designers around 1900 suggest, it is in these house designs that the fact would be demonstrated. I think it is: The spatial coordination of his theater model was stretched out horizontally to produce peculiarly monumental domestic landscapes that are (among other things) profoundly different from those of Frank Lloyd Wright. The domestic environments that Sullivan produced are intensely formal and public, but to him that is precisely what both design and life were. He made his domestic

clients display themselves as he was himself displayed through his emphatic architecture.

Progressive Design's Last Hurrah

The emergence of the Wrightian Prairie School, the Griffins's success in the Canberra competition, the establishment of George Elmslie's busy practice with William Gray Purcell in 1909, and the Minneapolis *Western Architect*'s advocacy of the "new architecture" (after Sullivan's supporter R. C. McLean assumed editorship in 1905) all gave the semblance of a burst of creative energy in Midwestern progressive design on the eve of the First World War. It was a false one: Griffin and Mahony went to Australia in 1913; Wright—tainted by marital troubles in 1909—was devastated by the Taliesin tragedy of 1914 and retreated to Japan and Los Angeles. Sullivan's 1913 display at the Chicago Architectural Club exhibition was his swan song and only a retrospective. By 1917 Thomas Tallmadge could declare, introducing a review of the Chicago Architectural Club, "Where are Sullivan, Wright, Griffin and the others? The absence of the work of these men has removed from the show the last vestige of local color."[1] Fellow travelers—like Tallmadge himself—abandoned what they now considered a style rather than a cause.[2] During the 1890s Sullivan's audience had been the entire city of Chicago—or even, with the Transportation Building at the Columbian Exposition, the world. From 1900 to 1914 his audience was the younger generation of architects and Chicago progressives. Now he had lost both audiences, but—creative to the last—he discovered another, more modest audience: old friends, small-town bank presidents, and alert young men. The late historian David Gebhard remembered his own desire to pursue the history of architecture being first awakened when in the 1930s his father, a bank examiner in Minneapolis, had taken him along when he had to spend several days in Owatonna conducting the reorganization

of Sullivan's National Farmers' Bank, which the younger Gebhard found architecturally magical.

What kept Sullivan going? What was his secret? My answer is that his ornament was a surrogate for his architecture; that the two existed on complementary planes, and that this is most clearly seen in his house plans. Each of his designs was the result of a problem, in the case of his ornament the pure manifestation of an entirely formal one. In his theater interiors it was a problem of geometric coordination within a single, compressed space. In his house plans it was one of elaborating an array of distinct functional spaces within a coordinating armature, and doing so processionally so that one experienced the spaces progressively in moving through them just as their design and ornament had been progressively elaborated in Sullivan's mind as he created them.

The conventional historical focus on the 1890s and Sullivan's skyscrapers has reinforced a functionalist interpretation of Sullivan's enterprise. What we need to do here is to focus instead at the moment around 1910 when Sullivan was fifty-four and (at least in his ornament) at the height of his powers. It was a confusing time. He had rid himself of a series of what had become incubi: the house on Biloxi Bay (sold in 1908), his unhappy wife (who left him in 1909 and divorced him in 1917), the weight of his furniture and fancy possessions (auctioned off on November 29, 1909), even his faithful but meddling chief draftsman, George Elmslie. The month after the auction he made the acquaintance of Dr. George Dute Arndt in Mount Vernon, Ohio, stayed with him for a thorough course of physical and psychological therapy, came away to write his friend and client Carl Bennett on January 4, 1910, about how restored he felt.

Upon our arrival…I was practically all in. After 3 days of intense suffering, mental, moral and physical, I began to mend and my progress was wonderfully rapid. At the end of 2 1/2 weeks I was practi-

cally normal, my courage, strength of nerve body and brain had returned… Strange as it may seem to you I feel a powerful sense of relief, now that I have survived the crisis. I am prepared to wipe out the past and face reconstruction in whatever it may take, provided only it furnish an outlet for my long pent-up aggressiveness and productivity.[3]

The Auditorium Tower drafting room was no longer as empty as before: Parker Berry was hired to replace Elmslie, followed by an office boy and draftsman Homer Sailor from the Armour Institute of Technology, and later Adolph Budina.[4]

And Sullivan had work—a motley scattering of jobs, but even these were helpful because more elastic design strategies were required for dealing with space and (for him) unaccustomed problems. These buildings include the Harold and Josephine Bradley House in Madison, Wisconsin (1909–10)[5], the Carl K. Bennett House in Owatonna, Minnesota (1912)[6], St. Paul's Methodist Church in Cedar Rapids, Iowa (1910–12 but executed in unornamented form by another architect in 1913–14),[7] the John D. Van Allen & Son Store in Clinton, Iowa (1911–14),[8] and the Merchants National Bank in Grinnell, Iowa (1913–15), followed by the Home Building Association in Newark, Ohio (1914–15) and the Peoples' Savings and Loan Association in Sidney, Ohio (1916–18).[9] This is a mixed group. The banks are usually treated separately in histories and put in the context of an evolving sequence of such structures starting with the National Farmers' Bank in Owatonna, Minnesota, designed as early as 1906[10] (in compositional strategy a throwback to the Wainwright Building and the Getty Tomb of 1890) and terminating with the Farmers' and Merchants' Union Bank in Columbus, Wisconsin, completed in 1920. It is not a functional type developing over time, however, that I wish to explore, but rather the problem of design strategy. Here a synchronic analysis is helpful, especially one

that begins with what seems the least characteristic and most opaque of the whole group: the Carl K. Bennett House project of 1912.

The Bennett House: "A Flower Opening Its Petals Toward the Sun"

Sullivan's design for Carl K. Bennett (the patron of his 1906 National Farmers' Bank) embodies an extraordinary vision of an American upper middle-class dwelling (figures 107–109).[11] Externally, it would have presented itself northward to Main Street as a tall, three-story, windowless mass banded (from bottom to top) in Roman brick, redwood, and stucco, marked by two pylonlike chimney stacks and a low entrance block. But southward to the deep backyard opening into the grounds of the neighboring Pillsbury Academy the mass would have opened in continuous bands of windows. Mrs. Bennett later explained:

Mr Sullivan's conception of our home was that it should be like a flower opening its petals toward the sun so he made the south side of the house mostly windows, and the north wall had *no* windows as I remember it.…

[His] reasons, aside from the artistic notion, were (1) the climate—much sunshine and very cold north winds—and protection from the public gaze (it was the street side); (2) *much space* on the south and [a] very interesting view of [the] Pillsbury [School] Campus and of its activities.

But his main idea is that he wanted this residence to be like a flower opening toward the sun in a location where there was so much space that there was nothing in the way to prevent the sun from shedding its kindly rays on the "flower" as it opened to receive the sun's blessing.

We thought this a very beautiful conception

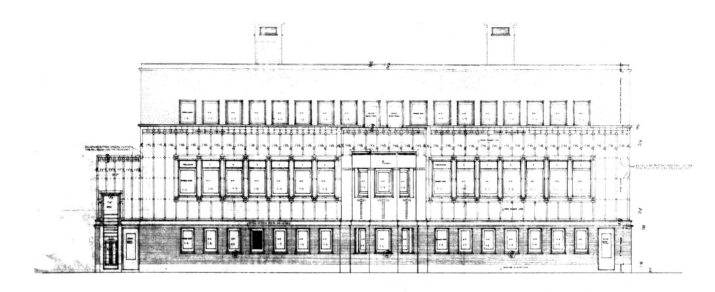

FIGURE 107 and (below right) 109. Project for Carl K. Bennett House, Owatonna, Minnesota, 1912, south façade, main floor plan.
(Art Institute of Chicago)

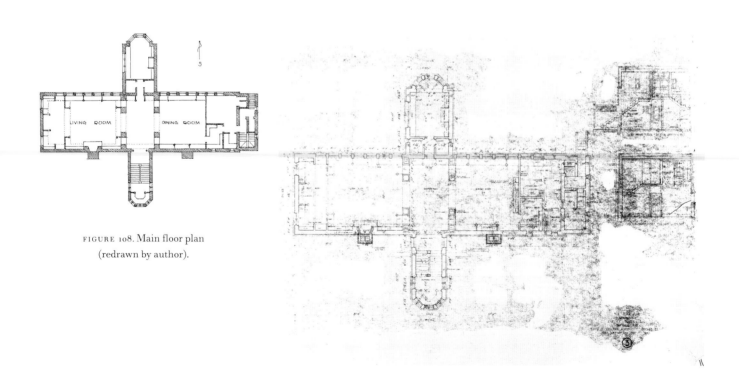

FIGURE 108. Main floor plan
(redrawn by author).

indeed and were in love with all its implications....It was a bitter disappointment that we were never able to build and occupy that house.[12]

Inside, the main, middle-level of the rectangular block is one great axial space, marked on the plans as "living room" at one end and "dining room" at the other. A "reception hall" is placed in between where the minor axis intersects, opening to a "den" in front (south) and the entrance stair behind (north). From the top of the entrance stair, climbing in two runs from a low vestibule at the ground level, the house's interior would have spread itself out left and right, the eye carried along by a continuous window band facing south. Sullivan transformed the glare and inarticulateness such an arrangement might have created by elaborating the wall enclosing this interior into a thick, compartmented carapace extending some three feet within the window line, producing a dense, pocketed wall all around. Into this wall the incidents of domestic life are inserted and geometrically disciplined: fireplaces, bookshelves, sideboard, window nooks. At the reception hall this diaphanous interplane crosses the space twice as a screen, left and right, to define (without enclosing) the functional zones.

There are three qualities in this design that the bank designs do not prepare us for: its layout across an open space as a composition of intersecting prismatic volumes; its thick perimeter wall, pocketed to become an annular space in itself and a transition between inside and out; and its creation of a panoramic spatial experience, here on a floor raised up to become a sort of *piano nobile*. The first and last of these qualities we see even more dramatically developed in Sullivan's contemporaneous church design; the latter two appear in his house designs from as early as the James Charnley House of 1891.

In St. Paul's Methodist Church, designed in 1910–12 (figures 110–112) for an open site similar to that of the Bennett House, we glimpse something of what might

have resulted there in three dimensions had the house been erected. The church is tall and boxy but, with its complex program, it is elaborate and even baroque in its contrasting volumes: a precisely semicircular worship hall set against a prismatic Sunday School block, with a very tall, thick, bare tower resolutely rising on axis as well as two entrances and stair blocks perversely and ornamentally projecting on the 45-degree diagonal axes. In the articulation of these volumes (which in execution by another architect consists only of the window pattern and box-lid roof) nothing is softened; unbroken pilastrades run around the semicircular façade, across the entrance blocks, and down the faces of the school wing, beating out the harsh rhythm of Sullivan's spatial geometry. The experience in the worship hall interior is dizzying.

Compared to the conventional Gothic Revival churches of the Midwest around 1910, this building is astounding, and in the same ways as the Bennett design. What was Sullivan trying to accomplish? In his center-city buildings, form could only follow function across a vertical plane pushed up to the lot line, as in the Wainwright and Guaranty buildings or even the Owatonna Bank. Here, at Cedar Rapids and Owatonna, on open sites, he got a chance to enclose function volumetrically, and he produced block compositions externally and panoramic spatial experiences internally, linked together through thick, pierced walls. Sullivan would have learned this method of manifesting a building as an array of characteristic volumes first at MIT and again in Vaudremer's atelier at the Ecole des Beaux-Arts.[13] This prejudice for tightly compressed, rhythmic compositions ordered by intersecting axes—with eight axes preferred at St. Paul's over four—as well as the use of thick, pocketed *poché* walls were all temptations that the stronger, French-trained designers of Sullivan's generation had succumbed to—for example, Ernest Flagg in his 1892 design for the Tilden Trust library (figure 99). What is extraordinary here is the relentlessness of Sullivan's geometri-

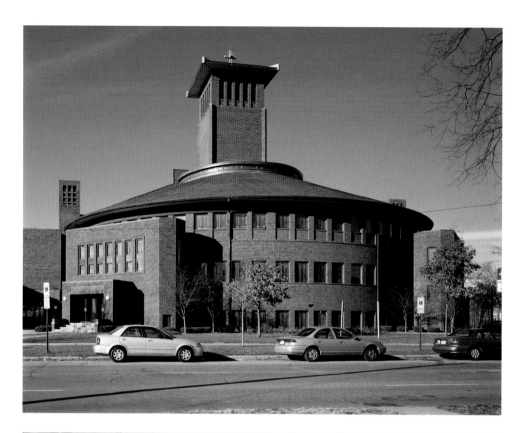

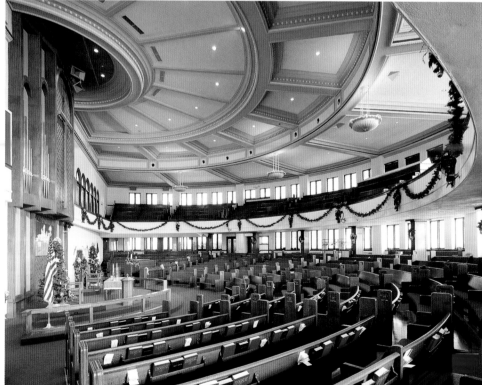

FIGURES 110, 111.
St. Paul's Methodist
Episcopal Church,
Cedar Rapids, Iowa,
1910–14 (executed by
W. C. Jones), exterior,
interior of sanctuary.

cizing, especially in his panoramic windowing of both the Bennett House and St. Paul's Church. Through it he created a powerful thrust outward through the buildings' walls, competing with the firm enclosure of their blocky masses. Sullivan's spatial geometry becomes less a means to clarity and repose than a rhythmic, almost musical elaboration of compression and release—one that Sullivan himself compared to floral efflorescence in speaking to Mrs. Bennett.

The "Architectural Promenade" of the Charnley House

Sullivan's conception of the Bennett house around the experience of a thick wall and a *piano nobile*—a kind of "fanfare for the common man"—appeared first in his work at a very important time, in the house for his close friends the Charnleys built on Astor Street in 1891 (figures 113, 115, and 116).[14] The design dates to Sullivan's moment of illumination in 1890–91 but it has been difficult to analyze because it is so compressed that its central experience and wonder, the second floor, competes with the spaces of the ground floor which are in fact merely preliminary, as their dark, arcaded treatment indicates. Immediately across from the deep entrance passage, one mounts the stair through an archway and behind a wall, emerging on the second floor around a wooden screen to be presented with the full tableau at the head of the stair (figure 116): first the diminutive top-lit "courtyard" at the heart of the house whose lower arcade has already been traversed to get to this point, then a broad, glazed, bench-flanked penetration of the thick front façade, and finally the balcony opening beyond, partly sunk into the façade's Roman brick mass and partly suspended out into Astor Street providing vistas beyond its squat Greek columns over the frontyards and down the crossing streets at this fortuitously skewed corner. This formal architectural promenade is easy to miss within the house, because it embraces the normally pri-

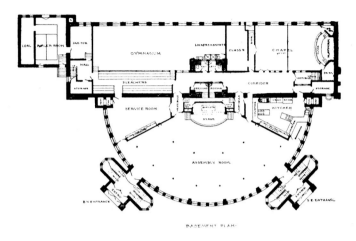

FIGURE 112. St. Paul's Methodist Episcopal Church, plan. (*Brickbuilder*, 1914)

vate, bedroom floor and also because a conflicting axis of attention is created on the ground floor by the living and dining rooms. In these rooms a Mediterranean vocabulary of arches, screens, and balconies is replaced by the conventional American one of square doors and windows. These conventional, boxy spaces work as architectural afterthoughts in the promenade in, up, and out to the balcony through what the French called "circulations."[15] These "circulations" at the Charnley House are elaborated to become not just a system of links but also a work of spatial architecture in themselves.

This architectural promenade has its destination in the balcony and labors to reach it through what Sullivan has shaped into a very thick, pocketed wall toward Astor Street. He would seem always to have had a sense of thick façade walls, in his loft façades of the early 1880s and in his early houses, like that built for Ann Halsted on Belden Avenue in 1883 (figure 114). Sullivan's original plans now at the Art Institute show 24-inch-wide, 4-foot-deep piers marching across the front (as in a loft façade), closed toward the street to contain the parlor and dining room

FIGURE 113. James Charnley House, 1365 North Astor Street, Chicago, 1891–92.

opposite
FIGURE 114. Ann Halsted House, 440 West Belden Avenue, Chicago, 1883.

spaces and open in the center bay as a broad vestibule. On the second story the wall plane drops to the back of these piers while, left and right, it is brought forward in two-sided bay windows whose brick center posts are carried on the expansive parlor and dining room window arches below. The façade is thus encased in a consistent structural cage accommodating the house's spatial contents: the bedroom bays above; the parlor, dining room, and vestibule spaces below. The composition is quite simple but is structurally "alive" as a plain brick front plane holed through for light could never be.

During the twenty years that separated the Charnley and Bennett commissions Sullivan produced a series of powerful house designs, always with emphatic interior *enfilades*, thick walls defining a spatial geometry, and in two cases an approximation of the elevated *piano nobile*. In 1898 Sullivan sent Albert W. Goodrich a project for a large house to be built at Harbor Springs, Michigan (figures 117–120).[16] It seems an expansive elaboration of the Charnley paradigm, wood-framed and shingled as was appropriate for a summer resort near Mackinac. It was laid out around a broad, square hall defined by thick walls excavated on four sides to embrace the entrance stair, and (across from that) a "nook" and bench. To the right on entering the hall was a dramatic circular dining room, to the left a living room open in a band of windows out the front and downhill. These two principal chambers did not, however, extend out to the surface of the enclosing shingle envelope but rather were set in from it to permit a gallery across the front and another around the dining room at the rear, beyond which the building mass achieves a simple rectangular shape, a geometric block embracing the *piano nobile*'s spatial volumes. At the third-floor level that block is holed through again with a gallery that runs around the entire building below an extending hipped roof, the shadowed back wall articulated by a continuous arcade of windows.

After the A. W. Goodrich House came a project for a

"cottage" for Cyrus McCormick's widow, Nettie Fowler McCormick, in Lake Forest, dated August 1901; then the Henry Babson House built in Riverside, Illinois in 1907–9 (figures 121–123).[17] If in the Goodrich House the powerful spatial geometry is tightly restrained, in the McCormick cottage it ebbs momentarily (appearing chiefly on the upper floor in the monumental octagonal hall heading the axial stairway and binding the spaces of the domestic level dramatically on its eight axes), to surge back and even break through the confining block at the Babson House. The privileging of the "circulations" in the Charnley House became the gathering of the whole interior space into a single, grand *enfilade* in the Goodrich design along which the individual rooms are incidents (not exceptions, as in the Charnley living and dining spaces). In the Babson House a battle is fought between an even more resolute *enfilade* and what we are told was the client's insistence that some distinction between the rooms be made. In an interview with Richard Nickel, Babson said that he refused to have the sort of

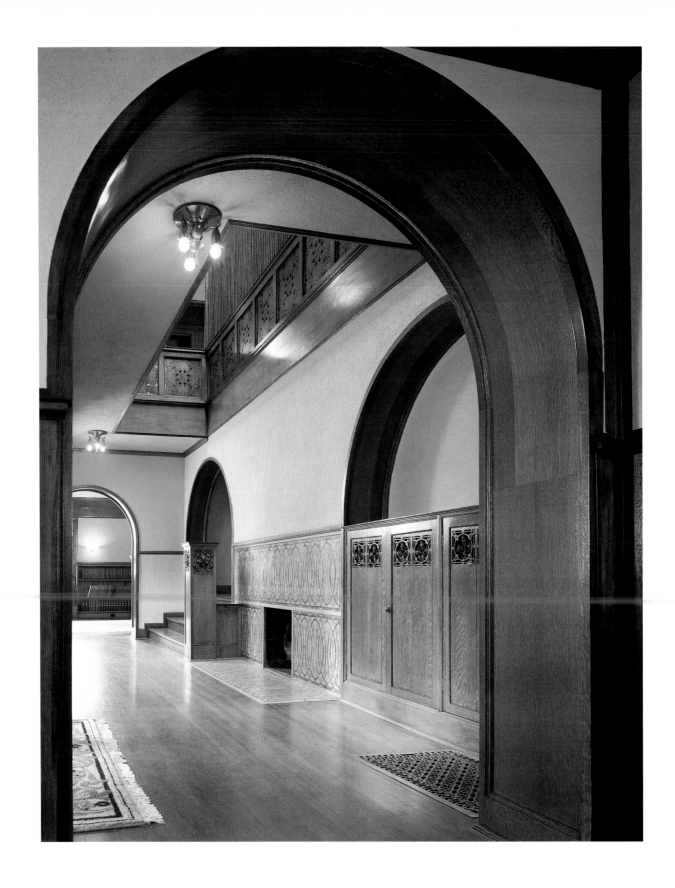

FIGURE 115. James Charnley House, Chicago, 1891–92, interior, looking from the dining room into the central hall.

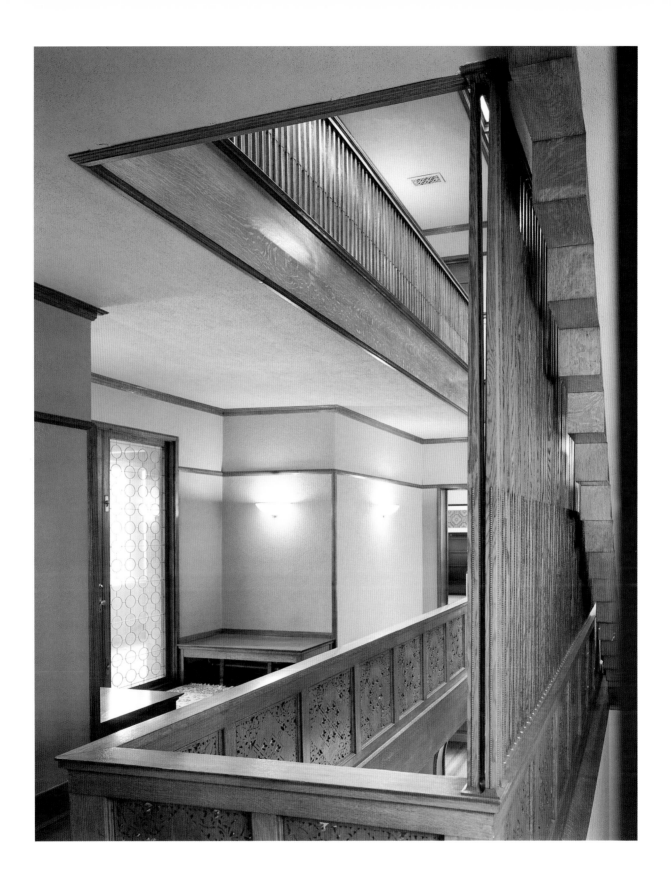

FIGURE 116. James Charnley House, second floor hall looking out toward balcony.

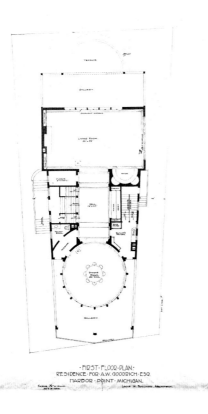

· FIRST · FLOOR · PLAN ·
RESIDENCE · FOR · A.W. GOODRICH · ESQ.
HARBOR · POINT · MICHIGAN.
SCALE ... Louis H. Sullivan Architect.

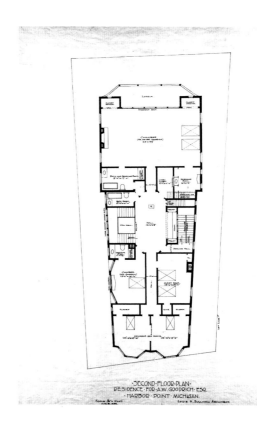

· SECOND · FLOOR · PLAN ·
RESIDENCE · FOR · A.W. GOODRICH · ESQ.
· HARBOR · POINT · MICHIGAN.
SCALE ... Louis H. Sullivan Architect.

house where one can see all the rooms from one place.[18] (The Goodrich plan indicates this was the sort of plan Sullivan was likely to have advocated.) Sullivan would seem to have compromised by putting in a fireplace to close off the axis at the dining room while adding a corridor along one side, almost as an afterthought. The stair to the second floor rises from this corridor at the entrance vestibule; thus the architectural promenade cannot achieve the power it does in the Charnley or Goodrich houses. The stair ends in a corresponding gallery above where it explodes into an upstairs sitting room worthy of the Charnley House, a half-octagonal bay at one end projecting an axis across the entire house and out onto an expansive balcony that dominates the façade when seen from the street (figure 121). The Babson House is peculiar in having stood as a neighbor and competitor to Frank Lloyd Wright's contemporaneous Coonley House in Riverside, to which a critic in the *Architectural Record* judged the Babson House to be superior in the efficiency with which it produced its effects.[19]

The Bradley House

One quality consistent in the spaces of Sullivan's houses from the Charnley to the Babson is their insertion in an embracing rectangular prism through which the major and minor axes struggle. Beginning in 1909 his interior spaces finally freed themselves from this restraining carapace, emerging in a series of cross-shaped plans in the two Bradley House projects and the Bennett House design (figures 107–9; 124–129). These compositions are no less processional, centering on a space just beyond the entrance point, enclosed in thickened *pochéd* walls, projecting dramatic axes forward and to each side, manifested externally as juxtaposed volumes. Sullivan's walls are thick, the windows deeply inset, and his masses can be marked with cantilevers like those over the porches of the erected Bradley House—not floating in the manner of Wright's Prairie Style but laboring with elaborate brackets to express the work of opening the interior space outward.

The Bradley House, in both its preliminary and its

·NORTH·ELEVATION·
RESIDENCE·FOR·A.W.GOODRICH·ESQ·
·HARBOR·POINT·MICHIGAN.
SCALE ⅛"=1 FOOT. Louis H. Sullivan Architect.
AUG.10.1898.

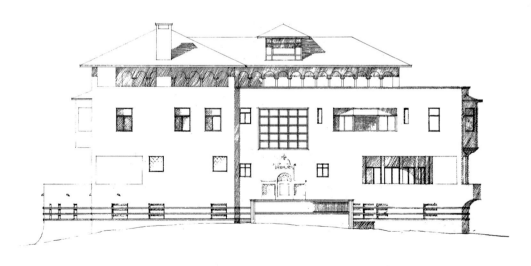

·WEST·ELEVATION·
RESIDENCE·FOR·A.W.GOODRICH·ESQ.·
·HARBOR·POINT·MICHIGAN.
SCALE ⅛"=1FOOT. Louis H. Sullivan, Architect.
AUG.10.1898.

FIGURES 119, 120.
Project for Albert W.
Goodrich House, Harbor
Point, Michigan, 1898,
north and west elevations.
(State Historical Society of
Wisconsin)

opposite
FIGURES 117, 118.
Project for Albert W.
Goodrich House, Harbor
Point, Michigan, 1898,
main and second-floor
plans. (State Historical
Society of Wisconsin)

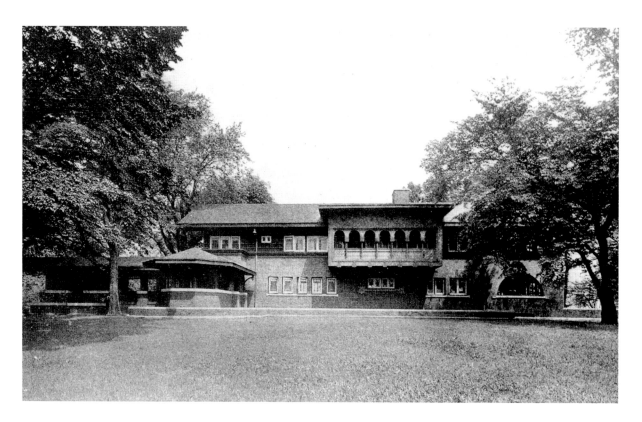

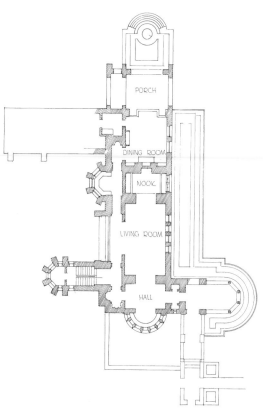

executed version, is the most complex and powerful of
Sullivan's domestic series. In both projects Sullivan set a
rectangular mass east–west along the south side of the
site on a hillside sloping diagonally up from the street
corner at Prospect and Van Hise to the lot's back, so that
the main block flies out over the hilltop neighborhood.
(Frank Lloyd Wright in his nearby Gilmore House of
1908 treated this accidented bit of glacial topography
even more dramatically, earning his house the name "the
airplane house.") Sullivan lifted the second story of his
house onto piers holding it over the *enfilade* of the first
floor and its high brick basement. It is the main *enfilade*
squeezed between the basement and the cantilever that
is the essence of the experience of the house, a sequence
of spaces defined by layered walls-within-walls—com-
partmentalized walls that were implicit in the Babson
House of two years earlier and explicit in the Bennett
project of two years later. These define spaces that are
harmonious and identical in their geometry yet func-
tionally adapted in their secondary incidents. In
Sullivan's initial Bradley House project, (figures 124 and

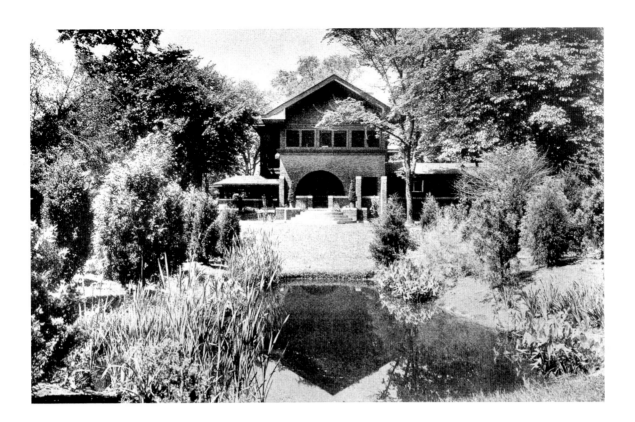

125), a narrow entrance entwined with the staircase opens first into a large entrance hall embedded within thick, pocketed walls, then leads beyond into an expansive living room that thrusts its space across a window wall out to a half-octagonal porch commanding a view downhill. A cross-axis at the entrance hall opens to the left onto an elaborately shaped dining room—a square with intersecting hemicycles and a half-octagon—and to the right onto a "den" with a half-octagonal porch beyond. As in the Charnley and Goodrich designs, the entrance hall is the heart and key of the composition: suddenly encountered from the door, windowless, thick-walled, but offering three very distinct vistas out to light and to porch views.

The Bradley preliminary design is the one surviving set of drawings in which Sullivan's construction of his plan can be followed. First he laid out the axis and cross-axis, then he marked points along them from which the space of the different rooms was generated by centrifugal diagonals. After this he erected secondary cross-axes that strike the room perimeters to determine the centers

FIGURE 123.
Henry Babson House, Riverside, Illinois, 1907–9. (*Architectural Record*, October 1911)

opposite
FIGURE 121.
Henry Babson House, Riverside, Illinois, 1907–9. (*Architectural Record*, October, 1911).

FIGURE 122.
Henry Babson House, plan redrawn by author.

for semicircular or octagonal outward extensions on these rooms' exterior faces. We have encountered this Beaux-Arts quadraxial method before. What is significant here is seeing Sullivan applying it to the elaboration of a complex plan. Examination of Sullivan's two sheets reveals that the centers of the principal rooms are fixed by two concentric squares erected around the intersection of the major and minor axes and whose lines are picked up in

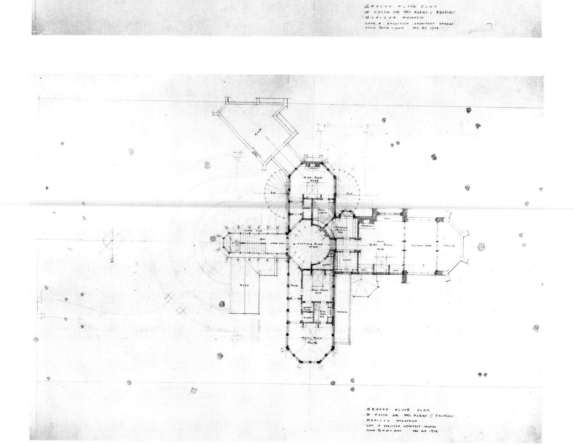

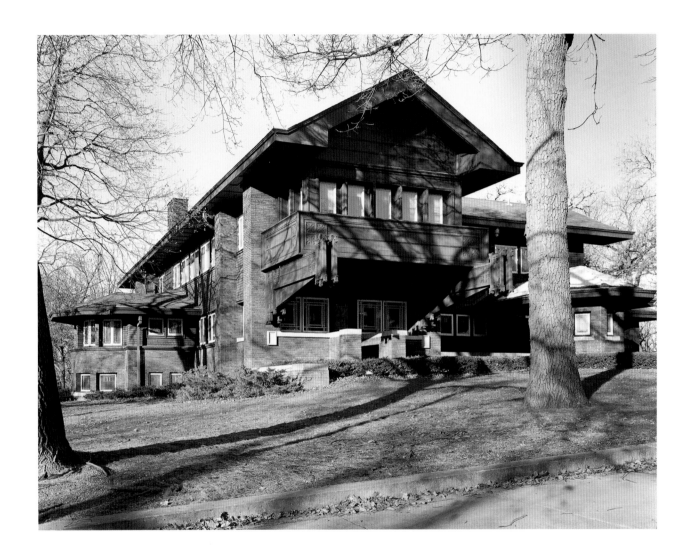

FIGURE 126. Harold and Josephine Crane Bradley House, 106 N. Prospect Street, Madison, Wisconsin, 1909–10.

opposite

FIGURE 124, 125. Preliminary project for Harold and Josephine Crane Bradley House, Madison, Wisconsin, 1908, main and second-floor plans. (Northwest Architectural Archives, University of Minnesota)

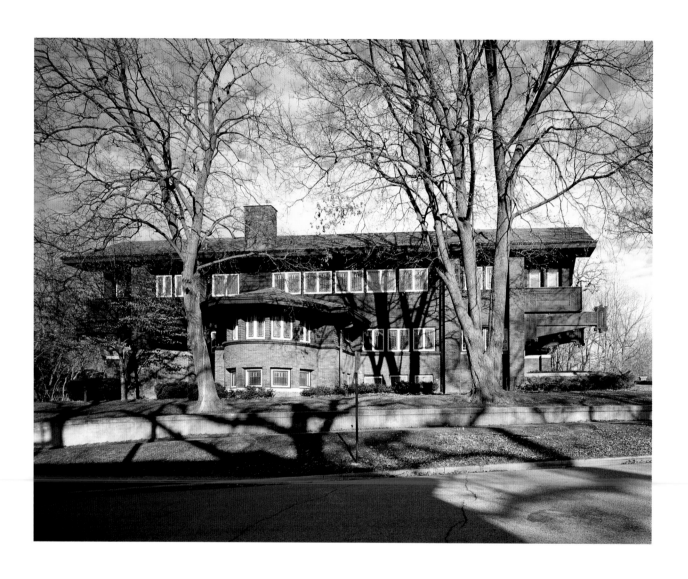

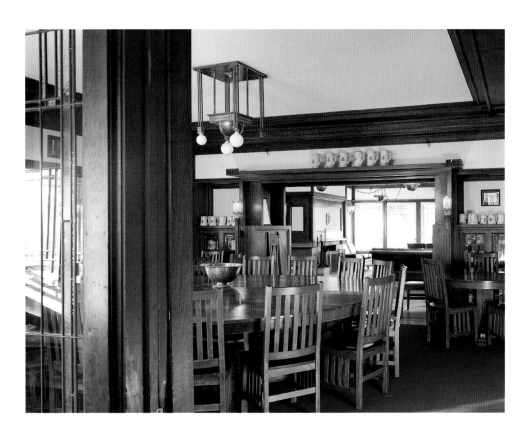

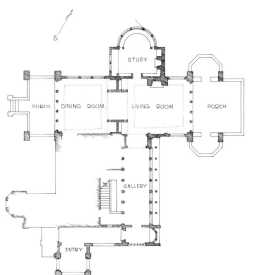

FIGURE 128. Harold and Josephine Crane Bradley House, Madison, Wisconsin, 1909–10, interior looking across dining room into living room.

FIGURE 129.
Harold and Josephine Crane Bradley House. Plan redrawn by author.

opposite
FIGURE 127. Harold and Josephine Crane Bradley House, 1909–10.

the semicircular formal garden borders Sullivan indicates in front of the house. This is an appropriation of a Beaux-Arts plan construction in which the garden indicated around a building plan is made to reflect the geometric construction underlying the interior spaces. The objective was to achieve unity of parts and of effect. Lawrence Harvey, an astute English student at the Ecole writing in 1870 (four years before Sullivan's arrival there) explained:

> The history of France is the history of centralization....Given an object of thought, and a French thinker there and then casts about for some dominant feature whereon to hang bright hints and ingenious speculations....
>
> Now, architecture, which might be defined as *the art of arranging parts*, is, of all arts, the most likely to be swayed by the French spirit of centralization; so it occurs that a French building is, as a rule, the organic outgrowth of *one* idea. Every portion, every ornament of the building,—ay the very ground it stands on and the gardens which surround it,—subserve that idea or purpose.[20]

It was Sullivan's selective understanding of the Beaux-Arts system that he would seem to have been referring to when he wrote to Claude Bragdon in 1904, "I believe I absorbed the real principles that the school envelops, so to speak—my work has constantly shown this."[21] Unity of graphic construction in Sullivan's house plans was matched by the panoptic spread of interior space that resulted. Standing at the door of the Bradley House project (or at the top of the entrance stair of the Bennett House design), one would indeed have had a response to Ecole Professor Gromort's admonition, "One need never ask one's way in a properly designed building."[22]

Caution—either aesthetic or financial (this was a wedding present from a wealthy father-in-law, Richard T. Crane)—reduced the cross-axis in the executed Bradley House (figures 126–129) to an entrance gallery and "den" projecting downhill through a window bay and drew the principal spaces of the structure into a two-room *enfilade*. This is joined by a compartmented cross-wall and culminates at each end in porches below second-story cantilevers. In the house in three dimensions, however, we can experience how such an axially generated design feels, and we find that the result is the processional experience of space first manifested in the Charnley House and foreign to Wright's compartmentalizing pinwheel plans of his Prairie Style.

The entrance-study cross-volume that increasingly appears in Sullivan's plans, especially in the Bradley and Bennett designs, might seem an adoption of Wright's spreading layouts, but I have tried here to show that there is a consistent elaboration of a processional construction in Sullivan's interiors that makes them the opposite of Wright's schemes, which are cut into compartments by a central chimney stack. This quality in Sullivan's interior planning hints at how we should read his exteriors: not as a balanced pinwheel but divided into a dominant block—one as solid as the Wainwright Building of 1890–91—penetrated by a smaller subordinate block at right angles to it. That subordinate cross-volume contains the path of movement and point of prospect: on one side of the major block the entrance and stairway, on the other side the study with its panoramic windows. The subordinate block is complexly shaped and active, the major block cubic and passive—the subordinate block is a disruption of the monumental stasis of the major one. This privileging of a disruption had already appeared in certain of Sullivan's skyscrapers of the 1890s like the Stock Exchange and the Carson Pirie Scott Store (figures 70 and 3), where a specific social function animated what would have been a passive block of rental space, as well as in Sullivan's late ornamental sheets where he sometimes consciously played one theme against another (see

figures 164 and 166). In Sullivan's house designs this active/passive balance of the circulations and the functional mass is what had already in 1891 created the most riveting external mark of the Charnley House, the balcony with its heavy Doric columns illogically founded on a bracketed overhang. The foundation of the conventional misreading of Sullivan's work has been the refusal to see it spatially, as the architectural enframement of an experience of movement to a goal, in spite of the theme of movement proclaimed in his ornament.

The Banks: Sullivan's Sensitivity to Clients and Sites

If Sullivan's house clients were sometimes taken aback by the resulting designs, it was not because Sullivan had refused to think his designs through, as the surviving Bennett correspondence proves and Richard Nickel's interviews with Babson, Bradley and Bennett document.[23] We get an even clearer glimpse of Sullivan's relation to his clients in his contemporaneous bank commissions (figures 5, 106, 130–138, 143–155). Sullivan treated the bank presidents and their directors with increasing familiarity as his own fortunes declined, from Bennett in Owatonna to the Wheelers in Columbus.[24] They, in turn, responded to the care he showed for the individuality of each problem and to the staggering beauty of the results.

These late banks were cited in the introduction in terms of their ornament and its relation to their massing, but there was more to them than that. There are stories in almost every town involved of the attentive if garrulous architect arriving and shaking out of his sleeve something logical, individual, and absolutely amazing. Of the Grinnell design (figures 143–146), Andrew Rebori related:

> After meeting the committee, he set about the customary task of learning the needs of the proposed building, not in a casual way, but in the most de-

tailed manner possible....For three whole days he talked and drew, rubbing out as changes were made, fitting and adjusting to the satisfaction of all....I asked Mr. Sullivan how it happened that his preliminary sketches were worked out in such a definite manner, and he answered quite simply that, "those were the requirements as given, and it only remained to jot them down on paper," which he did, using sheets of yellow paper available at the time.[25]

Of the Sidney bank (figures 149–152) we are told less sanctimoniously that Sullivan arrived, conferred with the building committee, and then

> Sullivan retired to the opposite corner, sat on a curbstone for the better part of two days, smoking innumerable cigarettes. Then at the end of that time, he announced to the directors that the design was made—in his head. He proceeded to rapidly draw a sketch for them, and announced an estimate of the cost.[26]

The professional critics of the late banks—Montgomery Schuyler, Andrew Rebori, Thomas Tallmadge—emphasize the distinctiveness of each design. On one hand they cite the layout of the Grinnell structure to fulfill specific office requirements or the clerestory of the Cedar Rapids bank (figures 137–138) to solve the problem of sufficient light in the central public space. On the other hand they praise Sullivan's dramatic opening of the whole of these interiors to create a "democratic" rather than a compartmentalized layout. It was this functional uniqueness that Andrew Rebori insisted inspired Montogmery Schuyler's 1912 declaration, "a new work by Louis Sullivan is the most interesting event which can happen in the American architectural world to-day." "It is an architecture of pure intent," Rebori wrote in 1916,

with form following function as its basic princi-ple....The great lesson that Sullivan's work teaches is not one of detail or ornament, but one more com-prehensive in which the solution of a particular problem is given artistic and practical expression. It is in his analyses of the conditions at hand and in the straight-forward and brilliant manner by which conditions are made to function that the works of this master architect fairly stand out in all their big-ness. It is the expression from within outward, or as Sullivan himself so aptly puts it, "mind over mat-ter."[27]

As Rebori emphasizes, Sullivan's solutions to the same problem were parallel, diverging on such issues as the lighting of the banking hall or the arrangement of the director's office and the women's lobby. Beyond this, Sullivan's solutions were to embody the institution's importance with an overscaled block embracing a single "democratic" space, the narrow street end composed around a door (almost always arched), the side elevation composed around a window wall, either gridded or arched. Like his earlier theater interiors or his capitals in the Auditorium hall, what is extraordinary is the varia-tions that Sullivan worked upon a narrowly defined type.

Unlike the houses, all Sullivan's banks were built and survive today. Visiting the towns in which they are locat-ed, one is impressed with the way in which Sullivan adjusted his buildings to their settings.[28] The Owatonna structure (figures 106, 130–136) serves as a marker or pylon at the point at which the town's main street opens onto a square, rising above the two-story texture of its surroundings and harmonizing with a single three-story block across the street—repeating the tall masses of the city hall and county courthouse that rise on the opposite side of the square. In Columbus (figures 153–155), the bank again terminates the main street, in this case extending its broad arcaded side to a small park in front

of the public library with a modest Civil War monument sandwiched between. When viewed from the library steps the monument is enframed by the side arches of Sullivan's bank in a public gesture of urban generosity.

Frank Lloyd Wright insisted that he opened his Prairie houses to their environment, but that environment was a generalized, "natural" one embodied in sunlight and the unbroken horizontal plane of the Midwestern prairie. Sullivan's idea of environment as manifest in the banks was a social one. His banks intervene in the history and structure of their towns. They are formal, public, like his houses. As he insisted in *Kindergarten Chats*, buildings are men as much as they are things.

Architecture as Ornament

Only Narciso Menocal has taken Sullivan's houses seri-ously, focusing on those designed after Wright's departure from Sullivan's firm in 1893, although he concludes that they were impossibly uncomfortable. Carl K. Bennett eventually turned to Purcell and Elmslie for an alterna-tive design (but built neither); the Bradleys moved out after five years, into another Purcell and Elmslie house.[29] I find the dismissal of Sullivan's houses by historians too easy. Sullivan asked a good deal of his later clients, but he was equally attentive to the uniqueness of the qualities and character of each project. Nothing pleased him more than solving a new problem. Three of Sullivan's house clients were close acquaintances: the Charnleys (perhaps his closest personal friends), Carl Bennett, and Richard Crane (a client for a string of industrial designs after 1900) who paid for the Bradley House. The problem with these designs was that they were not private but public, formal, open—because designing for Sullivan was not a private enterprise but a public one: the display of his imaginative power.

The elaborateness, freedom, richness of effect—and also passionate exaggeration—of Sullivan's late house

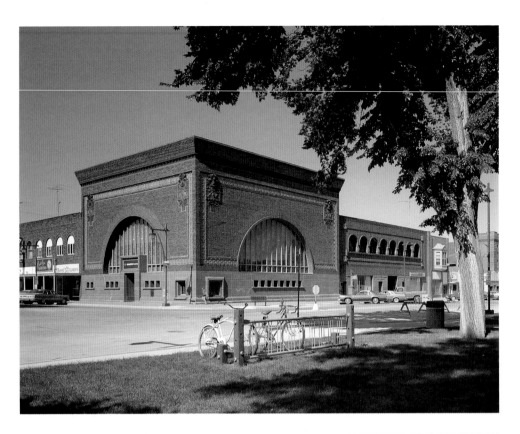

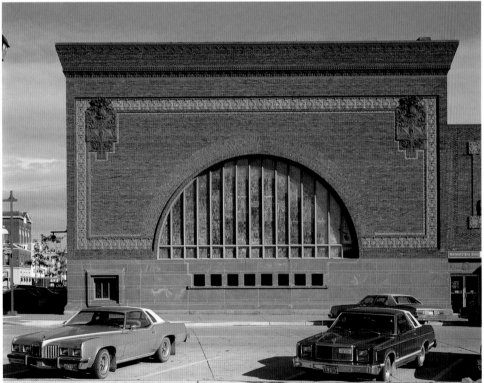

FIGURES 130, 131.
National Farmers'
Bank, Owatonna,
Minnesota, 1906–8.

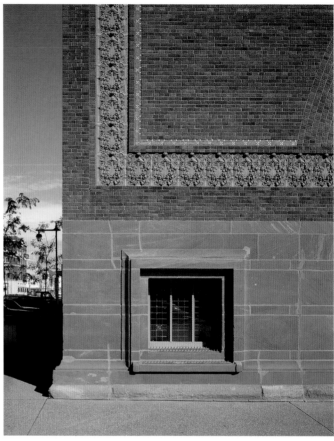

FIGURES 132, 133. National Farmers' Bank, cornice detail, corner detail.

opposite

FIGURES 134–136. National Farmers' Bank, interior views (decoration executed by Louis J. Millet).

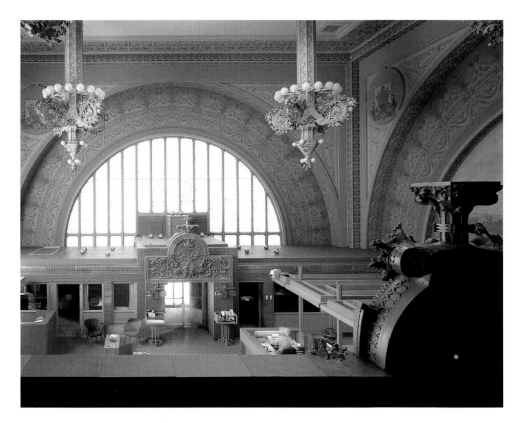

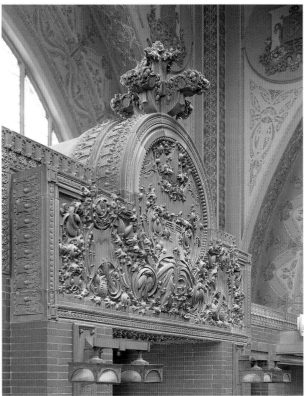

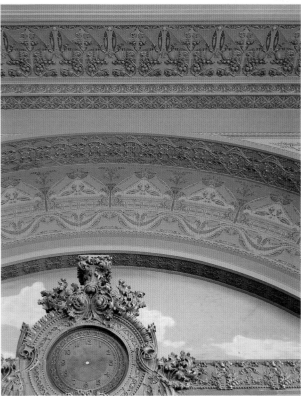

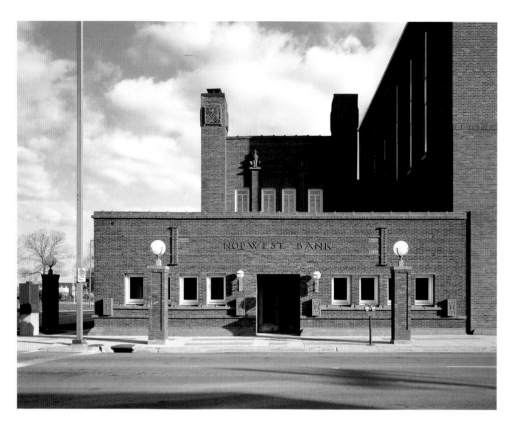

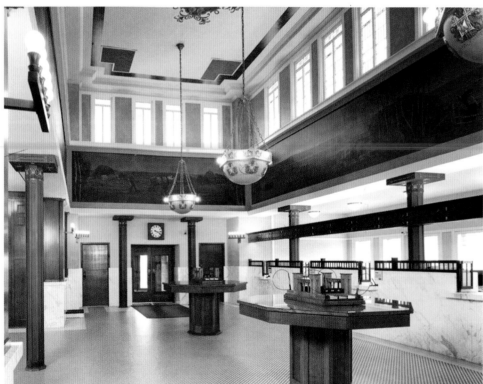

FIGURES 137, 138.
Peoples Savings Bank,
Cedar Rapids, Iowa,
1909–11.

plans permit us to glimpse his achievements from a different perspective than that framed by the conventionally accepted measure: the skyscrapers and the late banks. We see a parallel with his ornamental strategies in his making these plans concentrated statements of artistic individuality. It is not that the house plans reach out to become ornamental, but rather the opposite: his ornament reformulated spatially produces such planning compositions. The examination of his house plans shows their intense effects of immurement, movement down axes, enclosure, and release toward light. The major spaces of his late designs lie buried in layers of pocketed walling. Yet this walling permits glimpses of light beyond—slowly (at least visually) as every six inches is made to evoke plane after plane in these onionlike compositions. As the eye moves over the surfaces, further incidents and accidents show themselves, until we arrive at a great opening, pried out of the mass like the porch in the Bradley House under its bracketed cantilevers.

To appreciate this parallel of plan and ornament it is important to note that Sullivan's was not the usual sort of ornament documented, for example, in Owen Jones's encyclopedic *Grammar of Ornament* of 1856 (with editions until 1910). To Jones ornament was essentially continuous patterning, a motif that carried the eye smoothly over an architectural surface as Claude Bragdon demonstrated with his own system of "projective" geometric ornament beginning in 1915 (figure 157).[30] Sullivan's ornament does not follow this model, but rather that of the arabesque—a moving, twisting line that transforms, struggles, and evolves as it extends—a model that the musicologist Eduard Hanslick chose as the quintessential *topos* of the experience of music.[31] I find this musical analogy especially helpful here because, as Hanslick notes, the fundamental unit of the musical arabesque is repeated compression followed by release. So also in Sullivan's compositions of efflorescences the pattern struggles out of the inert surface, pushes through confining grids and borders, and explodes in a starburst of buds, flowers, and acanthus fronds.

This transformation of the arabesque and its work of striving and escape is fairly clear in Sullivan's ornamental figures or in the Grinnell ornamental centerpiece around and above the bank door, but it is important to gauge its presence in his plans, especially in the most complex of these, his house plans. In this medium the space is confined within the thick walls of the structure, escaping along the axes to mark grand approaches and making the house mass command the disciplined garden spaces. The fundamental objective of Sullivan's domestic architecture, starting as early as the Charnley House, was to enact a struggle outward toward light and air through thick encompassing walls. As we have seen in Mrs. Bennett's interview, Sullivan himself described this struggle toward light "like a flower opening its petals toward the sun," the spatial equivalent of the floral efflorescence or his ornament.

Louis Sullivan's architecture was not French; he picked up only certain aspects of the Beaux-Arts system for which his mind was already prepared, those of constructing a design in disciplined steps and of manifesting in these steps a dominant central idea. Planning, ornament (in the manner of Ruprich-Robert and Dresser), and exterior massing could all be elaborated in this manner. This was an architecture of striving: of solutions for problems of space forcing themselves into shape amid thick, resisting walls; of ornament blooming in efflorescence out of flat surfaces. This architectural concretization of striving was his enterprise. It was to this end that he employed a Beaux-Arts architecture of progressive elaboration. In the brilliance of the initial conceit, in the discipline of elaboration, and in the plenitude of variations the medium made possible, Sullivan found what his particular personality required.

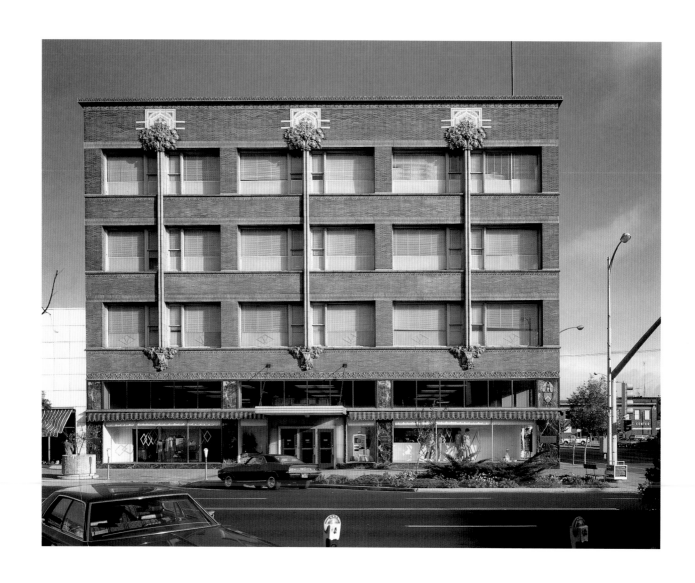

FIGURES 139, 140. John D. Van Allen & Son Store, Clinton, Iowa, 1911–14.

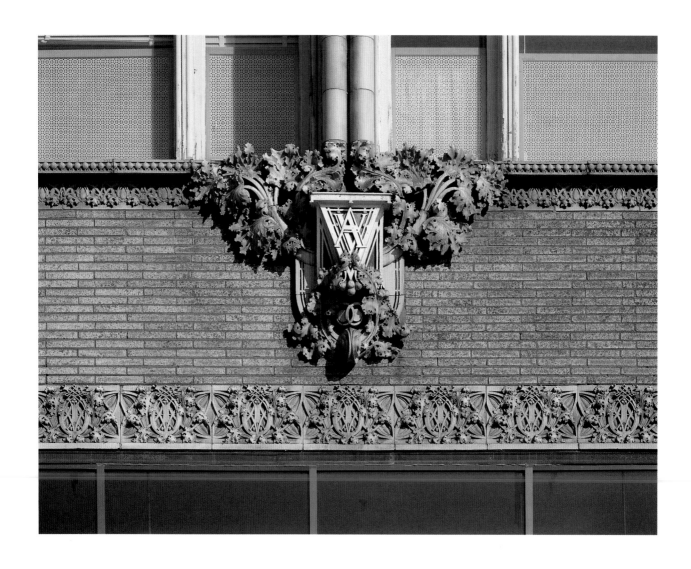

FIGURES 141, 142. John D. Van Allen & Son Store, Clinton, Iowa, 1911–14, lower and upper façade details.

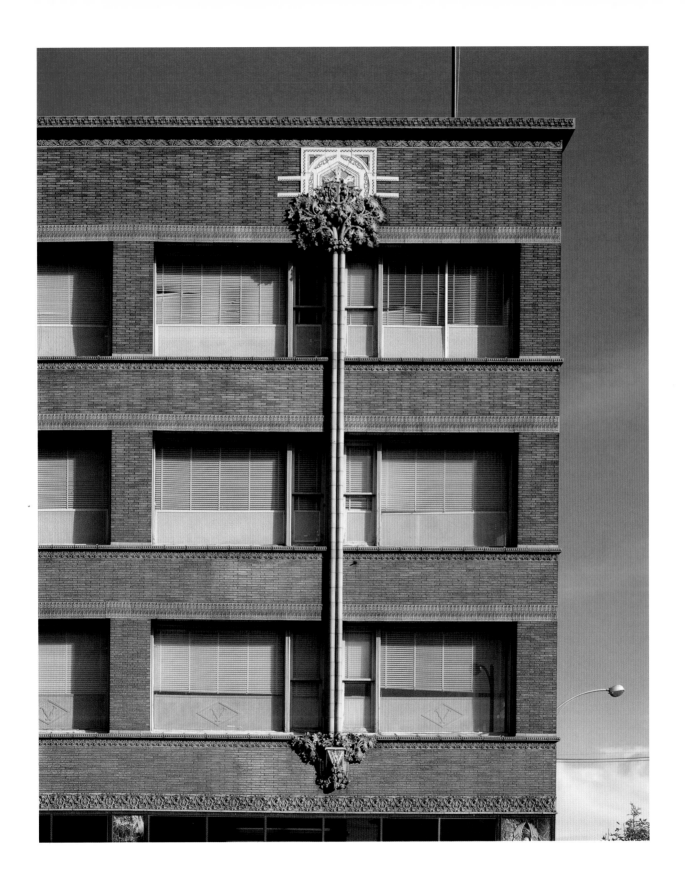

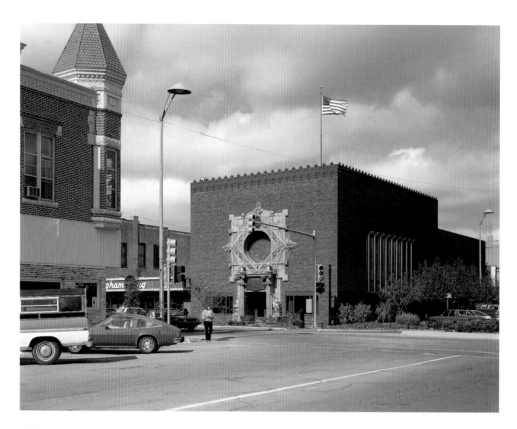

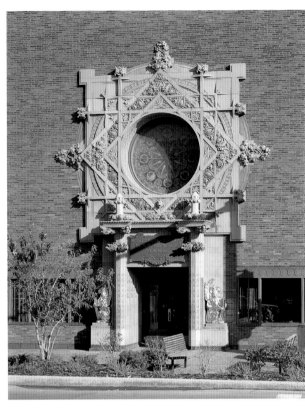

FIGURES 145, 146.
Merchants National Bank,
Grinnell, Iowa, 1913–14, entrance decoration, interior.

opposite
FIGURES 143, 144.
Merchants National Bank,
Grinnell, Iowa, 1913–14, entrance and side façades.

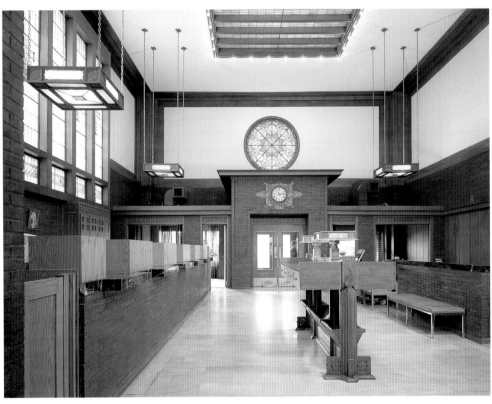

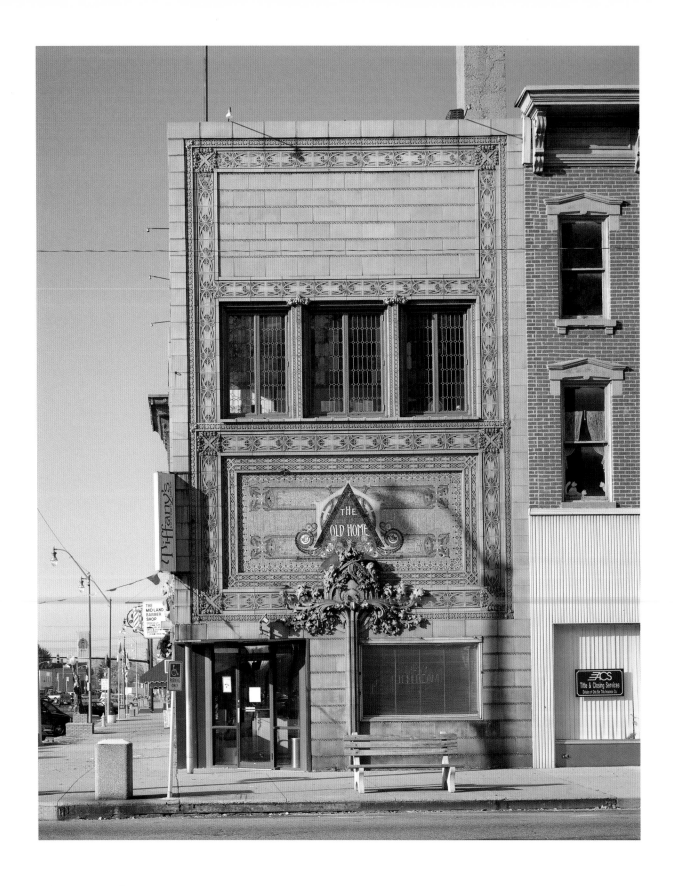

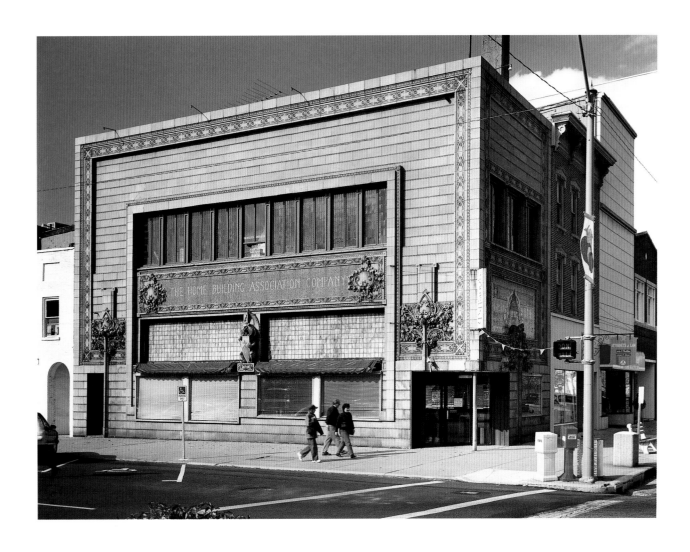

FIGURE 148. Home Building Association, Newark, Ohio, 1914–15.

opposite
FIGURE 147. Home Building Association, Newark, Ohio, 1914–15, façade on town square.

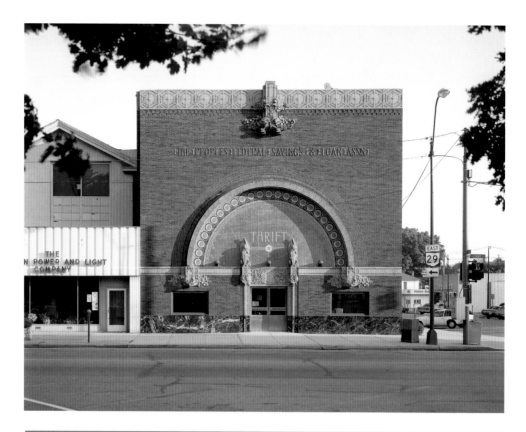

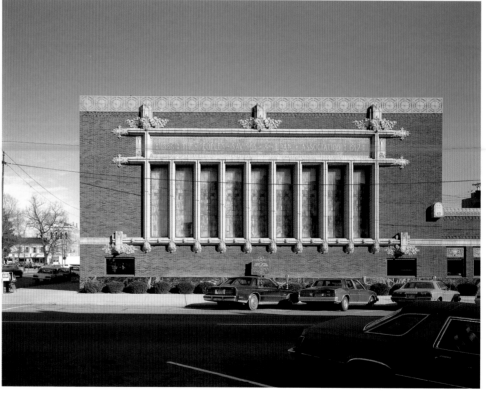

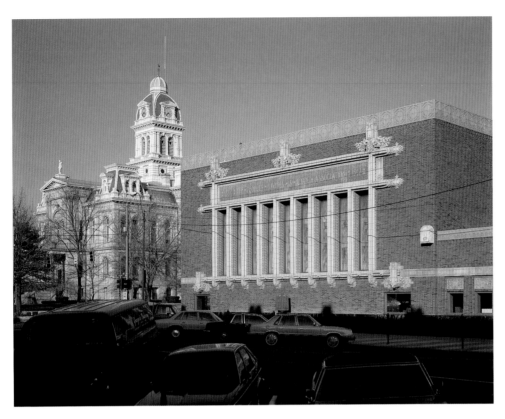

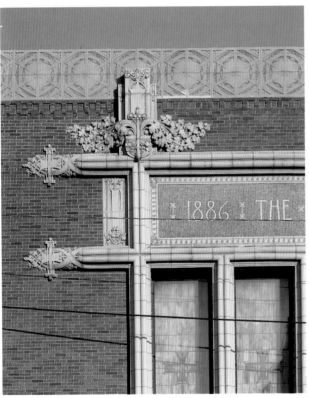

FIGURES 151, 152.
Peoples' Savings and Loan Association,
Sidney, Ohio, 1916–18, looking toward
courthouse, detail.

opposite
FIGURES 149, 150.
Peoples' Savings and Loan Association,
Sidney, Ohio, 1916–18, façade on town square,
side elevation.

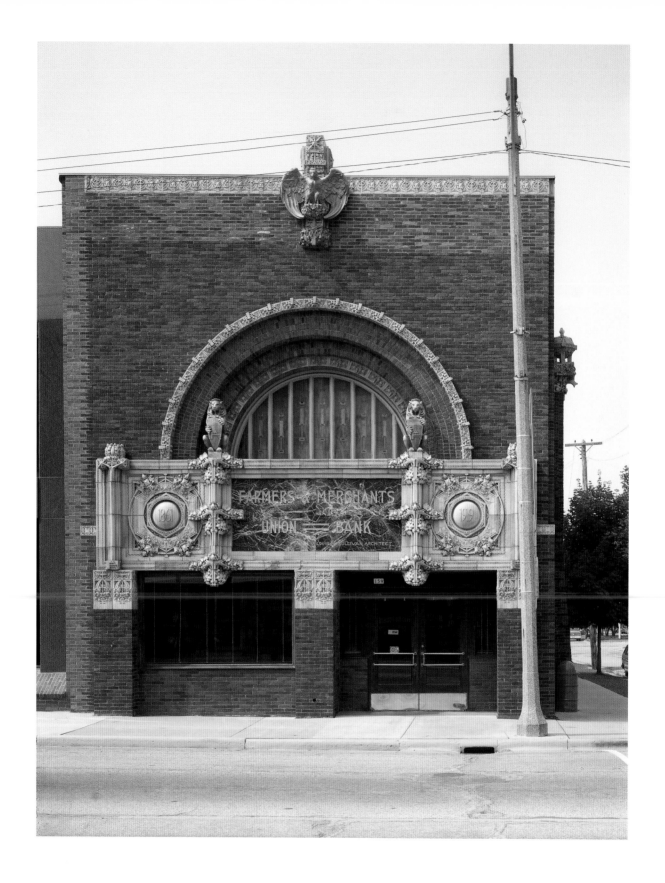

FIGURES 154, 155.
Farmers' & Merchants'
Union Bank, Columbus,
Wisconsin, 1919–20, side
elevation from the steps
of the public library;
detail.

opposite
FIGURE 153.
Farmers' & Merchants'
Union Bank, Columbus,
Wisconsin, 1919–20,
entrance façade.

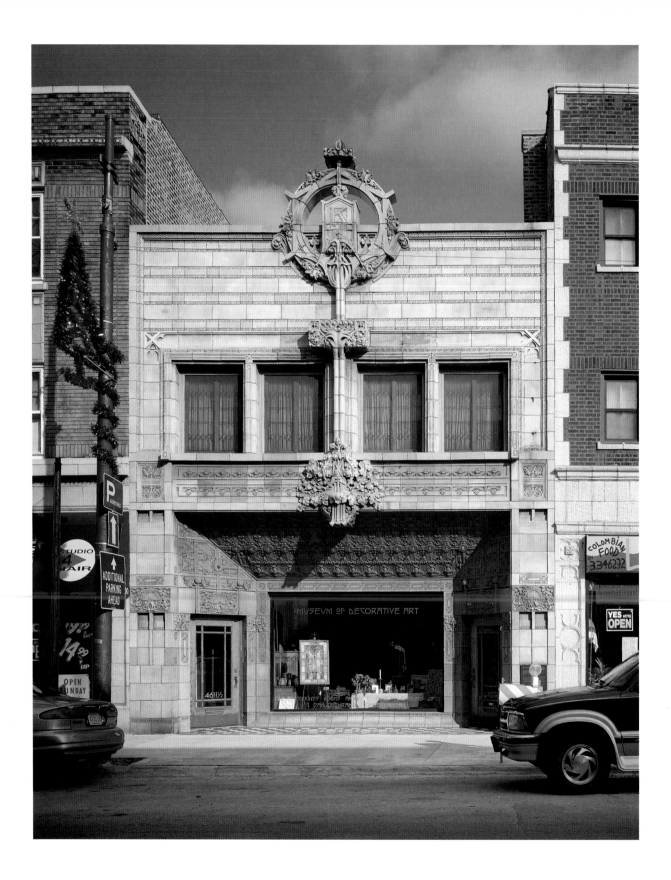

5

FINIS, 1922–1924

The offices of Louis Sullivan occupied the entire top floor of the Auditorium Tower, which he had designed. As I entered I saw a man sitting erect at his desk. His proud head held high, he gazed out into space. The fifty-board drafting room adjoining was without a single draftsman—no secretary, no office force, just Louis H. Sullivan—alone. One glance showed me that he had no work. I would not embarrass him by asking for a job. What would I say to him? I had always wanted to produce an attractive ash tray—"I'll ask him to design one for me, he can't do more than refuse."

"Mr. Sullivan." I spoke quietly, not wanting to startle him. He swung around in his chair, his eyes burned like embers. "I'm John Lloyd Wright, son of Frank Lloyd Wright." He seemed pleased, arose, shook my hand.

"Sit down, my boy, I knew you before you knew me. I knew you when you were a baby, I'm glad to see you."

His friendly manner put me at ease and I was soon talking about the ash tray and showing him samples of my toys. [J. L. Wright had come from selling toy designs to Marshall Field's.] He seemed genuinely interested, patted me on the shoulder and called me an "enterprising young man." I was not surprised when he agreed to design the ash tray. "What do you think it should be like?" he asked.

"You decide that, Mr. Sullivan. Anything you design will be what I want—while we're on the subject of business, what will be your charge?"

He hesitated. "I like that stork very much." He pointed to one mounted on a three-foot stick. It was jigsawed out of flat-wood, colored in a decorative manner, the long line of the head pointing upward. "Yes, I like that stork. How about trading me your design for one of mine?"

—John Lloyd Wright, *My Father Who is on Earth*, 1946, 104–5

FIGURE 156. Krause Music Store façade (William C. Presto, building architect), 4611 North Lincoln Avenue, Chicago, 1922.

Sullivan's Last Opportunity

Near the end of his life, during 1922–24, Sullivan produced two of his most remarkable works: the twenty plates of his *System of Architectural Ornament* and his *Autobiography of an Idea*. Neither his power as a writer nor as a designer had diminished, but they had now been transformed and interrelated.

After his Columbus bank Sullivan had received a small scattering of jobs, the most substantial of which was the request in 1922 for the design of a terra-cotta façade for the Krause Music Store on Lincoln Avenue in Chicago from its architect, William C. Presto, who knew Sullivan through his employment in the office of George C. Nimmons (figure 156).[1] By then the sixty-six-year-old Sullivan was destitute, living in a room at a residential hotel and eating at the Cliff Dwellers' Club on the charity of his friends: Nimmons, Max Dunning of the Chicago Architectural Club days, Adler's son Sidney, and

Frank Lloyd Wright (with whom he had been reconciled since 1914[2]). He had had to give up his last office on the Wabash Street side of the Auditorium and now had the use of a table in the drafting room of the American Terra Cotta Company through the generosity of its president, C. D. Gates.

In the winter of 1921–22 Dunning and Nimmons suggested that Sullivan execute twenty plates of ornament and got the Burnham Library at the Art Institute to advance him $500 for the project (to which they added $500 more after canvassing the architect members of the Cliff Dwellers').[3] The first sketches for the project are dated January 20, 1922. At about the same time Charles Whitaker, editor of the *American Institute of Architects Journal*, approached Sullivan about writing book reviews. Sullivan made counter-proposals and by the end of January 1922 had a contract for publishing his autobiography in installments paid at $100 each. Sullivan had already begun to write, and monthly chapters appeared

FIGURE 159. *A System of Architectural Ornament*, original drawing for plate 10 (1922). (Art Institute of Chicago)

opposite

FIGURE 157. Claude Bragdon, *Projective Ornament* (1915), facing p. 15.

FIGURE 158. Irving K. Pond, *The Meaning of Architecture* (1918), frontispiece.

FIGURE 160. *A System of Architectural Ornament*, original drawing for plate 11 (1922). (Art Institute of Chicago)

from June 1922 through August 1923. As the installments progressed, Whitaker and Sullivan worked out an agreement for the AIA to publish both the autobiography and the ornamental plates as books. Sullivan set to work with a will on this enlarged graphic project. The last plate of the ornament sheets is dated June 11, 1923, and the last installment of the autobiography appeared two months later.

This dual accomplishment was Sullivan's last. His health declined during the winter of 1923–24 and he became anxious to see the books printed and out. On April 11, 1924, he showed Frank Lloyd Wright the published *Autobiography of an Idea.* Max Dunning brought him the published *System of Architectural Ornament* at about the same time. On the morning of April 14 he died.

Interpretation of A System of Architectural Ornament

It is hard not to be fascinated and deeply affected by the sheets of *A System of Architectural Ornament*, especially when standing directly in front of the original drawings in the Art Institute of Chicago (figures 159–161, 163–170).[4] The sheets are 24 inches by 30 inches. They are not simply exercises in the articulation of architectural form. As you gaze at them your eye is carried back and forth by the intertwining efflorescences. Through this one discovers griddings and diaperings that layer to extraordinary, dark-hatched depths. "'Background'—the curse of all stupid ornament—ceased to exist," Frank Lloyd Wright observed in 1928.[5] The spaces between the elements are as powerful and assertive as the reeling arabesques themselves. In their rhythmic expansion countered by their exquisite detail in hidden patches, the patterns demand to be read as maps or aerial city views.

Sullivan's text for the *System* explains the project in the most innocent terms: a step-by-step demonstration of the elaboration of architectural ornament in eight plates, followed by a series of eleven demonstrative examples, several with helpful descriptive inscriptions. The first eight plates move from a progressive demonstration of the elaboration of a square through that of arrays of leaf forms and geometric shapes. Plate 6 demonstrates the generation of four distinct compositions of Sullivan efflorescences from the same configuration of three axes. Plates 7 and 8 demonstrate these principles in fully elaborated ornamental compositions.

The text that precedes these eight plates is not, however, an explanation of them but instead an evocation of man's imaginative powers when awakened by sympathy with nature in the style of his earlier "Essay on Inspiration," *Kindergarten Chats*, and *Democracy: A Man Search.* The book's subtitle—"According with a Philosophy of Man's Powers"—alerts us to this. The short "Interlude" that follows these first eight plates is more specifically relevant to ornament and claims direct demonstration following in the plates. It explains a "Doctrine of Parallelism" between the scientific and the mystical: "The chief exhibit of intellect is called logic; but the processes of Instinct involve a logic infinitely more subtle [sic], much more powerful—because primordial." In what is fundamental to "reading" the eleven plates that follow, Sullivan concludes:

It has been deemed urgent to devise this literary interlude, because, to evidence its varied suggestions apart, by graphic illustrations, would require space far beyond the limits of this work—however interesting it might be to the advanced student to observe a scientifico-poetic theory—or rather conviction— gradually unfold itself to the physical eye. It is to the inner eye therefore that a very considerable part of the appeal must perforce be made.

Sullivan's *System* must also be seen within the context of the wider discussion of ornament in the 1910s and 1920s, manifested in manuals embodying the emerging

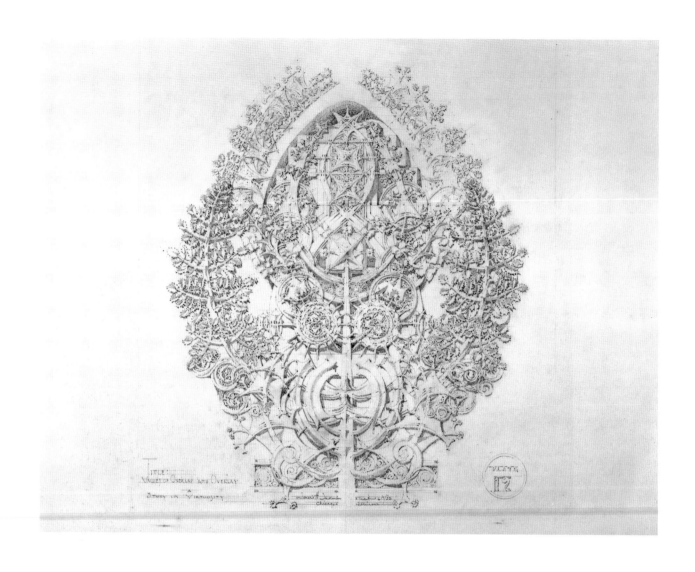

FIGURE 161. *A System of Architectural Ornament*, original drawing for plate 12 (1922). (Art Institute of Chicago)

"Art Deco,"[6] in large scholarly projects like that of William H. Goodyear, formerly curator at the Brooklyn Museum,[7] and especially in books on the theory and conceptualization of a "Modern American" ornament from Sullivan's immediate circle: Claude Bragdon's *Projective Ornament* of 1915 and Irving K. Pond's *Meaning of Architecture* of 1918 (figures 157 and 158).

But even at this most superficial level there is a problem, especially when we compare Sullivan's spreading folio pages to those of the hand-sized treatises of his friends Bragdon and Pond.[8] There is little of architectural surfaces in Sullivan's plates, no perspectives of architectural ensembles as in Bragdon, and none of Pond's discussion of the derivation of ornament from structure in Sullivan's text—no mention of exactly what this architectural ornament was meant to do for the architecture itself. Pond's ornament is always dug into architectural surfaces, in small (and all too unobtrusive) bits to express the structural thrust and counter-thrust of the building itself. Bragdon's presentation is extreme in the opposite direction: a netlike surface patterning of mathematical geometric projections. But Sullivan's ornament in these sheets is a thing unto itself, not an accompaniment to architecture but instead in its freedom a genre of art of its own, a surrogate for grander spatial composition.

Thus, besides the didactic, a second interpretation of these plates suggests itself: the sheets of the *System* are less a repetition of the incidental books of Bragdon and Pond than a declaration of Sullivan's general artistic *virtù* and as such the correct accompaniment to his *Autobiography of an Idea*. The *Autobiography* is a beautifully written account of Sullivan's life up to the moment when he began his practice. As a result it omits exactly what would make the story distinctive and historically illuminating: a narrative of the great deeds of Chicago and of the architecture during his life (both literally and metaphorically).[9] It is just the story of an observant boy

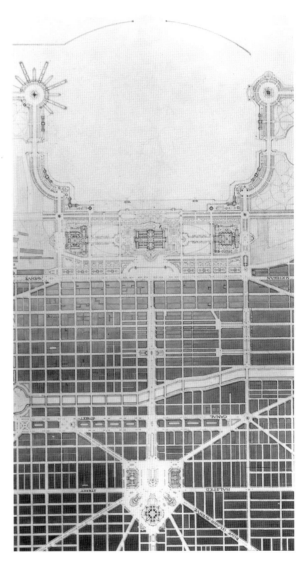

FIGURE 162.

Daniel H. Burnham and Edward Bennett, plan for Chicago (1909), the business center of the city. (Chicago Historical Society)

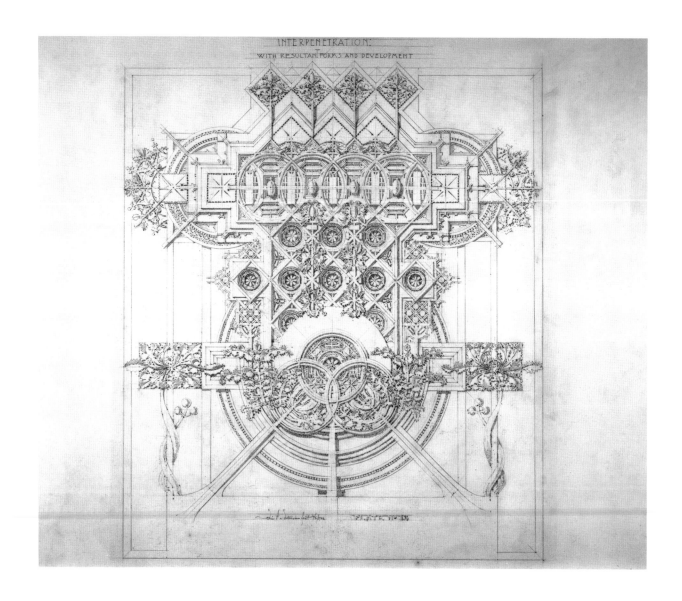

FIGURE 163. *A System of Architectural Ornament*, original drawing for plate 13 (1922). (Art Institute of Chicago)

growing up and discovering the world for himself. Similarly, Sullivan's architectural ornament in his *System* exists only as ornament essentialized, as spirit ready to assume architectural form only when (and if) the opportunity arises.

The *Autobiography* is the last reshaping of the "poetry" that Sullivan set as his objective all his career, in his "Essay on Inspiration" (1886) in the fields, seas, and seasons, in his *Kindergarten Chats* in the garden of architecture (1901–2), and in his *Democracy* (c. 1905) that (regrettably) focused on the cliché, "man." In his *Autobiography of an Idea*, Sullivan finally found his subject—himself as a child or young man when his sensations were naive and generic but above all sincere. If the *System* is the parallel and accompaniment of the *Autobiography*, we could say that here too Sullivan found his design "subject." But if this is true, what form did that subject assume?

There are some hints, especially in the last eleven plates, which come after the pedagogical exercise of the "Interlude." They are dated and annotated.[10] In the earlier of these eleven sheets Sullivan noted when he began and finished; the process took about a week but was not done all at one time, for the preliminary drawing for plate 19 is inscribed "Finished drawing 11¾ hours." (That sheet is also the simplest of the series.) The time between the drawings varied widely, implying creative streaks and crises:

PLATE 10: begun 4/26/22
 finished 5/1/22
PLATE 11: begun 5.18
 finished 5.23
 22 days since the completion of last plate, 10.
PLATE 12: begun May 25 1922
 finished June 7 1922
 15 days since the completion of last plate, 11.
PLATE 13: begun June 29 1922

finished July 6 1922
 29 days since the completion of last plate, 12.
PLATE 14: begun 7/11/22
 finished 7/18/22
 12 days since the completion of last plate, 13.
PLATE 15: begun 8/25/22
 finished 8/29/22
 42 days since the completion of last plate, 14.
PLATE 16: begun 10/17/1922
 finished 10/28/1922
 60 days since the completion of last plate, 15.
PLATE 17: finished 12/15/22
 48 days since the completion of last plate, 16.
PLATE 18: finished May 15, 1923
 57 days since the completion of last plate, 20.
PLATE 19: finished 6/11/23
 27 days since the completion of last plate, 18.
PLATE 20: finished March 19, 1923
 94 days since the completion of last plate, 17.

From this we ascertain that what in its swirling counterpoint of patterns appears the fiercest and most spontaneous sheet, plate 14, took the shortest time to produce: twelve days (seven of which were spent on the execution of the finished drawing). We also ascertain that the elaborate and uncharacteristic plate 16 took sixty days to produce, the skeletal plate 18 fifty-seven days, and finally the strange moon-landscape plate 20 took ninety-four days—also that, plate 20 is the only plate out of chronological sequence as published. The date of its completion is March 19, 1923, placing it chronologically between plates 17 and 18, leaving the simplest plate in the set, 19, as the actual termination of the project. But Sullivan has shifted the March 19 sheet to the end and (in a distinctly different manner from his other inscriptions on the sheets) harshly written "FINIS" across the top. As the drawings progress chronologically, the didactic inscriptions and asides on the plates, such as 10 ("Note: Illustration of

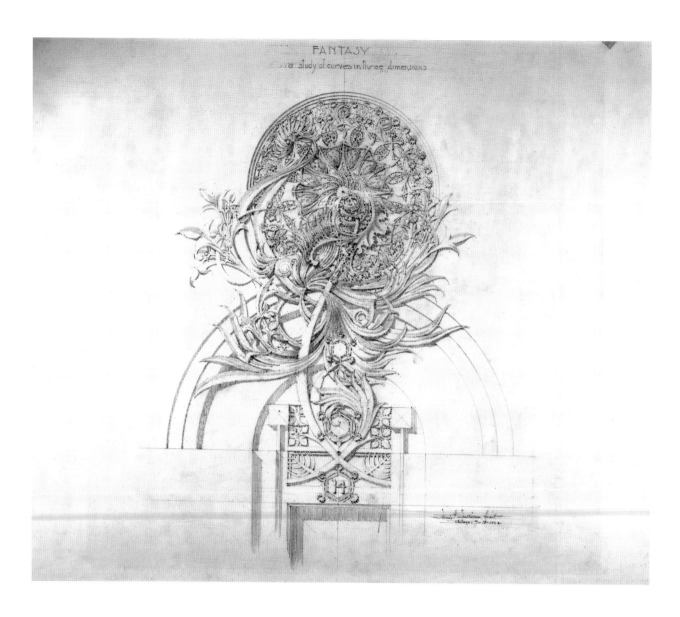

FIGURE 164. *A System of Architectural Ornament*, original drawing for plate 14 (1922). (Art Institute of Chicago)

non-symetrical [sic], rhythmical equilibrium…") or 13 ("Interpenetration: with resultant forms and development") disappear after sheet 17. The last three plates are left unmediated by words, and at least two of them are very powerful.

A struggle seems to be documented in these expansive surfaces, and its shows itself most obviously in the last three plates as rearranged by Sullivan. Plate 20 (the eighteenth executed) was finished on March 19, 1923, a Christmas, New Year, and Chicago winter (as well as a serious bout with the flu)[11] after plate 17, dated December 15, 1922. In its dark evenness and lack of decorative enlivenment in its individual units it is uniquely sepulchral but with rings of flat efflorescence striving to revive, like a depiction of the late Chicago wintertime that produced it. Plate 19 can seem truly terrifying if one remembers that it was the sheet following plate 20, for here the pattern rises and assumes dancelike repetitions while, unlike earlier plates, the decorative substance is attenuated and skeletalized, especially in the ribs of the three central figures, making the music of the sheet a sort of macabre Saraband. Then, only twenty-seven days after the completion of the effortful plates 20 and 18, came plate 19, the simplest in the series, elaborating one single centralized theme: a spreading starburst. On the original sheet at the Art Institute the drawing covers a smaller area of the paper's surface than any of the preceding drawings. (It was enlarged in the AIA publication to maintain continuity with the reordered final plate 20.) Sullivan's hand was as firm here as in all the other sheets; the drawing was intentionally modest. Plate 19 gives one ending; plate 20 another. Why did he rewrite his story? What was his story?

Clearly, since we know that Sullivan worried about the order, we can view the last eleven plates as a sequence. Plates 10 and 11 are relatively simple; 12 and 13 are, in contrast, effusive, complex, and commanding; plate 14 (the most rapidly produced) is interwoven, crisis-ridden,

almost at war with itself. Next is a series of maturely complex designs in plates 15, 16, and 17, culminating—as in the sequence 10–13—in an expansive "mapsheet," the greatest display of confident *virtù* in the series. Finally come plates 18–20, the dark terminating sequence whose ending troubled Sullivan so much. In their contrasts and development the plates constitute a piece of visual music or evocative Whitmanesque poetry, as much a reprise of Sullivan's 1886 "Essay on Inspiration" as it is the *Autobiography of an Idea.*

The last eleven plates of the *System* might also constitute two further things: first, Sullivan's life in his art, the part of his story omitted from the *Autobiography*; second, the actual architecture and urbanism his artistic life never enabled him to produce. The first is easily imagined: Sullivan's stiff first architectural efforts might be seen as being represented in plates 10 and 11 (plate 10 even reproduces his characteristic teardrop motif of the early 1880s); his early maturity in plates 12 and 13; his crises with Wright, Adler, and his own brother in plate 14 (which even has major and minor counter-themes battling an embracing central one); the unencumbered creativity of 1895–1902 in plates 15 and 17; and his final decline and battle with artistic (and physical) extinction in the remarkable terminating trio of sheets—where one might imagine that Sullivan puzzled whether to accept his fate (embodied in the feint plate 19) or rage against it (in the actual terminating plate 20).

We can never know the truth of this interpretation, but it interests me less than the second, intersecting reading. I would call it the Ulysses interpretation, after the *topos* of the ending of Homer's *Odyssey* when the hero finally arrives home in Ithaca, unrecognized, a tattered beggar, to find his wife and home taken over by importunate suitors. By a series of signs Ulysses slowly reveals himself until, in the competition to string his own old bow, with completely unexpected force, he bends the wood, sends the arrow through the twelve axes, and turns

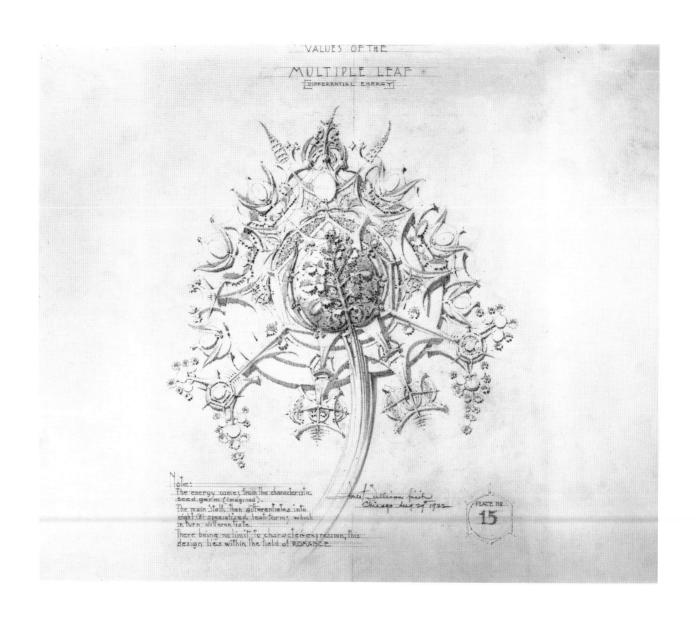

FIGURE 165. *A System of Architectural Ornament*, original drawing for plate 15 (1922). (Art Institute of Chicago)

opposite

FIGURE 166. *A System of Architectural Ornament*, original drawing for plate 16 (1922). (Art Institute of Chicago)

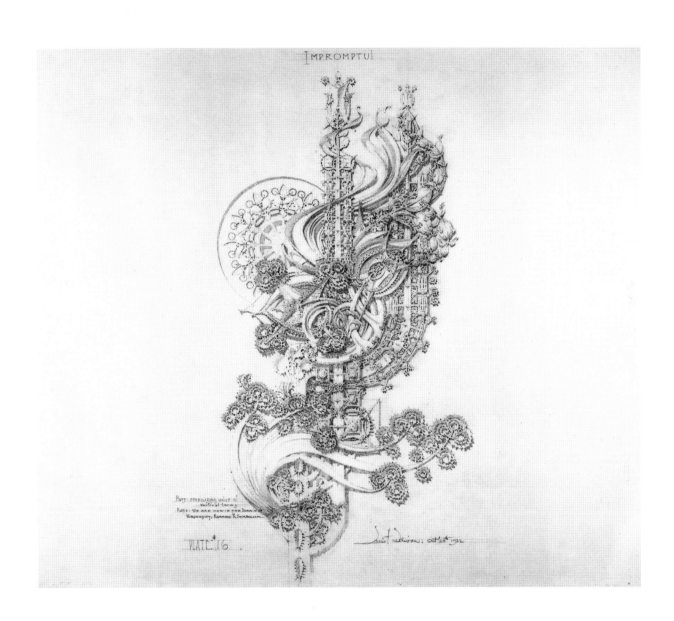

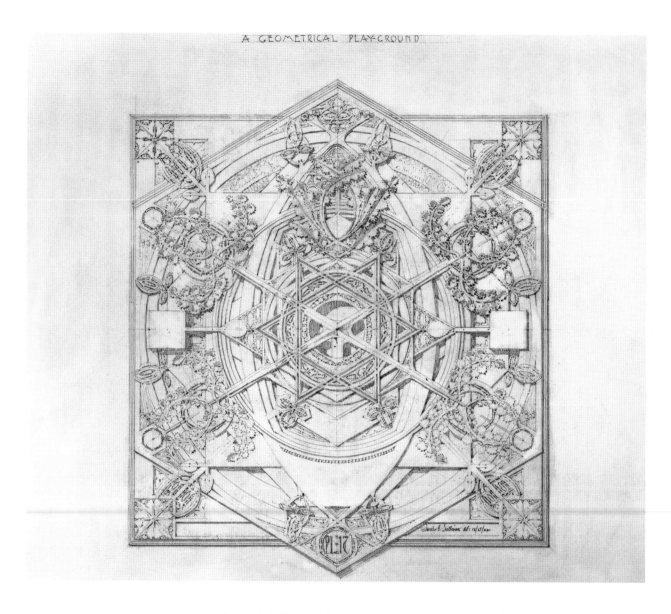

FIGURE 167. *A System of Architectural Ornament*, original drawing for plate 17 (1922). (Art Institute of Chicago)

opposite
FIGURE 168. *A System of Architectural Ornament*, original drawing for plate 18 (1923). (Art Institute of Chicago)

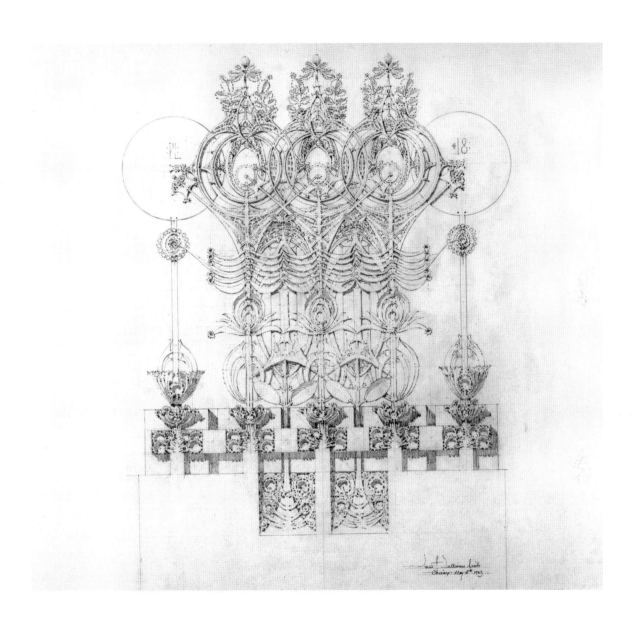

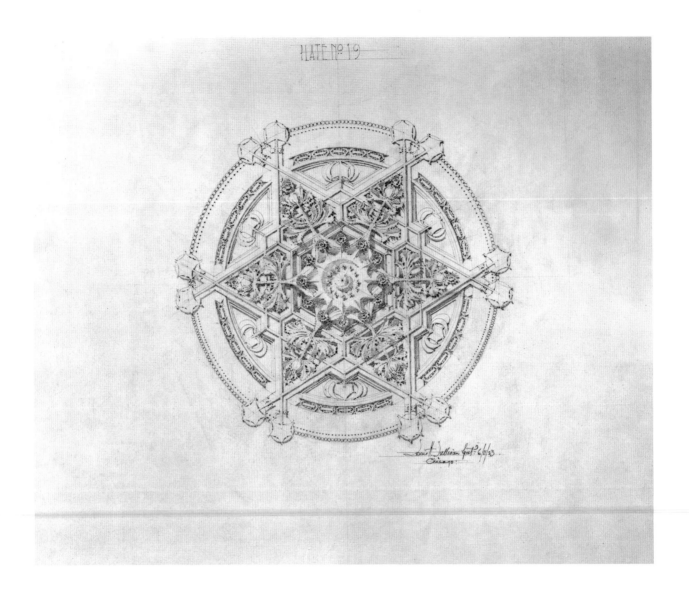

FIGURE 169. *A System of Architectural Ornament*, original drawing for plate 19 (1923). (Art Institute of Chicago)

opposite

FIGURE 170. *A System of Architectural Ornament*, original drawing for plate 20 (1923). (Art Institute of Chicago)

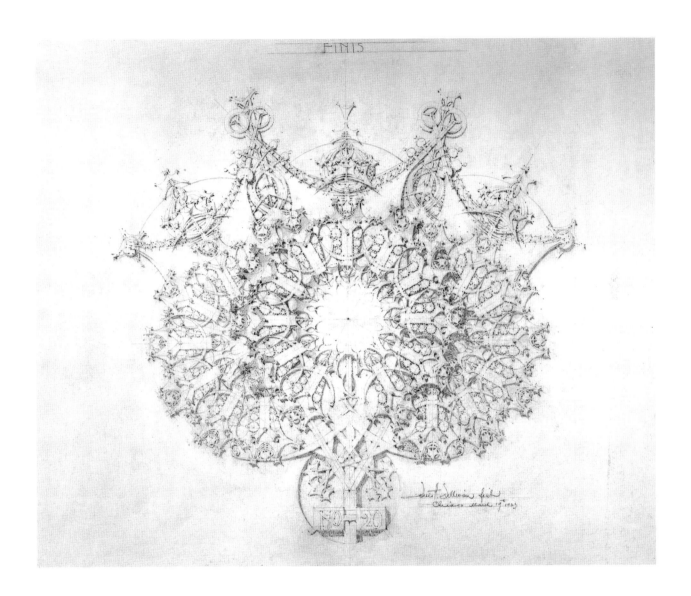

the weapon on the suitors—who died, we are told, not comprehending what had come upon them.[12] I might suggest that in this context Sullivan's folio of ornament was meant to be like Ulysses' bow, a demonstration of *virtù* in the territory, still accessible to him, of pencil lines on a sheet of paper—a demonstration that once published would "slay" all the Burnhams, Ponds, and Tallmadges around him. Thus, to return to where this chapter began, the plates are metaphorical building designs, as real perhaps as any architectural drawing is in respect to actual construction.

If these plates can be seen as architectural plans, then what we accept as plans and what we accept as architecture fall into a tellingly unexpected perspective—as Robert Bruegmann phrases it, part of a general late-nineteenth-century fixation on patterned organization as a solution and a virtue by itself.

Unlike the ornamental building surfaces of, for example, the Krause Music Store, the folio plates of the *System* can only be contemplated spread out on a table like building plans or city maps. One leans down close to them; one's eye is drawn into them, penetrating their depicted cavities as well as following their efflorescences. The patterns seems to pop into three dimensions. Plate 13 can be compared to Burnham's 1909 grandiose plan for Chicago (figure 162). At the bottom of plate 13 we might see the domical city hall with its flanking buildings and projecting diagonal and annular avenues ordering the urban texture, above it the tight grid of the Loop marked by a file of projecting skyscrapers, finally across the top of the sheet something akin to the parks and piers extending out into a sort of void suggesting the water of Lake Michigan. We should not take this parallel literally. What connects the two plans most closely is the act of contemplation that they both suggest, the paths and incidents that they spin out graphically to lead and fascinate the eye. We must remember that Burnham's plan when presented in 1909 was no more "real" yet than Sullivan's

ornament in 1924. But, whether representing reality or merely seeming to, Burnham's plan worries us with its megalomania. Sullivan's, by pretending to be mere ornament, escapes censure. If we get too involved, we can take refuge in the excuse that Sullivan's sheets were never meant to represent a human environment but only pure, innocent fantasy.

"Ah, That Supreme, Erotic, High Adventure of the Mind...."

In his 1924 *Architectural Record* obituary of Louis Sullivan, Frank Lloyd Wright wrote, "Often I would see him, his back bent over his drawing board, intent upon what?" How could Wright not have known "what"? This was an architect's office and it was Wright as Sullivan's chief assistant who would be given the sketches on the drawing board to render into buildings. Wright could only have been unsure of "what" if Sullivan's architecture were symbolic of something else, something lying within the action of actually drawing it out, his back turned away and bent in concentration. "Ah, that supreme, erotic, high adventure of the mind that was his ornament!" What is an "adventure of the mind"? Clearly something that he puzzled through—drawn on by conclusions he could not predict. What is "erotic" in this? The sheer consuming fascination of it, the temptation to push it ever further. Such drawing was the means by which Sullivan seduced and dominated his clients—and Wright himself—if only to induce them to share and build his imaginings. "I knew his symbolism—I caught his feelings as he worked." Wright was certain of Sullivan's symbolic transference intuitively because it was discernible in how he drew perhaps more than in the finished design. "Beside this sensuous master of adventure with tenuous, vibrant, plastic form, Casanova was a duffer; Gil Blas a torn chapeau; Boccaccio's imagination no higher than a stable-boy's....The soul of Rabelais

alone could have understood and would have called him brother." Why only Rabelais, the inventor of Gargantua and Pantagruel? the narrator of consuming sensual excess? Only if Sullivan's architecture (or better, Sullivan's drawing, for Wright makes it clear that this is what he is talking about) was itself a consuming sensual gluttony sublimated in an "adventure of the mind." "How often have I held his cloak and sword while he adventured in the realm within, to win his mistress; . . ." Within what? Sullivan's own mind or his lady's boudoir? Perhaps both, because in Sullivan's drawings they are one. "Those days! And now, I say this caress that was his own should be his own, forever sacred to him and treasured high for its own sake...." Again the physical and the mental together: Sullivan's pencil stroke was his caress and his caress his style, one of sensual affection and seduction. But Wright continues, "This rhythmic pulse of the wings of America's creative genius..." and suddenly his grip has slackened, his images snap into conventionality, and he starts hectoring about the flight of genius and the absolute authority of the artist while just the moment before he had struck a puzzling and convincing chord.

> Genius the Master had—or rather it had him. It possessed him, he revelled in it, squandered it and the lesser part of him was squandered by it. He lived! And compared to what came to him in life from his effort, the effort itself being a quality of it, the greatly successful careers were, I imagine, relatively lifeless.

CONCLUSION

SULLIVAN'S CITY of this book's title was triple and each was reflected in his ornament. First was the Chicago of 1890, of which he believed himself to have been an equal creator with Burnham and the other leaders of his generation, a city reshaped by buildings like the Schiller, where mass gave order to common urban form and ornament articulated mass. Second was the city in which Sullivan around 1900 documented his presence, when his ornament left the building surfaces and proclaimed itself as the reflection of a separate, powerful personality reiterating the stance taken in his first lofts of 1880 upon his entry into the field. The third, secret city of his last years appeared when ornament and plan combined progressively until in *A System of Architectural Ornament* a sheet of ornament had all the spatial fascination of a building layout or even a city plan, but none of the restraints of reality that kept back the force of artistic suggestiveness. The second of his cities is in our heads, the third was only in his own.

We have observed of Sullivan's early loft façades that he was announcing his presence in the city as a designer, and of his theaters of 1890–91 and the Auditorium banquet hall capitals that he was taking pleasure in solving the same problem repeatedly, as exercises rather than as models. We have extended that to suggest that the illumination lying behind his grand designs of the early 1890s was not a functional but a formal one, that what he could give to his young admirers at the end of that decade was a system of design based on progressive elaboration, and that his house plans at and after the turn of the century start to parallel, in their manner of conceptualization as a struggle out toward light, his ornamental compositions. We have seen that he sought to release immediate inspiration while at the same time imagining domestic environments of theatrical publicness. Design, to Sullivan, was a performance and in the end the subject of that performance was Sullivan himself. It was a benevolent performance, he seems to have believed, but it manifested a certain swiftness and finality of artistic thought embodied in his inimitable ornament that allowed neither competition nor refutation. Whatever he did, could he but turn it into ornament, he was peerless in his authority. His last production seems to have been an anti-autobiography intertwined with twenty sheets of penciled ornament.

Sullivan's plates were a demonstration that—even

alone, sick, working in the corner of a terra-cotta shop—he retained *all* his powers. There is no argument beyond these drawings. Even in his forgotten corner, Sullivan still maintained his authority—if authority is what architecture is about.

The interpretation of an enterprise like that of Sullivan operates on three planes. First, it should attempt to define *what* artists did, because the professional boundaries of a calling like architecture are meaningless to a sincere, driven practitioner. There is no reason why Sullivan's architecture shouldn't slip back and forth into what we think of as ornament. Second, such an interpretation should deal with *why* an artist such as Sullivan worked as he did, which seems to be in order to present himself and, intertwined with this—inevitably complicating matters—to carry out some sort of "family romance," perhaps, with his contemporary Burnham and certainly his student Wright. Metaphorically, his career, as well as his architectural spaces, is an unrelenting struggle outward toward light. Third, the interpretation should explain *how* such an artist elaborated his work, in the case of Sullivan by an exaggeration of conventional Beaux-Arts quadraxial plan drawing which, when reduced to lines on paper, can be made to evoke a public institution as surely as a house or city plan or a sheet of decorative ornament.

Architecture is the humane realization of social life in shelters. If my interpretation of Sullivan's enterprise is convincing, it raises one further question that would require a separate essay to answer: What does it say about architecture? How have we come to have such a long tradition of thought justifying architecture as the free play of a designer's will? Why did such a brilliant and powerful individual as Sullivan choose architecture as his challenge? Has architecture always been what we did not want to realize, ornament?

Notes

INTRODUCTION

1. Louis H. Sullivan, "The Tall Office Building Artistically Considered," *Lippincott's Magazine* 57 (March 1896), pp. 403–9. The famous phrase—with the word "ever"—appears on page 408. The "Tall Office Building" essay was first used as a basic measure of Sullivan's enterprise by Claude Bragdon in 1905 ("An American Architect: Being an Appreciation of Louis H. Sullivan," *House and Garden* 7 [January 1905], pp. 47–55) and was codified in Hugh Morrison's scholarly monograph of 1935, *Louis Sullivan: Prophet of Modern Architecture* (New York: Norton, 1935; reprint edition, 1998) in the fifth chapter, "Giving Form to the Skyscraper." Adler questioned Sullivan's aphorism as being merely metaphorical as early as the fall of 1896 (*Inland Architect* 28 #4 [November 1896], pp. 34–36) and Wright later attributed the ideas to Adler himself in "Form and Function," *Saturday Review* 13 (December 14, 1935), p. 6: "'Form follows Function'? Has it occurred to no one, then, that Dankmar Adler, not Louis Sullivan, deserves the credit for that dogma?"

2. Frank Lloyd Wright, "Louis H. Sullivan—His Work," *Architectural Record* 56 #1 (July 1924), pp. 28–32, esp. p. 29.

3. Vincent Scully, "Louis Sullivan's Architectural Ornament," *Perspecta* 5 (1959), pp. 73–80. See also Paul E. Sprague, *The Drawings of Louis Henry Sullivan* (Princeton: Princeton University Press, 1979); Theodore Turak, "French and English Sources of Sullivan's Ornament and Doctrine," *Prairie School Review* 11 #4 (1974), pp. 5–28; Alfonso Ianelli, "Evaluation of Louis H. Sullivan's Ornament," *Prairie School Review* I #2 (1964), pp. 25–26.

4. Vincent Scully, *Frank Lloyd Wright* (New York: Braziller, 1960), p. 15. The observation was first suggested by Henry-Russell Hitchcock, "Frank Lloyd Wright and the 'Academic Tradition' of the Early Eighteen-Nineties," *Journal of the Warburg and Courtauld Institutes* 7 #1–2 (January–June 1944), pp. 46–63. It was developed by William H. Jordy in *American Buildings and their Architects*, volume 3 of *Progressive and Academic Ideals at the Turn of the Twentieth Century* (New York: Doubleday, 1972).

5. Morrison, *Sullivan*; Willard Connely, *Louis Sullivan: The Shaping of American Architecture* (New York: Horizon Press, 1960); Robert Twombly, *Louis Sullivan: His Life and Work* (New York: Viking, 1986). See also Louis Sullivan, *The Autobiography of an Idea* (New York: Press of the American Institute of Architects, 1924; reissue, Dover, 1956) and his reminiscences of his practice with Dankmar Adler in *The Economist* 55 #26 (June 24, 1916), p. 1252, and 56 #1 (July 1, 1916), pp. 39–40.

6. C. Shillaber, *The Massachusetts Institute of Technology School of Architecture, 1861–1961: A Hundred Year Chronicle* (Boston: MIT, 1963).

7. At least one debutante remembered him well: Addie Hibbard Gregory, *Reminiscences of Lydia Beekman Hibbard, by her Eldest Daughter* (Chicago: privately printed, 1929), p. 41: "She got up a large private dancing class which met in a hall on the south side of 22nd Street, and was taught by a Mr. Sullivan, father of Louis Sullivan, the architect of the Auditorium, etc." See also her *Great-Grandmother Remembers* (Chicago: Kroch, 1940), p. 39: "As another part of our social education, Mother early organized a private dancing class which met in the central neighborhood of 22nd Street. It was taught by a Mr. Sullivan, father of Louis Sullivan, the well-known architect."

8. J. A. Chewning, while a graduate student at MIT, found in a

general photograph of an 1873 exhibition of student drawings the grainy ghost of a respectable Vaudremer-like façade which he identified as Sullivan's (Sullivan's teacher, Létang, was a student of Vaudremer).

9. I have tried to trace these first years in my essay, "Sullivan to 1890" in *Louis Sullivan: The Function of Ornament*, Wim de Wit, editor (New York: Norton, 1986), pp. 12–63.

10. Theodore Turak, *William Le Baron Jenney: A Pioneer of Modern Architecture* (Ann Arbor: UMI Research Press, 1986).

11. Robert Twombly found Sullivan's name on the passenger lists: *Sullivan*, pp. 55, 73. Sullivan himself implied that he stayed two years in Paris (Morrison, *Sullivan*, p. 51, note 2; Twombly, *Sullivan*, p. 74). Sullivan's meager record at the Ecole survives in the Archives Nationales: Aj52 383.

12. Paul E. Sprague and Donald Drew Egbert, "In Search of John Edelmann," *Journal of the American Institute of Architects* 45 (February 1966), pp. 35–41.

13. On Adler: Rochelle S. Elstein, "The Architecture of Dankmar Adler," *Journal of the Society of Architectural Historians* 26 #4 (December 1967), pp. 242–49.

14. Carl W. Condit, *The Rise of the Skyscraper* (Chicago: University of Chicago Press, 1952); Arnold Lewis, *An Early Encounter with Tomorrow: Europeans, Chicago's Loop and the World's Columbian Exposition* (Urbana and Chicago: University of Illinois Press, 1997); Miles L. Berger, *They Built Chicago: Entrepreneurs Who Shaped a Great City's Architecture* (Chicago: Bonus Books, 1992); and, most recently, Robert Bruegmann, *The Architects and the City* (Chicago: University of Chicago Press, 1997).

15. See the critic Montgomery Schuyler's respectful treatment in his "Great American Architects Series" for the *Architectural Record*, 1895 and after.

16. For example, this was forecast by Adna Weber in New York writing in 1899 of the phenomenal growth of cities in the nineteenth century: *The Growth of Cities in the Nineteenth Century: A Study in Statistics* (New York: Columbia University Press, 1899).

17. According to Timothy Samuelson, there had grown up a deep-seated personal incompatibility which only exploded with the "bootleg" houses.

18. Connely first pursued Albert's side of the story in *Louis Sullivan*; Herbert Leibowitz considers the impact of the break in *Fabricating Lives: Explorations in American Autobiography* (New York: Knopf, 1989), pp. 71–114.

19. See Joseph Siry's thorough *Carson. Pirie. Scott: Louis Sullivan and the Chicago Department Store* (Chicago: University of Chicago Press, 1988).

20. Jack Quinan, *Frank Lloyd Wright's Larkin Building: Myth & Fact* (New York: Architectural History Foundation, 1987), p. 7.

21. Edward J. Vaughn, "Sullivan and the University of Michigan," *Prairie School Review* 6 #1 (1969), pp. 21–23.

22. Twombly summarizes what is known of her in *Sullivan*, pp. 356, 402.

23. The auction catalogue survives at the Art Institute (*Williams, Barker & Severn Company, auction catalogue #5533, November 29, 1909. At Auction at our Salesrooms, no. 185 Wabash Avenue, Monday, Nov. 29, 10:30 AM: Household Effects, Library, Oriental Rugs, Paintings…of Mr. Louis Sullivan*) and its contents are published by David Andrew, *Louis Sullivan and the Polemics of Modern Architecture* (Urbana and Chicago: University of Illinois Press, 1985), pp. 161–70.

24. Connely, *Sullivan*, p. 240, quotes the Swedish portraitist Anders Zorn: "'What is the matter with you in Chicago? . . . There in the Auditorium Tower sits your country's greatest living architect, one of the world's leaders in his profession, doing nothing. This could not happen in Europe.'"

25. Although Sullivan sought a publisher—attempting to recruit Harriet Monroe (as letters dating from between 1905 and 1916 in her papers at the University of Chicago document), it was only published in 1961: *Democracy, A Man Search*, Elaine Hedges, editor (Detroit: Wayne State University Press).

26. *Book of the Twenty-sixth Annual Exhibition of the Chicago Architectural Club* (Chicago: Chicago Architectural Club, 1913). Harriet Monroe reviewed it respectfully in the *Chicago Tribune*, May 11, 1913.

27. The basic interpretations: Sherman Paul, *Louis Sullivan: An Architect in American Thought* (Englewood Cliffs, NJ: Prentice-Hall, 1962); Narciso Menocal, *Architecture as Nature: The Transcendentalist Idea of Louis Sullivan* (Madison: University of Wisconsin Press, 1981); Lauren Weingarden, *Louis H. Sullivan's Metaphysics of Architecture (1885-1901): Sources and Correspondences with Symbolist Art Theories* dissertation, (University of Chicago, 1981). The basic Sullivan texts: *The Autobiography of an Idea*; *Kindergarten Chats*, Claude Bragdon, editor (Lawrence, Kansas: Scarab Fraternity Press, 1934; republished 1947, 1965); *Democracy, A Man Search*. Anthologies: *Kindergarten Chats and Other Writings*, Isabella Athey, editor (New York: Wittenborn, Schultz, 1947); *Louis Sullivan: The Public Papers*, Robert Twombly, editor (Chicago: University of Chicago Press, 1988).

28. Sometimes literally—Paul starts his book with a letter Sullivan wrote to Whitman in 1887 and which Whitman valued. Paul, *Louis Sullivan*, pp. 1–3.

29. Twombly, *Public Papers*, pp. 10–28.

30. *Kindergarten Chats*, 1947 edition, pp. 28–29, 140. Emphasis in original.

31. A huge topic, recently broadly and intelligently surveyed in

Michael Snodin and Maurice Howard, *Ornament: A Social History Since 1450* (New Haven and London: Yale University Press, 1996).

32. Charles Moore, *Daniel H. Burnham: Architect, Planner of Cities* (Boston: Houghton Mifflin, 1921), II, p. 166; Paul Starrett, *Changing the Skyline* (New York: Whittlesey House, 1938), p. 43; Louis Sullivan, *Autobiography of an Idea*, p. 291.

33. Frank Lloyd Wright, describing his first encounter with Sullivan in 1888, records a conversation in which the latter claimed not to know Owen Jones, but guessed it to be a parallel to Raguenet (*An Autobiography* [New York: Duell, Sloan and Pearce, 1943 edition], p. 92). Habert-Dys's *Fantaisies décoratives* was in Sullivan's library when it was auctioned in 1909, as well as long runs of César Daly's journal *Revue générale de l'architecture et des travaux publics*, the *Encyclopédie d'architecture*, and *Croquis d'architecture: Intime club*.

34. *Journal of Design and Manufactures*, 1849, quoted in Nikolaus Pevsner, *Some Architectural Writers of the Nineteenth Century* (Oxford: Clarendon Press, 1972), p. 158.

35. Nikolaus Pevsner, *Pioneers of Modern Design* (New York: Museum of Modern Art, 1949); Sigfried Giedion, *Space, Time and Architecture* (Cambridge: Harvard University Press, 1941), fifth edition 1966, pp. 291–334 and *Mechanization Takes Command* (New York: Oxford University Press, 1948; New York: Norton, reissued in 1969), pp. 347–60; Alf Boe, *From Gothic Revival to Functional Form* (Oslo: Oslo University Press, 1957).

36. For Dressser see Stuart Durant, *Christopher Dresser* (London: Academy Editions, 1993); Widar Hal'an, *Christopher Dresser: Ein viktorianischer Designer, 1834–1904* (Cologne: Kunstgewerbemuseum, 1981). Ruprich-Robert is much less well documented: see Jean-Michel Leniaud, *Les cathédrales au XIXe siècle* (Paris: Economica, 1993), pp. 778–80. He is chiefly known as the author of *Flore ornementale* (Paris: Dunod, 1866–76).

37. James F. O'Gorman et al., *The Architecture of Frank Furness* (Philadelphia: Philadelphia Museum of Art, 1973); George E. Thomas et al., *Frank Furness: The Complete Works* (New York: Princeton Architectural Press, 1991; second edition, 1996); Turak ("French and English Sources," in *Prairie School Review*) first suggested the Ruprich-Robert connection. I explore this in detail in "Sullivan to 1890" in *Louis Sullivan: The Function of Ornament*.

38. Christopher Dresser, *The Art of Decorative Design* (London: Day & Son, 1862), ch. 1, par. 21.

39. Ibid., ch. 3, par. 21.

40. Ruprich-Robert, *Flore ornementale*, p. 2. Emphasis in original.

41. Ibid., p. 8.

42. Giedion, *Space, Time and Architecture*, fifth edition, pp. 388–92. Here he went so far as to crop a photograph across the front of the Carson Pirie Scott & Company Store to omit its base and cornice, then set it in juxtaposition with Walter Gropius's Chicago Tribune project of 1922.

43. Carl W. Condit, "The Chicago School and the Modern Movement in Architecture," *Art in America* 36 #1 (January 1948), pp. 19–36; *Rise of the Skyscraper*.

44. Philip Johnson, "Is Louis Sullivan the Father of Functionalism?" *Art News* 40 (December 1956), pp. 44–46, 56–57.

45. Frank Lloyd Wright, "Form and Function."

46. A few years later in 1951, George Elmslie's partner, William Gray Purcell, would write:

"Sullivan did not say that architecture had to be logical. On the contrary he said that architecture had to be poetry: that the most potent functions that it was impelled to express were: the heart of Man, man related to Nature, and, yes, the inscrutable logic of the mountains, forests, and the sea." "Louis H. Sullivan, Prophet of Democracy," *Journal of the American Institute of Architects* 16 (December 1951), pp. 265–71.

47. Vincent Scully, "Louis Sullivan's Architectural Ornament."

48. Sherman Paul, *Sullivan*; Narcisso Menocal, *Art as Nature*; Lauren Weingarden in numerous essays, especially "Naturalized Nationalism: A Ruskinian Discourse on the Search for an American Style of Architecture," *Winterthur Portfolio* 24 (Spring 1989), pp. 43–68.

49. William Jordy, *American Buildings*; "The Tall Office Buildings" in *Louis Sullivan: The Function of Ornament*, pp. 65–157. Joseph Siry, *Carson. Pirie. Scott*; "Louis Sullivan's Building for John D. Van Allen and Son," *Journal of the Society of Architectural Historians* 49 #1 (March 1990), pp. 67–89; "Adler and Sullivan's Guaranty Building in Buffalo," *Journal of the Society of Architectural Historians* 55 #1 (March 1996), pp. 6–37; "Chicago's Auditorium Building: Opera or Anarchism," *Journal of the Society of Architectural Historians* 57 #2 (June 1998), pp. 128–59. See also David S. Andrew, *Louis Sullivan and the Polemics of Modern Architecture*; James O'Gorman, *Three American Architects: Richardson, Sullivan and Wright, 1865–1915* (Chicago: University of Chicago Press, 1991); Donald Hoffmann, *Frank Lloyd Wright, Louis Sullivan and the Skyscraper* (New York: Dover, 1998).

50. Thomas Beeby, "The Grammar of Ornament/ Ornament as Grammar," *Via III*, Journal of the Graduate School of Fine Arts, University of Pennsylvania, 1977, pp. 10–29.

1. Timothy Samuelson, "Revised List of Buildings," in Morrison, *Sullivan* (1998 edition), pp. 257–62.

2. A typed transcript of the letter survives in the papers of J. Carson Webster, Northwestern University Archives.

3. *The Daily Inter-Ocean*, August 12, 1882. First cited by Twombly, *Sullivan*, p. 145, and partially republished by him in *Public Papers*, pp. 1–2.

4. For example, *Real Estate and Building Journal*, March 26, 1881, wrote of the resemblance of the Borden Block and the newly begun Rothschild Store.

5. Thomas Eddy Tallmadge, *Architecture in Old Chicago* (Chicago; University of Chicago Press, 1941), p. 154.

6. Condit, *Rise of the Skyscraper*, p. 113.

7. Commission on Chicago Landmarks, *Chicago Historic Resources Survey* (Chicago, 1996), pp. 255–56.

8. Sullivan, *Autobiography of an Idea*, pp. 158–59. Sullivan's emphasis.

9. Ibid., pp. 220–21. Sullivan's emphasis.

10. Ibid., pp. 191–93.

11. Ibid., p. 193; Thomas et al., *Frank Furness*, p. 176.

12. *Chicago Times*, May 21, 1876; *Chicago Tribune*, April 8 and June 2, 1876. See Sprague and Egbert, "Search"; Twombly, *Sullivan*, pp. 87–89.

13. Among the Emil Lorch papers at the Bentley Historical Library, University of Michigan.

14. Charles E. Gregersen's book *Dankmar Adler: His Theatres and Auditoriums* (Athens: Ohio University Press, 1990) is invaluable. Adler himself gave an account of his theater building: "Theatre Building for American Cities," *Engineering Magazine* 7 (1894), pp. 717–30, 815–29. See also Lloyd Englebrecht's "Adler & Sullivan's Pueblo Opera House; City Status for a New Town in the Rockies," *Art Bulletin* 67 #2 (June 1985), pp. 277–95.

15. *Chicago Tribune*, December 5, 1879, reporting the inauguration.

16. To these Gregersen would add the Kalamazoo (Michigan) Academy of Music of 1881–82, the First and Second May Festival Auditoriums in the Inter-State Industrial Exposition Building of 1882 and 1884, the Zion Temple of 1885, and the North American Sängerfest Hall in Milwaukee of 1885–86. Samuelson adds the Chicago Opera House redecoration of 1886 (see *Chicago Tribune*, April 4, 1886).

17. *Building Budget* I #4 (June 1885), p. 31.

18. For example, see the *Chicago Tribune* real estate review of April 4, 1886.

19. Thomas Schlereth, "Solon Spencer Beman, Pullman, and the European Influence on and Interest in his Chicago Architecture," *Chicago Architecture, 1872–1922. Birth of a Metropolis*, John Zukowsky, editor (Munich: Prestel, 1987), pp. 173–87.

20. Daniel Bluestone, *Constructing Chicago* (New Haven and London: Yale University Press, 1991), ch. 4. On the socioeconomic nature of the office building, see Earle Shultz and Walter Simmons, *Offices in the Sky* (Indianapolis: Bobbs-Merrill, 1959); Carol Willis, *Form Follows Finance: Skyscrapers and Skylines in New York and Chicago* (New York: Princeton Architectural Press, 1995); and Neil Harris, *Building Lives: Constructing Rites and Passages* (New Haven and London: Yale University Press, 1999). See also Frank A. Randall, *History of the Development of Building Construction in Chicago* (Urbana: University of Illinois, 1949).

21. A contemporary observer, the builder Henry Ericsson, writes in his autobiography *Sixty Years a Builder* (Chicago: A. Kroch and Son, 1942): "But our modern idea of town planning in Chicago stems from John B. Sherman's plan for the Union Stock Yards, where, with an abundance of white pine and the principle of the balloon frame, an industrial city was pioneered. George M. Pullman carried the idea further with brick...," p. 342. See also Gerald Larson, "Chicago's Loop, 1830–1890: A Tale of Two Grids," in *Fragments of Chicago's Past*, Pauline Saliga, editor (Chicago: Art Institute of Chicago, 1990), pp. 68–79.

22. *The Real Estate and Building Journal* followed this closely, especially because it opposed the removal of the Board of Trade from the North Loop: April 9, 1881 (p. 155), February 4, 1882 (p. 43), April 1, 1882 (p. 123). See also *The Daily Inter-Ocean*, February 12, 1881.

23. The Rookery Building tenant list for 1891 survives among the Brooks papers in the Chicago Historical Society and shows us a tremendous variety of renters: banks, insurance companies, railroads, manufacturing representatives, and private individuals.

24. Morrison and Twombly both devote chapters to the story of the Auditorium Building, but more thorough and contextual is Joseph Siry, "Chicago's Auditorium Building." See also Dankmar Adler, "The Chicago Auditorium," *Architectural Record* I (April–July 1892), pp. 415–34; Edward R. Garczynski, *The Auditorium* (New York: Exhibit Publishing Company, 1891).

25. On the motif of the skyscraper as a world to itself, see Bluestone, *Constructing Chicago*, pp. 141–44. By 1893 Henry Blake Fuller was already playing with this motif in *Cliff Dwellers*.

26. In the possession of Laflin's family, who have kindly provided copies.

27. Frank Harris, "Louis Sullivan," *Latest Contemporary Portraits* (New York: MacCaulay, 1927), pp. 166–78, esp. pp. 175–76.

28. Wright, *Autobiography*, p. 90. The exact date of Wright's

arrival in Sullivan's employ is unclear—see Neil Levine, *The Architecture of Frank Lloyd Wright* (Princeton: Princeton University Press, 1996), p. 437, note 9.

29. Paul E. Sabine, "The Acoustics of the Chicago Civic Opera House," *Architectural Forum* 52 #4 (April 1930), pp. 599–604.

30. Condit, *Rise of the Skyscraper*, pp. 212–27. Sullivan, "Development of Construction," p. 40.

31. *Autobiography of an Idea*, pp. 294–98.

32. Beaux-Arts spatial composition is a large subject that I have surveyed in "Le système des Beaux-Arts," *Architecture d'aujourd'hui* 189 (November–December 1975), pp. 97–106, and "Le système des Beaux-Arts, II," *Architectural Design* Profiles 17 (1979), pp. 66–79. More recent is Richard A. Etlin, *Symbolic Space: French Enlightenment Architecture and Its Legacy* (Chicago: University of Chicago Press, 1994).

33. *Autobiography of an Idea*, pp. 298–303. This sense of epiphany reappears in one of Sullivan's letters of 1903 to Claude Bragdon (*More Lives Than One* [New York: Knopf, 1938], p. 157): "It was a very sudden and volcanic design (made literally in three minutes)," and is cited by Wright in his 1924 tribute to Sullivan in *Architectural Record* (p. 29): "When he brought in the board with the motive of the Wainwright Building outlined in profile and in scheme upon it and threw it down on my table, I was perfectly aware of what had happened….The 'skyscraper' as a new thing beneath the sun, an entity with virtue, individuality and beauty all its own, was born." Also in his 1949 *Genius and the Mobocracy* (New York: Duell, Sloan and Pearce), p. 59.

34. Drawings for these capitals are dated from April to July 1890 (Sprague, *Drawings*, numbers 32–34). These are among a collection of drawings given by Sullivan to Frank Lloyd Wright immediately before he died.

35. One classicist who insisted that the ornamentation of the same motif should vary was Constant-Dufeux, Ruprich-Robert's teacher and architect of the rue Racine façade of the École Gratuite de Dessin that Sullivan's Paris mansard looked out on; the façade carried a string of Greek pateras, each individually designed.

36. Garczynski, *Auditorium*, devotes several pages to the capitals and glories in their variety.

37. Jean Castex in a recent article analyzes Frank Lloyd Wright's early house plans as variations on a limited number of spatial types which he sees as inspired by biological morphology, citing Sullivan's interest in Spencer and Darwin. "Darwin, Wright and the Typology of the Prairie House," *Rassegna* 74 (1998), pp. 64–75. This argument might be folded back on the analysis of Sullivan's process of architectural and ornamental design.

CHAPTER TWO

1. For example, Chicago novels like Henry Blake Fuller's *Cliff-Dwellers* and *With the Procession* (New York: Harper & Brothers, 1893 and 1895).

2. Giedion, *Space, Time and Architecture*, pp. 393–96.

3. *Autobiography of an Idea*, pp. 304–8, 314–15, 325.

4. Ibid., p. 316.

5. Daniel Burnham to Theodore Thomas, October 26, 1901, Newberry Library, Theodore Thomas Papers. Emphasis is Burnham's.

6. The dramatic change in Chicago's self-projection is best depicted by Helen Horowitz, *Culture and the City: Cultural Philanthropy in Chicago from the 1880's to 1917* (Chicago: University of Chicago Press, 1976). See also Ross Miller, *American Apocalypse: The Great Fire and the Myth of Chicago* (Chicago: University of Chicago Press, 1990).

7. Both announced in the same note in the *Economist*, November 29, 1890, p. 901.

8. *American Architect and Building News*, March 21, 1891, p. 189. The design was first published in *Inland Architect* in May 1891.

9. *Illinois Staats Zeitung*, January 27 and February 15, 1891. See also Paul Sprague, "Adler & Sullivan's Schiller Building," *Prairie School Review* 2 #2 (second quarter, 1965), pp. 5–20.

10. *Report of the President of the Board of Directors of the World's Columbian Exposition, 1892–1893*, Chicago, 1898; Daniel Burnham, "The Organization of the World's Columbian Exposition," *Inland Architect* 23 #1 (August 1893), pp. 5–8; Daniel Burnham and Francis D. Millet, *World's Columbian Exposition, The Book of the Builders* (Chicago: Columbian Memorial Publications, 1894); Charles Moore, "Lessons of the Chicago World's Fair: An Interview with the late Daniel H. Burnham," *Architectural Record* 33 (January 1913), pp. 35–44; Charles Moore, *Daniel H. Burnham, Architect, Planner of Cities*, vol. I, pp. 31–68; Thomas Hines, *Burnham of Chicago: Architect and Planner* (Chicago: University of Chicago Press, 1974), chs. 4–6. Relevant documents are in the Burnham papers in the Art Institute of Chicago and in the Charles Moore papers in the Library of Congress.

11. Moore, "Lessons of the Fair."

12. Interpretations are in David H. Crook, "Louis Sullivan and the Golden Doorway," and Dimitri Tselos, "The Chicago Fair and the Myth of the 'Lost Cause,'" both *Journal of the Society of Architectural Historians* 27 #4 (December 1967), pp. 250–68; Lauren Weingarden, "A Transcendentalist Discourse in the Poetics of Technology: Louis Sullivan's Transportation Building and Walt Whitman's 'Passage to India,'" *Word and Image* 3 #2 (April–June

1987), pp. 202–19. See also, probably from Adler & Sullivan, "The Transportation Building," *Handbook of the World's Columbian Exposition* (Chicago: Rand McNally, 1893), pp. 30–34, republished in Twombly, *Public Papers*, pp. 85–87.

13. "Last Words About the World's Fair," *Architectural Record* 3 (January–March 1894), pp. 271–301, republished in Jordy and Coe, *American Architecture and Other Writings by Montgomery Schuyler* (Cambridge: Harvard University Press, 1961), vol. II, pp. 556–74, esp. p. 564.

14. Wright, "Louis H. Sullivan—His Work," pp. 29–30.

15. Burnham Library, Art Institute of Chicago, republished in Jordy, "Tall Buildings." Sullivan gave a lecture at the accompanying World's Congress of Architects entitled "Polychromatic Treatment of Architecture" which has been lost (*American Architect and Building News* 41 #919 [5 August, 1893], p. 90).

16. Thomas E. Tallmadge, "The 'Chicago School,'" *Architectural Review* 15 #4 (April 1908), pp. 69–74.

17. André Bouilhet, "L'exposition de Chicago," *Revue des arts décoratifs* 14 (1893), pp. 66–79; Jacques Hermant, "L'Art à l'exposition de Chicago," *Gazette des beaux-arts* 3S 10 (1893), esp. pp. 441–50, together with his "Architecture aux Etats-Unis: l'exposition universelle de Chicago," *Architecture* 7 #42 (October 20, 1894), pp. 341–46; "France Honors Louis H. Sullivan," *Inland Architect* 25 #2 (March 1895), pp. 20–21; Jean Schopfer, "American Architecture from a Foreign Point of View: New York City," *Architectural Review* 2 #3 (March 30, 1900), pp. 25–30. See also Lauren Weingarden, "Louis H. Sullivan: Investigation of a Second French Connection," *Journal of the Society of Architectural Historians* 39 #4 (December 1980), pp. 297–303; Lewis, *Encounter with Tomorrow*, ch. 8.

18. These fears were reviewed in the *Chicago Tribune*, November 6, 1887.

19. Ibid.

20. Ibid, April 27, 1890.

21. Ibid, August 21, 1892.

22. Bruegmann, *Architects and the City*, chs. 6, 7.

23. Robert Judson Clark told me that in his later years Mullgardt's drawing for the façade was displayed framed on his wall.

24. Bluestone focuses on this largely forgotten structure in *Constructing Chicago*, pp. 123–28.

25. He had the project published as widely as possible, for example in the *Inland Architect* of July 1888, the *Chicago Tribune* on September 2, 1888, and even the French *La construction moderne* of September 1888, pp. 577–80. In the 1930s and 1940s there was a burst of scholarly investigation of this event: E. M. Upjohn, "Buffington and the Skyscraper," *Art Bulletin* 17 #1 (March 1935),

pp. 48–70; Hugh Morrison, "Buffington and the Invention of the Skyscraper"; Dmitri Tselos, "The Enigma of Buffington's Skyscraper"; Muriel Christison, "How Buffington Stacked His Claim," *Art Bulletin* 26 #1 (March 1944), pp. 1–24.

26. The building was widely noticed (for example, in *La construction moderne*, March 7 and 21, 1891, pp. 257–59, 285–87). See also Sarah Landau and Carl Condit, *The Rise of the New York Skyscraper 1865–1913*, (New Haven and London: Yale University Press, 1996), pp. 197–203.

27. Beman's premiated (and later constructed) design was published in *Inland Architect and News Record*, March 1891.

28. *Deutsche Bauzeitung*, 21 November, 1891, p. 564, citing the "New York Revue" of August 30. Dinkelberg was a sometime associate of Charles Atwood and, like Atwood, worked for Daniel Burnham. See also John Zukowsky, "Frederick P. Dinkelberg and the Chicago Architectural Club," *Chicago Architectural Club Journal*, 1985, p. 32; Arnold Lewis, *An Early Encounter with Tomorrow*, p. 119; Landau and Condit, *The Rise of the New York Skyscraper*, pp. 211, 302.

29. November 23, 1890. Pabst's contemporaneous headquarters building in Milwaukee was likewise a statement of German presence in America, but using different terms.

30. Foreign observers especially remarked the Schiller Building: Hermant, "Exposition"; Adolphe Bocage, "Architecture aux Etats-Unis," *L'Architecture* 7 # 41 (October 13, 1894), p. 333–38; Alphonse de Calonne, "Maisons hautes en Angleterre et en Amerique," *Revue des deux mondes* #122 (April 15, 1894), pp. 853–75, esp. p. 869.

31. Published in a pamphlet, *To the Odd-Fellows of Chicago and the State of Illinois*, signed by William C. Mclintock, president, J. P. Ellacott, vice-president, and Norman Totten, secretary and treasurer. See also *Chicago Tribune*, September 5, 1891.

32. Louis Sullivan, "The High Building Question," *The Graphic* (December 19, 1891), p. 405. Republished in Twombly, *The Public Papers*, pp. 76–79. See also Donald Hofmann, "The Set-back Skyscraper of 1891: An Unknown Essay by Louis H. Sullivan," *Journal of the Society of Architectural Historians* 29 #2 (May 1970), pp. 181–87.

33. *Engineering Magazine* II (December 1891), p. 396.

34. Jordy in *The Function of Ornament*, p. 83.

35. Wright, "Louis Sullivan—His Work," p. 29.

36. Condit, *Rise of the Skyscraper*, pp. 198–201. For Schiller: James Bartlett, "Foundations," *Encyclopedia Britannica*, eleventh edition (vol. 10, 1910), p. 741.

37. One should note that aluminum was light, could be cast, and was noncorrosive.

38. Timothy Samuelson relates the circumstances of the publication of *Louis Sullivan: Prophet of Modern Architecture* in detail in his revised edition, pp. xix–xxxvii.

39. *Chicago Tribune*, November 6, 1887; January 22, 1888.

40. *Chicago Tribune*, January 13, 16, and 24; March 31; June 1, 2, and 8; July 14; and August 18, 1889.

41. See, for example, *Oak Park Reporter*, January 9, 1891, on the projected Loop YMCA Building.

42. William Le Baron Jenney had already argued for the steel-skeletal system in his presentation of the Home Insurance Building, "The Construction of a Heavy Fireproof Building on a Compressible Soil," *American Sanitary Engineer*, December 10, 1885, pp. 32–33.

43. William H. Birkmire, *Skeleton Construction in Buildings* (New York: John Wiley & Sons, 1893); Joseph Kendall Freitag, *Architectural Engineering with Special Reference to High Building Construction Including Many Examples of Chicago Office Buildings* (New York: John Wiley & Sons, 1895).

44. Edited, republished, and with comments by William Jordy and Ralph Coe, *Schuyler*, esp. I, pp. 246–91, "Glimpses of Western Architecture: Chicago"; *Architectural Record: Great American Architects Series #2*: Adler and Sullivan, D. H. Burnham and Company, Henry Ives Cobb, December 1895.

45. Barr Ferree, "The Modern Office Building," *Journal of the Franklin Institute*, January 1896, pp. 47–140, esp. pp. 47–48.

46. Obituary: *New York Times*, October 15, 1924. *Who's Who in America*, 1914–15, p. 775. Ferree became a member of the Brooklyn Museum Department of Architecture in 1890, joined its advisory board in 1891, became secretary in 1896 and president in 1897, serving until 1902. He gave his library to Princeton University, where it remains intact as the Barr Ferree Room in McCormick Hall.

47. "Chicago Architecture," *Lippincott's Magazine* 52 (July–December 1893), pp. 80–94; "The High Building and Its Art," *Scribner's Magazine* 15 #3 (March 1894), pp. 297–318; "Structure and Material in High Design," *The Brickbuilder* 3 #3 (March 1894), pp. 43–45.

48. *Engineering Magazine* I (1891), pp. 185–202.

49. Edelmann: "Pessimism of Modern Architecture," Ibid. 3 (1892), pp. 44–54; Sullivan: "Ornament in Architecture," 3 (1892), pp. 632–44; Adler: "Tall Office Buildings—Past and Future," 3 (1892), pp. 765–73; "Light in Tall Office Buildings," 4 (1892), pp. 171–86; "Theatre Building for American Cities," 7 (1894), pp. 717–30, 815–29; "The Stimulus of Competition in Architectural Construction," 12 (January 1897), pp. 643–49.

50. *Engineering Magazine* 4 (1893), pp. 297–302.

51. Ferree, "The Modern Office Building," pp. 49–50.

52. Ibid., p. 136.

53. Jordy, "Tall Buildings," pp. 65–157; *American Architects*, pp. 83–179.

54. Morrison in particular was at sea with this design (*Sullivan*, pp. 169–72) and was chided by Frank Lloyd Wright, "I can explain, for Mr. Morrison, the 'mystery' of the oriels of the Stock Exchange Building.... Calculate the floor space stolen, by ordinance, from the street and see 'why' they were there! Then consider that such bays were preferred by tenants because they could look up and down the street without sticking their heads out of the windows, etc." ("Form and Function," *Saturday Review*, 1935).

55. "Interesting New Store Fronts in Chicago," *Brickbuilder* 8 #12 (December 1899), pp. 24–25.

56. Sullivan, *Autobiography of an Idea*, p. 299.

57. In a famous scene of about 1895 that Wright depicts in his *Autobiography*, 1943 edition, pp. 125–28.

58. Karen Sawislak starts to explore the uniquely Chicagoan system of organization that marked the city's accomplishments in *Smoldering City: Chicagoans and the Great Fire, 1871–1874* (Chicago: University of Chicago Press, 1995).

CHAPTER THREE

1. *Inland Architect and Building News* 33 #5 (June 1899), p. 43.

2. Wilbert Hasbrouck, "The Early Years of the Chicago Architectural Club," *Chicago Architectural Journal* 1 (1981), pp. 7–14; Stephen Sennott, " 'But We Are Not in France': Early Competitions from the Chicago Architectural Sketch Club," *The Chicago Architectural Journal*, 8 (1989), pp. 12–19; George R. Dean, "A New Movement in American Architecture," *Brush and Pencil* 5 #6 (March 1900), pp. 254–59; Robert C. Spencer, "Work of the Younger Architects," *Brush and Pencil* 8 #2 (May 1901), pp. 113–20; *Charter, Constitution, By-Laws, House Rules, Officers and Members of the Chicago Architectural Club*, Chicago, 1904–5. See also Mark Peisch, *The Chicago School of Architecture* (New York: Random House, 1964); H. Allen Brooks, *The Prairie School; Frank Lloyd Wright and his Midwest Contemporaries* (Toronto: University of Toronto Press, 1972).

3. Listed with their students in the *Chicago Architectural Club Catalogue* of 1898, pp. 33–35.

4. Documented in the club's publication cited above: *Charter, Constitution, By-Laws*. See also *Construction News*, March 9, 1904.

5. Frank Lloyd Wright, *Autobiography*, 2nd edition, p. 151; *A Testament* (New York: Bramhall House, 1957), p. 34.

6. H. Allen Brooks, *The Prairie School*, esp. pp. 28–32.

7. Mary Woods, *From Craft to Profession: The Practice of Architecture in Nineteenth Century America* (Berkeley and Los Angeles: University of California Press, 1999), pp. 38–42.

8. Although frequently mentioned (Paul, *An Architect*, pp. 54–57; Brooks, *Prairie School*, p. 39; Narciso Menocal, "Frank Lloyd Wright and the Question of Style," *Journal of Decorative and Propaganda Arts* 2 [summer 1986], pp. 4–19; Mardges Bacon, *Ernest Flagg: Beaux-Arts Architect and Urban Reformer* [New York: Architectural History Foundation, 1986], ch. 3), there is no modern history of the association. Its activities were followed in the architectural press, especially the Chicago *Inland Architect*, and it published a yearbook, *The Architectural Annual* (1900, 1901, 1906). In 1912 it combined with the American Institute of Architects, transferring its records to that association. See Emil Lorch's papers (Bentley Historical Library, University of Michigan).

9. Sandra L. Tatman and Roger W. Moss, editors, *Biographical Dictionary of Philadelphia Architects, 1700–1930* (Boston: G. K. Hall, 1985), pp. 37–39.

10. Bacon, *Flagg*, pp. 183–96.

11. *Inland Architect* 33 #5, p. 43.

12. *Architectural Annual* 1 (1900), p. 27. The following volume of 1901 contained two appreciations of Sullivan's work by A. W. Baker and Charles H. Caffin, "Louis H. Sullivan, Thinker and Architect" and "Louis H. Sullivan, Artist Among Architects, American Among Americans," pp. 49–68.

13. *Inland Architect* 33 #5 (June 1899), p. 40.

13. Wright's paper "The Architect" was published in the Chicago weekly *Construction News* 30 (June 16, 1900), pp. 518–19, and his other paper, "A Philosophy of Fine Art," in Frederick Gutheim's anthology, *Frank Lloyd Wright: Selected Writings, 1894–1940* (New York: Duell, Sloan & Pearce, 1941), pp. 6–21.

14. *Inland Architect* 35 #5 (June 1900), pp. 33–44.

15. *Inland Architect* 37 #5 (June 1901), pp. 34–35.

16. Thomas E. Tallmadge, "The 'Chicago School,'" *Architectural Review*. See also his *Story of Architecture in America* (New York: Norton, 1927), p. 217, where he uses the term in direct relation to Sullivan's work.

17. His basic paper read to the 1901 Architectural League convention had also been read before the Chicago Architectural Club on May 4, 1901, and was published in the Chicago art journal *Brush and Pencil* 8 #5 (August 1901), pp. 253–62, entitled "A New Departure in Study of Architectural Design."

18. Both were asked to send remarks on "pure design" to the 1901 Philadelphia convention, responding briefly and with some confusion. See *Inland Architect* 37 #5 (June 1901), p. 38.

19. Emil Lorch, "Some Considerations upon the Study of Architectural Design," *Inland Architect* 37 #5 (June 1901), p. 34. Emphasis in original.

20. A manuscript entitled "May Not Architecture Again Become a Living Art?" in the Art Institute of Chicago, published in Twombly, *The Public Papers*, pp. 113–18, esp. p. 117.

21. Lorch, "Some Considerations," p. 34. Emphasis in original.

22. David Hanks, "Louis J. Millet and the Art Institute of Chicago," *Bulletin of the Art Institute of Chicago* 67 #2 (March–April 1973), pp. 13–19.

23. Eugène Delaire, et al., *Les architectes élèves de l'Ecole des Beaux-Arts* (Paris: Chaix, 1895; second edition, 1907). Millet called himself a student not only of Train but also of the sculptor Aimé Millet and the decorator Pierre-Victor Galland (*School of the Art Institute of Chicago: Catalogue, 1892–1893*).

24. Wright, *An Autobiography*, 2nd edition, p. 104. Ron White told the author that Millet's granddaughter remembers dinners at their home with Sullivan on one side of the table and Wright on the other.

25. Viollet-le-Duc's *Lettres inédites recuillées et annotées par son fils* includes a letter to Millet of February 4, 1862 (Paris: Librairies-imprimeries réunies, 1902), pp. 31–32. In 1886 Emile Millet retired to France.

26. Henri Dumesnil, *Aimé Millet: souvenirs intimes* (Paris: Lemerre, 1891).

27. Osmund Overby, "A Place Called Union Station; An Architectural History of Saint Louis Union Station," *St. Louis Union Station: A Place for People, a Place for Trains* (Saint Louis: Mercantile Library, 1994), pp. 59–89.

28. *The Economist*, September 14, 1889, p. 819; *Catalogue* 1892–93. William Rotch Ware founded both the MIT and the Columbia programs in 1867 and 1881, respectively; they were considered the leading architectural programs in the United States (Shillaber, *M. I. T.*, T. K. Rohdenburg, *A History of the Architecture School* [New York: Columbia University Press, 1954]). In 1886 Ware had backed Adler & Sullivan's appointment as architect for the Auditorium Building.

29. The Perkins papers at the Chicago Historical Society make it clear that Fellows was the principal designer in the firm after his arrival.

30. W. M. R. French's letters at the Art Institute document a quiet revolution in the spring of 1901, led by an advisory committee of professional architects consisting of Daniel Burnham, Howard Van Doren Shaw, James Gamble Rogers, Charles Frost, and Charles Coolidge. In May Lorch was let go and Victor C. Alderson replaced Millet as dean. In the meantime a principal design instructor was sought, first C. Howard Walker of Boston, who declined, then a recent Beaux-Arts graduate, Henry Hewitt

(teaching 1904–5), then when he found the city uncongenial, the MIT-produced Herman von Holst (1905–6, who in 1909 took over Frank Lloyd Wright's practice upon his sudden departure), then Thomas Tallmadge (1906–7). Von Holst in 1908 wrote several illuminating letters to Lorch about the situation; the letters survive in the Lorch papers in the Bentley Historical Library, University of Michigan.

31. Emil Lorch, "A New Departure in Study of Architectural Design," pp. 253–62.

32. Dietrich Neumeyer, " 'The Century's Triumph in Lighting': The Luxfer Prism Companies and Their Contribution to Modern Architecture," *Journal of the Society of Architectural Historians* 54 #1 (March 1995), pp. 24–53. See also *Inland Architect* 32 #2 (September 1898), pp. 15–16.

33. In 1904 Boari won an international competition to design the Mexico National Opera, settling in Mexico City to enjoy an important practice. (Tom Reese and Victor Jimenez [National University of Mexico] told the author that his papers survive in part in Mexico City.) Frank Lloyd Wright cites him in *A Testament* (New York: Bramhall House, 1957), p. 35.

34. *Construction News*, February 21, 1901, p. 128.

35. Extensively documented in the 1901 and 1902 club exhibition catalogue illustrations. See: *Construction News*, January 26, 1901, p. 53; *Inland Architect* 37 #3 (April 1901), p. 24.

36. Bacon, *Ernest Flagg*, pp. 67–69.

37. Presented by Wright himself: "In the Cause of Architecture," *Architectural Record* 23 #3 (March 1908), pp. 155–66. See also Brooks, *Prairie School*, pp. 78–87; David Van Zanten, "Schooling the Prairie School: Wright's Early Style as Communicable System," in *The Nature of Frank Lloyd Wright*, Carol Bolon, Robert Nelson, Linda Seidel editors (Chicago: University of Chicago Press, 1988), pp. 70–83; and "Frank Lloyd Wright's Kindergarten: Professional Practice and Sexual Roles," in *Not at Home: The Suppression of Domesticity in Modern Art and Architecture*, Christopher Reed, editor (New York: Thames and Hudson, 1996), pp. 92–97, republished from *Architecture: A Place for Women*, Ellen Perry Berkeley and Matilda McQuaid, editors (Washington: Smithsonian Institution Press, 1989), pp. 55–62.

38. Robert C. Spencer, "The Work of Frank Lloyd Wright," *Architectural Review* 7 #6 (June 1900), pp. 61-72.

39. The earliest explanation of the iconography appears in Robert C. Spencer, "The Work of Frank Lloyd Wright,". . ."The open book and pendant scroll beneath the fruitful tree typify the elements of an architect's work," pp. 64–65.

40. Robert C. Spencer, publishing a survey of Wright's work in 1900, pointed out that he claimed inspiration in the kindergarten exercises of Froebel Blocks which his mother had given him as a child. See David Van Zanten, "Frank Lloyd Wright's Kindergarten"; Wright, *An Autobiography* 2nd edition, p. 13.

41. The Chicago Architectural Club's 1900 catalogue starts with an essay by James F. Gookins, "The Hour of Opportunity," on replanning the Chicago railroad net; it also contains a section on workers' housing. Earlier, in 1896, the club had produced a plan for the monumental treatment of the city's lakefront, the perspective drawn by Hugh Garden and published in the 1896 catalogue.

42. Sheets from Kelsey's "The Science of Cities" were published throughout the 1900 *Architectural Annual*. See David Brownlee, *Building the City Beautiful: The Benjamin Franklin Parkway and the Philadelphia Museum of Art* (Philadelphia; University of Pennsylvania Press, 1989).

43. City Club of Chicago, *Twenty-fifth Anniversary Yearbook* (Chicago: City Club, 1929); David Handlin, "The Context of the Modern City," *Harvard Architecture Review* 2 (1981), pp. 77–89. From 1907 on the club published a *Bulletin*. Its papers survive in the Chicago Historical Society.

44. Barry Byrne told the story that he helped Griffin draw the project while Wright was in Japan in 1905, that it was extraordinary for an openwork screen extending across the facade, and that Wright was so incensed that Griffin had competed for work on his own during his absence that Griffin left the studio early in 1906 as a consequence.

45. Alfred B. Yeomans, *City Residential Land Development: Studies in Planning* (Chicago: University of Chicago Press, 1916). Bernhard was in Wright's Taliesin (Wisconsin) drafting room in 1912: Anthony Alofsin, *Frank Lloyd Wright: The Lost Years, 1910–1922: A Study of Influence* (Chicago: University of Chicago Press, 1993), p. 72.

46. Otto Wagner in his correspondence with Griffin was sent the competition program, translating it into German with the intention of using it as a program for his students in Vienna.

47. Eleanor Ellis Perkins, *Perkins of Chicago* (Evanston: self-published, 1966), pp. 80–81 and *Eve Among the Puritans: A Biography of Lucy Fitch Perkins* (Boston: Houghton Mifflin, 1956).

48. Joseph M. Siry, *Unity Temple; Frank Lloyd Wright and Architecture for Liberal Religion* (New York: Cambridge University Press, 1996), pp. 37–50; Ellen Christensen, "A Vision of Urban Social Reform," *Chicago History* 22 #1 (March 1993), pp. 50–61.

49. Perkins's appointment was a personal disaster as he was accused of malfeasance and—after a notorious trial—pushed out of office. See Perkins's more effective *Report of the Special Park Commission to the City Council of Chicago on the Subject*

of the Metropolitan Park System (Chicago: City of Chicago, 1904).

50. In 1911 Lucy and Dwight Perkins were among the small circle at the Ickes' wedding, but by the completion of the second house—a large mansion on Tower Road in Winnetka—Perkins and Ickes were barely on speaking terms. T. H. Watkins, *Righteous Pilgrim: The Life and Times of Harold L. Ickes, 1874–1952* (New York, Holt, 1990), pp. 109, 151–52.

51. See Griffin's description of his project: *New York Times*, June 2, 1912. See also John W. Reps, *Canberra 1912: Plans and Planners of the Australian Capital Competition* (Melbourne: Melbourne University Press, 1997); K. F. Fischer, *Canberra: Myths and Models: Forces at Work in the Formation of the Australian Capital* (Hamburg: Institute of Asian Affairs, 1984); David Van Zanten, "Walter Burley Griffin's Design for Canberra, the Capital of Australia," *Chicago Architecture, 1872–1922*, John Zukowsky, editor (Munich: Prestel, 1987), pp. 319–43.

52. The balancing of democracy and grid planning is an important and complex matter: Hendrik Hartog, *Public Property and Private Power: The Corporation of the City of New York in American Law, 1730–1870* (Chapel Hill, N.C.: University of North Carolina Press, 1983), ch. 11.

CHAPTER FOUR

1. Thomas Tallmadge, "The Thirtieth Annual Architectural Exhibit in Chicago," *Western Architect* 25 (April 1917), pp. 27–28.

2. Brooks, *Prairie School*, pp. 295ff.; Peisch, *The Chicago School of Architecture*, pp. 125ff. (Both put this watershed date at 1914.)

3. Robert R. Warn, "Part I: Bennett and Sullivan; Client and Creator," *Prairie School Review* 10 #3 (1973), pp. 5–15, publishing an important series of letters stretching over this same period of years.

4. Berry was brilliant but died young. Donald Hoffmann, "The Brief Career of a Sullivan Apprentice: Parker N. Berry," *Prairie School Review* 4 #1 (1967), pp. 7–15. Letters from Sullivan to Budina during 1917 and 1918 survive in the Art Institute of Chicago library.

5. Narciso Menocal alone treats the late houses as a group and seriously in *Architecture as Nature*, pp. 102–27. See also Gordon Orr, "The Collaboration of Claude and Starck with Chicago Architectural Firms," *Prairie School Review* 12 #4 (1975), pp. 5–12. The preliminary project survives at the Northwest Archi-

tectural Archives, University of Minnesota, and is published in Brian A. Spencer, *The Prairie School Tradition* (New York: Whitney Library of Design, 1979), pp. 38–41.

6. Robert R. Warn, "Part II: Louis Sullivan '…an air of finality,' " *Prairie School Review* 10 #4 (1973), pp. 5–19.

7. Remarkably little attention has been paid to this important project: "A Sullivan Design That Is Not Sullivan," *Western Architect* 20 #3 (August 1914), p. 85; August 1914, pp. 87–88; *Brickbuilder* 23 #10 (1914), plate 152. Twombly tells the story of Sullivan failing to meet the congregation's budget, their request that the Chicago architect W. C. Jones execute these plans without the ornament, and Elsmlie's intervention to save the skeleton of Sullivan's idea: *Sullivan*, pp. 412–14. Sullivan's impressive rendering of the building with the intended ornament hangs in the church itself.

8. Joseph Siry, "John D. Van Allen & Son." To these one might add his tiny structures for the H. C. Adams & Co. Land and Loan Offices in Algona, Iowa, of 1913 and the Purdue State Bank of West Lafayette, Indiana, of 1913–14.

9. Lauren Weingarden provides careful documentation of each of the banks in *Louis H. Sullivan: The Banks* (Cambridge: MIT Press, 1987). See also Wim de Wit, "The Banks and The Image of Progressive Banking," *Louis Sullivan: The Function of Ornament*, pp. 159–97; Craig Zabel, "The Prairie Banks of Frank Lloyd Wright," *The Frank Lloyd Wright Newsletter* 5 #1 (October 1982), pp. 3–13. See a bank president's perspective: Carl Bennett, "A Bank Built for Framers," *The Craftsman* 15 (November 1908), pp. 176–85; and three important reviews: Schuyler, "The People's Savings Bank of Cedar Rapids"; Andrew Rebori, "An Architecture of Democracy: Three Recent Examples from the Work of Louis H. Sullivan," *Architectural Record* 39 #5 (May 1916), pp. 437–65; Thomas Tallmadge, "The Peoples Savings & Loan Association Building of Sidney, Ohio: Louis H. Sullivan, Architect," *American Architect* 114 #2235 (October 23, 1918), pp. 477–82.

10. Larry Millet, *The Curve of the Arch: The Story of Louis Sullivan's Owatonna Bank* (St. Paul: Minnesota Historical Society Press, 1985). See also Warn, "Bennett"; Paul E. Sprague, "The National Farmer's Bank, Owatonna, Minnesota," *Prairie School Review* 4 #2 (1967), pp. 5–21.

11. Something dramatically evident when it is compared to the counter-project presented by Purcell and Elmslie: Warn, "Bennett," part II, p. 13.

12. Mrs. Carl K. Bennett to Richard Nickel, February 23, 1957, quoted in Millett, *The Curve of the Arch*, p. 110. Emphasis in original.

13. This is the subject of my essay "Sullivan to 1890."

14. By 1940 Frank Lloyd Wright was claiming authorship of the Charnley House while continuing to describe himself as a "pencil in the master's [Sullivan's] hand." Henry Russell Hitchcock, *In the Nature of Materials* (New York: Duell, Sloan and Pearce, 1942), pp. 11–12; based on interviews with Wright: Wright, *Genius and the Mobocracy*, p. 61.

15. Julien Guadet, *Eléments et théorie de l'architecture* (Paris: Librairie de la construction moderne, 1901–4), I, p. 117; Gromort, *Essai sur la théorie de l'architecture* (Paris: Vincent, Fréal & Cie, 1942), part II, ch. xiv.

16. There is one set of drawings, dated August 10, 1898, in the McCormick Collection, State Historical Society of Wisconsin, Madison.

17. The drawings for the McCormick House survive in the McCormick collection in the State Historical Society of Wisconsin, Madison; those for the Bradley House are in the Northwest Architectural Archive at the University of Minnesota, Minneapolis. A Sullivan sketch for the Babson facade was sold in 1990 at the Leslie Hindman Gallery, Chicago, and is illustrated in their catalogue, *Important 19th and 20th Century Architectural Objects and Designs*, #429A.

18. I owe this information to Timothy Samuelson.

19. (Unsigned) "A Departure from Classic Tradition: Two Unusual Houses by Louis Sullivan and Frank Lloyd Wright," *Architectural Record* 30 #4 (October 1911), pp. 327–38.

20. Lawrence Harvey, "The French Mind," *The Builder* 28 #1418 (April 9, 1870), p. 280. Emphasis in original.

21. Claude Bragdon, *More Lives Than One* (New York: Alfred A. Knopf, 1938), p. 155; originally published by Bragdon in "Letters from Louis Sullivan," *Architecture* 64 #1 (January 1931).

22. Georges Gromort, *Essai*, p. 159. cf. Grant Hildebrand's application of Appleton's theory of "refuge" and "prospect": *The Wright Space* (Seattle: University of Washington Press, 1991).

23. The Bennett correspondence is in the Northwestern Architectural Archives; the interviews are on tapes belonging to John Vinci.

24. John Szarkowski's book starts with touching reminiscences of Sullivan's visits by the Columbus bank's president and his wife: *The Idea of Louis Sullivan* (Minneapolis: University of Minnesota Press, 1956), pp. 3ff.

25. Rebori, "An Architecture of Democracy," p. 438.

26. W. H. Wagner, president of the Peoples Savings and Loan Association, Sidney, Ohio, quoted from Weingarden, *The Banks*, p. 111. He continues: "One of the directors was somewhat disturbed by the unfamiliarity of the style, and suggested that he rather fancied some classic columns and pilasters for the facade. Sullivan very brusquely rolled up his sketch and started to depart, saying that the directors could get a thousand architects to design a classic bank but only one to design this kind of bank, and that as far as he was concerned it was one or the other."

27. Rebori, "An Architecture of Democracy," p. 437.

28. Lauren Weingarden is especially sensitive to this in her book *Louis H. Sullivan, The Banks.*

29. Menocal, "New Ventures, New Perspectives, and Their Failure," *Architecture as Nature*, pp. 102–27. Menocal quotes Purcell's diary in 1913: "Mr. Sullivan simply had no conception whatever of American family life" (p. 105).

30. Claude Bragdon, *Projective Ornament* (Rochester, N.Y.: Manas Press, 1915). Much more complex is the parallel with Frank Lloyd Wright's ornament at this moment, especially as it appears in Midway Gardens (1913–14)—explored by Paul Kruty, *Frank Lloyd Wright and Midway Gardens* (Urbana and Chicago: University of Illinois Press, 1998); and Anthony Alofsin, *Frank Lloyd Wright: The Lost Years, 1910–1922* (Chicago and London: University of Chicago Press, 1993).

31. Eduard Hanslick, *Vom Musikalisch-Schönen*, 1854, many times reprinted and translated, e.g., in *The Beautiful in Music*, translated by Gustav Cohen (Indianapolis: Bobbs-Merrill, 1957).

CHAPTER FIVE

1. B. C. Greengard, "Sullivan/Presto/The Krause Music Store," *Prairie School Review* 6 #3 (1969), pp. 5–10.

2. Kenneth W. Severens, "The Reunion of Louis Sullivan and Frank Lloyd Wright," *Prairie School Review* 12 #3 (1975), pp. 5–21.

3. The closest chronicles of Sullivan's last years are Connely (1960), updated and expanded by Twombly (1986).

4. Louis Sullivan, *A System of Architectural Ornament According with a Philosophy of Man's Powers* (New York: Press of the American Institute of Architects, 1924); republished with a note by Ada Louise Huxtable (New York: Eakins Press, 1967). The original drawings are published with commentary by Lauren Weingarden, *Louis H. Sullivan: A System of Architectural Ornament*, John Zukowsky and Susan Glover Godlewski, editors (New York: Rizzoli, 1990).

5. Frank Lloyd Wright, "In the Cause of Architecture: V. The Meaning of Materials—the Kiln," *Architectural Record* 63 #6 (June 1928), pp. 555–61, esp. p. 556.

6. Rosemarie Haig Bletter, "The Art Deco," in Bletter and

Cervin Robinson, *The Skyscraper Style* (New York: Oxford University Press, 1975), pp. 35–81. The Austrians Josef Urban, Paul Frankl, and Jacques Ely Kahn (Kahn trained at the Ecole des Beaux-Arts) set the style in New York. In the 1930s Frankl sent his son to be one of Wright's first apprentices at the Taliesin Fellowship.

7. For example, William H. Goodyear, *The Grammar of the Lotus* (London: S. Low, Marston & Co., 1890).

8. Both wrote autobiographies, Pond's as a manuscript in the American Institute of Arts and Letters in New York, Bragdon's published as *More Lives than One*.

9. For a study of Sullivan's strategy in the *Autobiography of an Idea* in the context of the literary genre see Herbert Leibowitz, *Fabricating Lives*.

10. These dates and annotations are partially removed in the original 1924 publication of the *System*, but are mostly visible and transcribed in the 1990 Art Institute publication of the original sheets.

11. Frank Lloyd Wright, *Letters to Architects*, Bruce Brooks Pfeiffer, editor (Fresno: California State University Press, 1984), p. 37, letter of September 3, 1922.

12. Here I have been greatly helped by a paper of and conversation with Ahuvia Kahane, my colleague at the Northwestern University Department of Classics.

BIBLIOGRAPHY

IN ADDITION to the published works listed below, a number of important volumes are in progress at the time of writing: Joseph Siry's Sullivan studies, most recently a volume on the Auditorium Building; Rochelle Elstein's monograph on Dankmar Adler; a volume of essays on the Charnley House edited by Richard Longstreth; and a critical edition of Sullivan's *Kindergarten Chats* edited by Richard Etlin. There are also significant studies in preparation on the "Chicago School," among them Gerald Larson's on the architectural and real estate development of the Chicago Loop; a monograph on S. S. Beman by Thomas J. Schlereth; Wilbert Hasbrouck's research into the history of the Chicago Architectural Club; Lisa Schrenk's study of the draftsmen in Frank Lloyd Wright's Oak Park Studio; and a dissertation on the work of the Pond brothers by Ted Newcomen at the University of York.

ARCHIVES AND DRAWING COLLECTIONS

Art Institute of Chicago: Library (Sullivan and Burnham papers), Archives (School and W. M. R. French Papers), and Department of Architecture (Sullivan Drawings).
Chicago Historical Society: Brooks Estate Papers, City Club Records, Dwight Perkins Papers.
Newberry Library, Chicago: Theodore Thomas Papers.
Avery Architectural and Fine Arts Library, Columbia University: Sullivan Drawings.
Northwestern University, University Archives: Carson Webster Papers.
University of Michigan, Bentley Historical Library: Emil Lorch Papers, and Irving K. Pond MS autobiography (copy).
University of Minnesota, Northwest Architectural Archives: Sullivan Drawings, Carl Bennett and William Gray Purcell Papers.
State Historical Society of Wisconsin: McCormick Papers.

COLLECTIVITIES

Annual of the Chicago Architectural Club, Being the Book of the Thirteenth Annual Exhibition, Chicago, 1900.
Annual of the Chicago Architectural Club, Being the Book of the Fourteenth Annual Exhibition, Chicago, 1901.
The Chicago Architectural Annual, Chicago, 1902.

Book of the Twenty-sixth Annual Exhibition of the Chicago Architectural Club, Chicago: Chicago Architectural Club, 1913.

Charter, Constitution, By-Laws, House Rules, Officers and Members of the Chicago Architectural Club, Chicago, 1904–5.

BOOKS AND ARTICLES

Anonymous, "A Departure from Classic Tradition; Two Unusual Houses by Louis Sullivan and Frank Lloyd Wright," *Architectural Record* 30 #4 (October 1911), 327–38.

Anonymous, *Early Modern Architecture in Chicago 1870–1910*. New York: Museum of Modern Art, 1933 (mimeograph).

Adler, Dankmar, "The Chicago Auditorium," *Architectural Record* 1 (April–June 1892), 415–34.

———, "Theatre Building for American Cities," *Engineering Magazine* 7 (1894), 717–30, 815–29.

Alofsin, Anthony, *Frank Lloyd Wright: The Lost Years, 1910–1922: A Study of Influence*. Chicago: University of Chicago Press, 1993.

Andrew, David S., *Louis Sullivan and the Polemics of Modern Architecture: The Present Against the Past*. Chicago and Urbana: University of Illinois Press, 1985.

Bacon, Mardges, *Ernest Flagg: Beaux-Arts Architect and Urban Reformer*. New York: Architectural History Foundation, 1986.

Beeby, Thomas, "The Grammar of Ornament/Ornament as Grammar," *Via III*, Journal of the Graduate School of Fine Arts, University of Pennsylvania, 1977, 10–29.

Bennett, Carl, "A Bank Built for Farmers: Louis Sullivan Designs a Building Which Marks a New Epoch in American Architecture," *The Craftsman* 15 #2 (November 1908), 176–85.

Berger, Miles L., *They Built Chicago: Entrepreneurs Who Shaped a Great City's Architecture*. Chicago: Bonus Books, 1992.

Birkmire, William H., *Skeleton Construction in Buildings*. New York: Wiley, 1893.

Bluestone, Daniel, *Constructing Chicago*. New Haven and London: Yale University Press, 1991.

Bocage, Adolphe, "Architecture aux Etats-Unis," *L'architecture* 7 41 (October 13, 1894), 333–39.

Bouilhet, André, "L'exposition de Chicago," *Revue des arts décoratifs* 14 (1893), 66–79.

Boyer, M. Christine, *Dreaming the Rational City: The Myth of American City Planning*. Cambridge, Mass.: MIT Press, 1983.

Bragdon, Claude, "An American Architect: Being an Appreciation of Louis H. Sullivan," *House and Garden* 7 (January 1905), 47–55.

———, "Letters from Louis Sullivan," *Architecture* 64 #1 (July 1931), 7–10.

———, *More Lives than One*. New York: Alfred A. Knopf, 1938.

———, *Projective Ornament*. Rochester, N.Y.: Manas Press, 1915.

Brooks, H. Allen, *The Prairie School; Frank Lloyd Wright and His Midwest Contemporaries*. Toronto: University of Toronto Press, 1972.

———, *Writings on Wright: Selected Comment on Frank Lloyd Wright*. Cambridge, Mass.: MIT Press, 1981.

Brownlee, David, *Building the City Beautiful: The Benjamin Franklin Parkway and the Philadelphia Museum of Art*. Philadelphia: University of Pennsylvania Press, 1989.

Bruegmann, Robert, *The Architects and the City: Holabird & Roche of Chicago, 1880–1918*. Chicago: University of Chicago Press, 1997.

Burnham, Daniel, "The Organization of the World's Columbian Exposition," *Inland Architect* 22, #1 (August 1893), 5–8.

Burnham, Daniel, and Francis D. Millet, *The World's Columbian Exposition, The Book of the Builders*. Chicago: Columbian Memorial Publications, 1894.

Calonne, Alphonse de, "Maisons hautes en Angleterre et en Amérique," *Revue des deux mondes* #122 (April 15, 1894), 853–75.

Castex, Jean, "Darwin, Wright and the typology of the Prairie House," *Rassegna* 20 #74 (1998), 64–75.

Christensen, Ellen, "A Vision of Urban Social Reform," *Chicago History* 22 #1 (March 1993), 50–61.

Christison, Muriel, "How Buffington Staked His Claim," *Art Bulletin* 26 #1 (March 1944), 13–24.

Commission on Chicago Landmarks , *Chicago Historic Resources Survey*. Chicago, 1996.

Condit, Carl W., "The Chicago School and the Modern Movement in Architecture," *Art in America* 36 #1 (January 1948), 19–36.

———, *The Rise of the Skyscraper*. Chicago: University of Chicago Press, 1952.

———, *The Chicago School of Architecture*. Chicago: University of Chicago Press, 1964.

Condit, Carl W., and Sarah Bradford Landau, *The Rise of the New York Skyscraper, 1865–1913*. New Haven and London: Yale University Press, 1996.

Connely, Willard, *Louis Sullivan: The Shaping of American Architecture*. New York: Horizon Press, 1960.